THE SWINGING SIXTIES

AN ICONIC DECADE IN PICTURES

First published 2012 by
Ammonite Press
an imprint of AE Publications Ltd,
166 High Street, Lewes, East Sussex, BN7 1XU

Text © AE Publications Ltd, 2012
Images © Mirrorpix, 2012
Copyright © in the work AE Publications Ltd, 2012

ISBN 978-1-907708-72-5

British Cataloguing in Publication Data. A catalogue
record of this book is available from the British Library.

Editor: Ian Penberthy, Caroline Watson
Series Editor: Richard Wiles
Picture research: Mirrorpix
Design: Gravemaker+Scott

Colour reproduction by GMC Reprographics
Printed and bound in China by Hung Hing Printing Co. Ltd

Page 2

Blowin' and dancin'

Denny Payton, saxophonist
with the Dave Clark Five, takes
his music to the fans at a
dance in Basildon Essex.

1st September, 1963

Page 5

Sole proprietor

Mary Quant surrounded by
her models after putting on a
fashion show in London.

1st August, 1967

Page 6

Fab Four and the Maharishi

The Beatles with the Maharishi
Mahesh Yogi, who became
a guru to the band in the
late sixties. He is credited as
being the spiritual leader who
developed the transcendental
meditation technique.

August, 1967

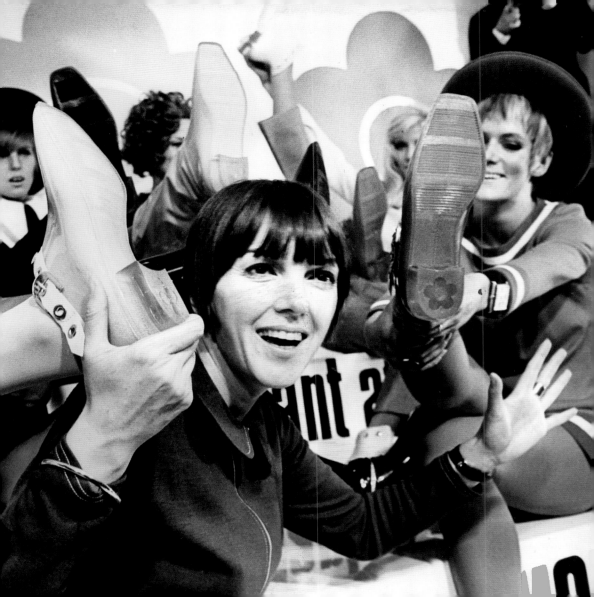

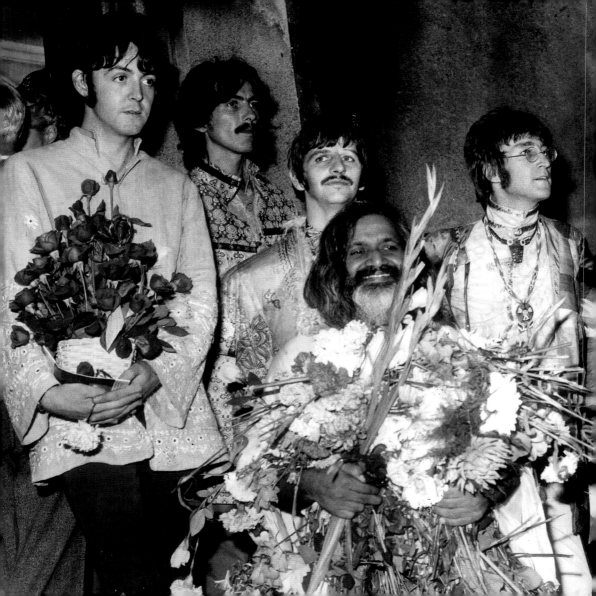

Introduction

The Swinging Sixties was a name given to the fashion and cultural scene that developed in Great Britain during the 1960s, with 'Swinging London' as the hip capital. The predominantly youth-orientated phenomenon emphasised all that was new and modern in a period of optimism and hedonism that flourished after the austerity of the post-war years.

Fashion designers experimented with new materials and styles, notably Frenchman André Courrèges and British style guru Mary Quant, both of whom laid claim to the invention of the miniskirt. Trendy photographers like David Bailey captured evocative images of sultry models such as Jean Shrimpton, the 'Face of the Sixties', and the elfin Twiggy.

The latest fashions were sold in trendy shopping areas such as London's Carnaby Street and King's Road, and the Mini, launched in 1959, became the ubiquitous vehicle of choice for the hip and fashionable. The Union flag was adopted as a symbol of the swinging scene, too, the surge of patriotism being aided by England's victory in the 1966 World Cup.

Pop music formed the anthem of the decade, broadcast by pirate radio stations and top TV shows such as *Ready Steady Go!* and *Top of the Pops*. This was the decade that saw the emergence of The Beatles, and very British pop bands like The Who, The Kinks and The Dave Clark Five, and later the first of the supergroups, Cream.

It was an era of permissiveness, with a relaxation of censorship laws leading to nudity and sexual explicitness on the stage and in films. Young women were liberated by the contraceptive pill, and later in the decade hippies turned to recreational drugs to "turn on, tune in and drop out".

This book takes an affectionate look back at the fashions, music scene and lifestyles of this vibrant decade in over 330 photographs hand-picked from the vast archives of Mirrorpix.

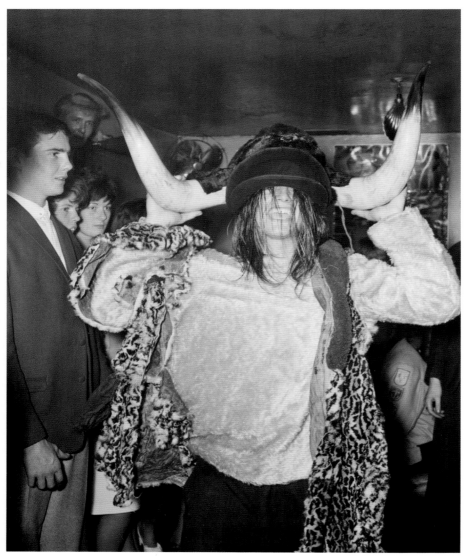

Sutch a scream!

A youthful Screaming Lord Sutch, as outlandish as ever, performs at the famous 2 I's coffee bar in Soho, London. The cafe provided regular live entertainment, and several stars were discovered or performed there, including Tommy Steele, Cliff Richard, The Shadows and Eden Kane.

24th September, 1960

The Swinging Sixties AN ICONIC DECADE IN PICTURES

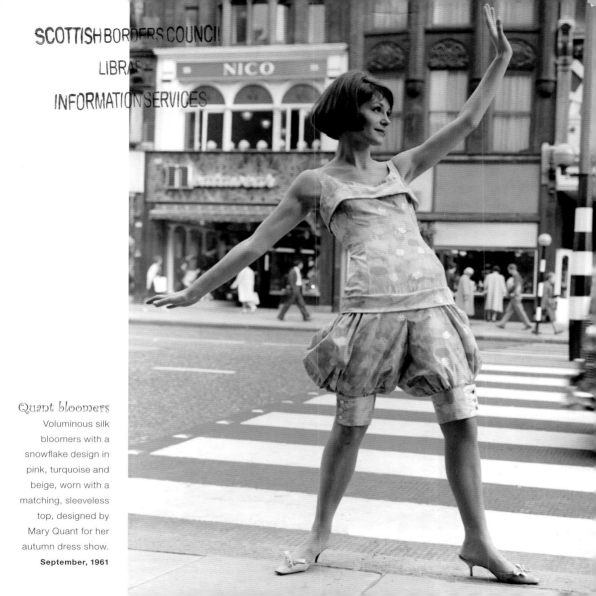

NICO

Quant bloomers

Voluminous silk
bloomers with a
snowflake design in
pink, turquoise and
beige, worn with a
matching, sleeveless
top, designed by
Mary Quant for her
autumn dress show.

September, 1961

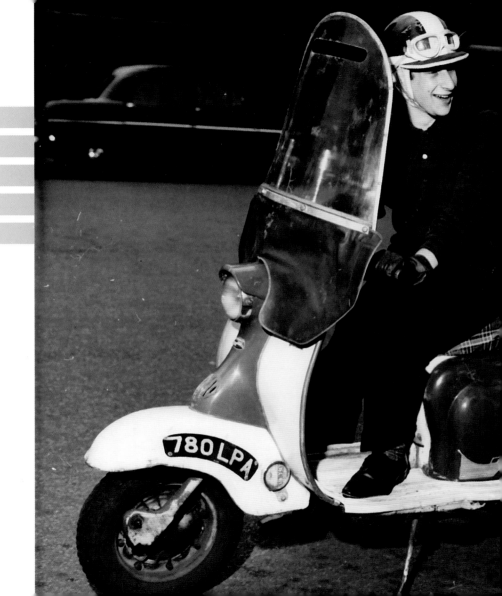

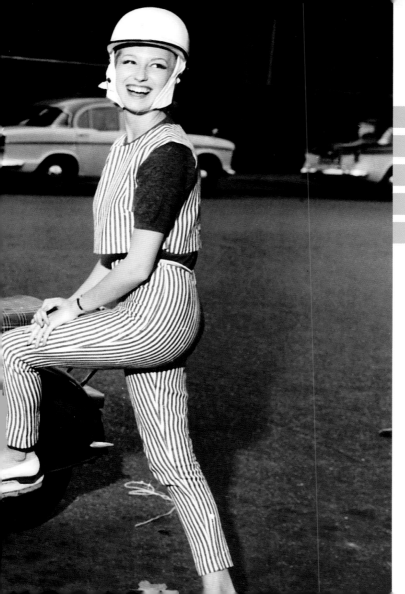

Pillion pals

A girl in a nifty, two-piece striped outfit of tapered trousers with matching tabard top, worn over a T-shirt, catches a lift on the back of her boyfriend's scooter. By the middle of the decade, scooters would become the wheels of choice for style-conscious Mods.

1961

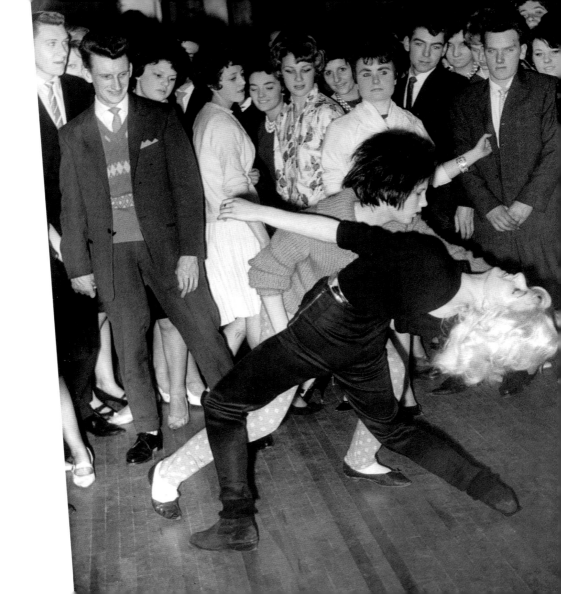

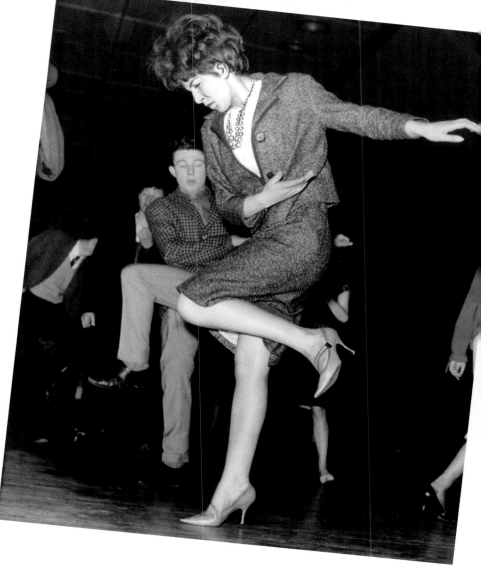

Twisting the night away

Left and right: Teenagers demonstrate the latest dance craze from America, the Twist, at the Majestic Ballroom in Newcastle. Old fogies considered the gyrating hip motions far too provocative.

January, 1962

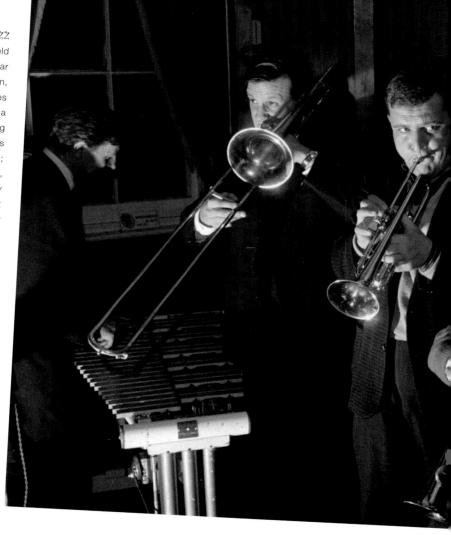

All that jazz

At the Springfield Club in Earlsfield, near Tooting, South London, a group of media types and musicians enjoy a jam session. L–R: Reg Wale, one of Britain's top vibraphone players; unknown; Jack Hutton, editor of the *Melody Maker* on trumpet; Pat Doncaster, *Daily Mirror* music critic, on piano; Eggy Ley, jazz band leader, on clarinet; Chris Roberts, *Melody Maker* reporter, on guitar; and Mike Nevard, *Daily Herald* disc columnist, on drums. Jazz had been the music of the young, but all that changed in the sixties.

5th January, 1962

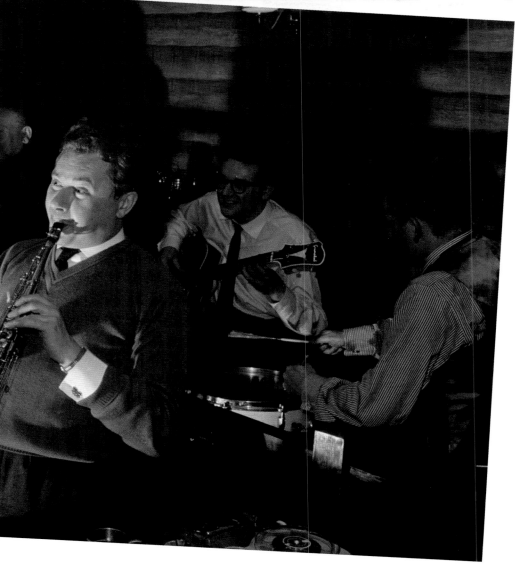

The Swinging Sixties AN ICONIC DECADE IN PICTURES **15**

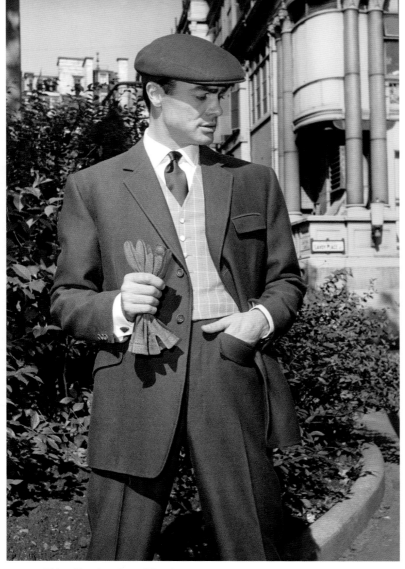

Suits you, sir

In the early Sixties, much of men's clothing was still very conservative in style. This suit, with its high-waisted and flap-pocketed trousers, worn with a checked waistcoat, may have been a step too far for many. It was being shown at a menswear fashion show in London.

1962

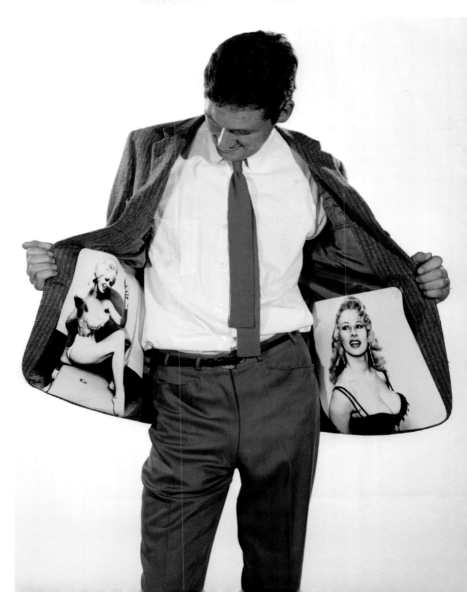

Pin-up material

There was a quirky and thankfully short-lived fashion for men's jackets to come with pin-ups of the stars of the day sewn into the lining. Don't tell the wife!

1962

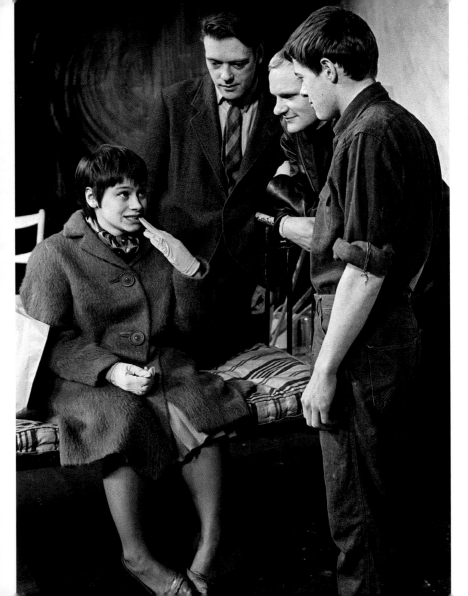

Learning the knack

Rita Tushingham rehearses *The Knack* with (L–R) Philip Locke, Julian Glover and James Bolam at the Cambridge Arts Theatre, Cambridge. The play, about the art of male seduction, was made into a successful film in 1965, starring Tushingham.

26th March, 1962

Lunchtime platter

Right: Song and dance man Sammy Davis Jnr, a member of the American group of entertainers known as the Rat Pack, which included Frank Sinatra and Dean Martin, puts a record on the Dansette in a London restaurant during lunch with friends.

7th May, 1962

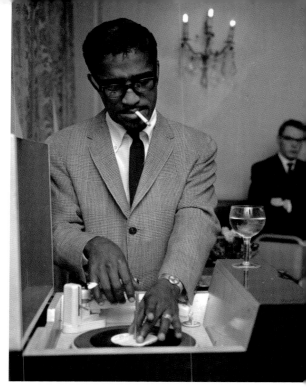

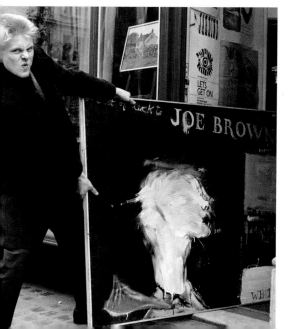

In the picture

Left: Cockney singer and guitarist Joe Brown struggles to collect a portrait of himself from the Portal Gallery in London. That year, he was voted Top UK Vocal Personality in an *NME* magazine poll. The multi-talented entertainer went on to appear on the stage, on TV and in films, as well as becoming a radio broadcaster.

5th July, 1962

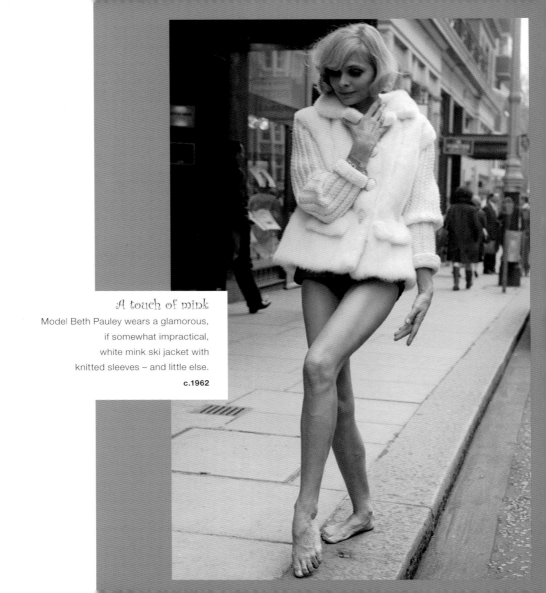

A touch of mink
Model Beth Pauley wears a glamorous,
if somewhat impractical,
white mink ski jacket with
knitted sleeves – and little else.

c.1962

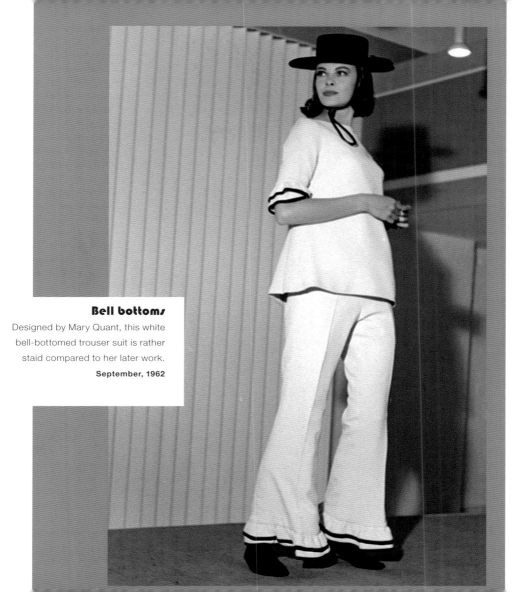

Bell bottoms

Designed by Mary Quant, this white
bell-bottomed trouser suit is rather
staid compared to her later work.

September, 1962

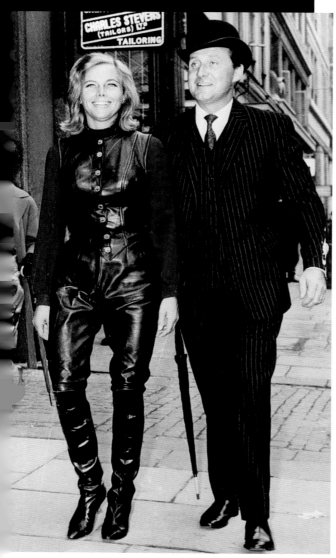

Bowler and boots

Left: Honor Blackman and Patrick Macnee in the leather and pinstriped outfits that became synonymous with their hit television show, *The Avengers*. The espionage-themed series became cult viewing in the Sixties.

1963

Gale force

Right: Patrick Macnee and Honor Blackman (third L), who played John Steed and Cathy Gale in the television series *The Avengers*, surrounded by mannequins displaying some of Mrs Gale's outfits from the show.

1963

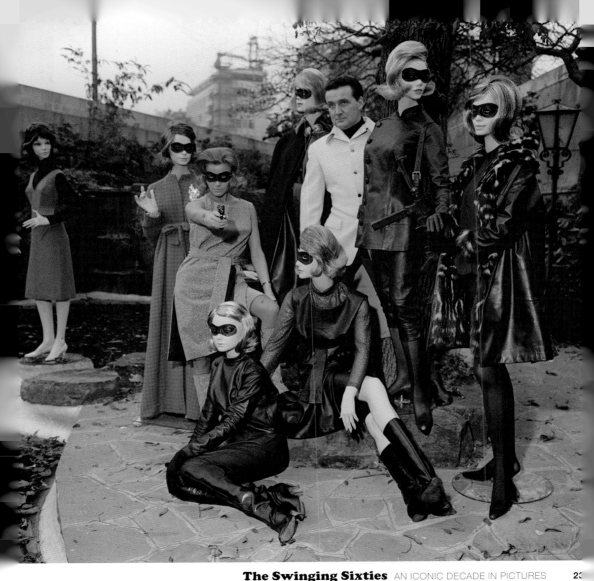

Changing style

By the early Sixties, designers were tinkering with the styling of men's traditional clothing, as shown by this raincoat with its unusual round collar design and the natty tweed hat.

1963

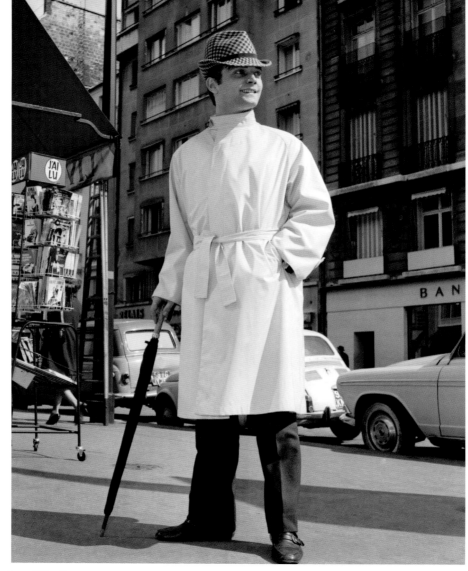

Mexican waves

Below: Men's beachwear with a South American flavour: a patterned Mexican jacket is teamed with striped swimming shorts.

1963

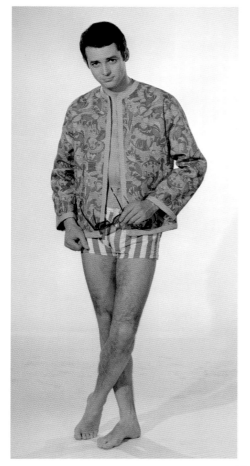

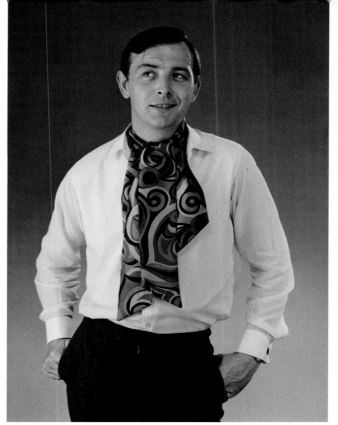

Making a statement

Above: The style for bold, over-sized cravats was a popular fashion statement for men throughout the Sixties.

c.1963

Multi-talented

Right: Singer, comedian, composer and actor Kenny Lynch, who had a number of hits and made the top ten in 1962 with *Up On The Roof*. He also co-wrote the Small Faces' hit *Sha-La-La-La-Lee*.

4th July, 1963

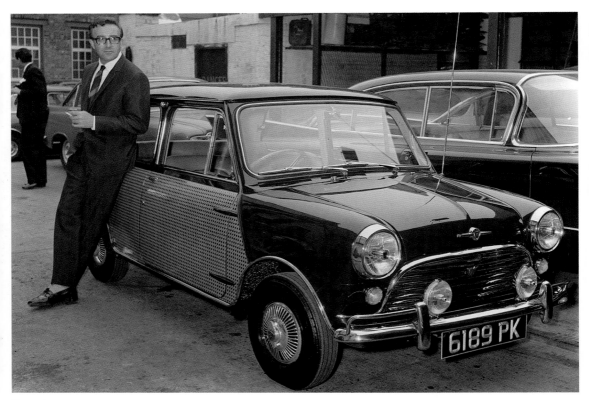

Star's car

Legendary comic actor Peter Sellers at the Mini Cooper works in Kilburn, London, where he was having improvements made to the interior of his own Mini Cooper.

8th May, 1963

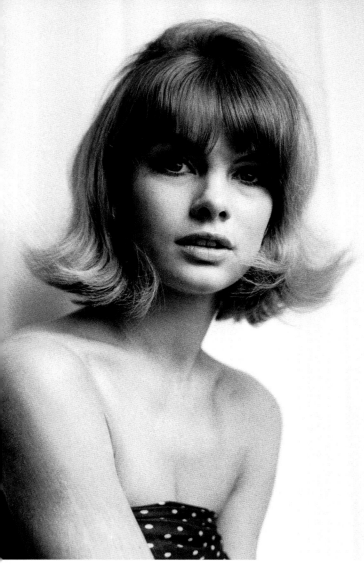

The Shrimp

Left: Model Jean Shrimpton, nicknamed 'The Shrimp', was one of the most widely recognised faces of the Sixties, thanks to ground-breaking fashion shots taken of her by iconic photographer David Bailey.

28th March, 1963

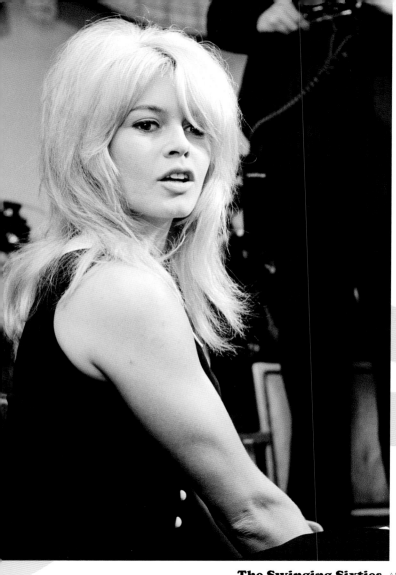

Blonde bombshell

French actress and Sixties sex symbol Brigitte Bardot, pictured at a press conference in London to publicise her latest film, *The Ravishing Idiot*. Bardot starred in a total of 47 films, although her role in husband Roger Vadim's film *And God Created Woman* catapulted her to international stardom. Later in life, she became better known as an animal-rights activist and generated further controversy by criticising French immigration policy, a stance that led to her being accused of inciting racial hatred.
23rd October, 1963

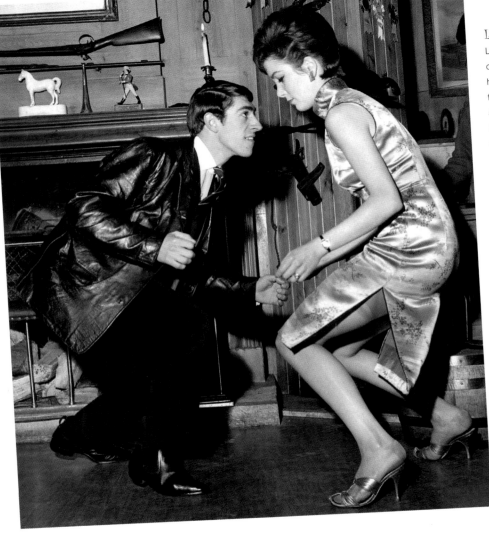

The Swinging Sixties AN ICONIC DECADE IN PICTURES

Let's twist again:
Left: A young coupl
dance the Twist. He
has ditched his suit
for a leather jacket
and elastic-sided
Chelsea boots, wh
she wears a split-
sided, Suzi Wong-
style sheath dress

May, 1963

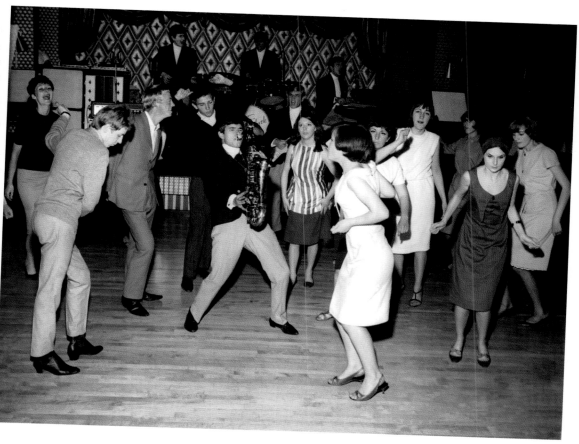

Playing to the crowd

Without any fear of being mobbed, North London band The Dave Clark Five play their set among the well-behaved dancers at a club in Basildon, Essex. A few months later, their single *Glad All Over* would knock The Beatles off the number-one spot in the charts and things would never be the same again.

1st September, 1963

The Swinging Sixties AN ICONIC DECADE IN PICTURES 31

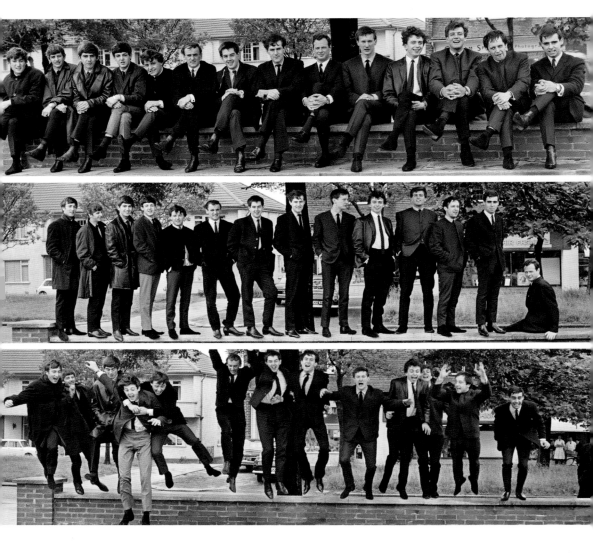

Merseybeat maestros

Left: A photocall in Liverpool to showcase some of the top groups to have come out of the city, all managed by Brian Epstein. Top row, L–R: The Beatles (John Lennon, Ringo Starr, George Harrison and Paul McCartney); Gerry and The Pacemakers (Gerry Marsden, Freddy Marsden, Les Chadwick and Les McGuire); Brian Epstein; Billy J. Kramer and The Dakotas (Robin McDonald, Mike Maxfield, Billy J. Kramer, Ray Jones and Tony Mansfield).

20th June, 1963

Midas touch

Right: Brian Epstein, manager of The Beatles and the man with the Midas touch as far as Liverpool beat groups were concerned in the early Sixties.

20th June, 1963

Singing a secret

Left: Liverpool singer Billy J. Kramer who, along with his backing band, The Dakotas, was one of several successful acts represented by Beatles' manager Brian Epstein. He recorded a number of songs written by John Lennon and Paul McCartney, including *Do You Want To Know A Secret*, which reached number two in Britain in 1963.

10th September, 1963

Ferry man

Lead singer of Gerry and The Pacemakers, Gerry Marsden wrote a number of hits, such as *Ferry 'Cross The Mersey*.

16th December, 1963

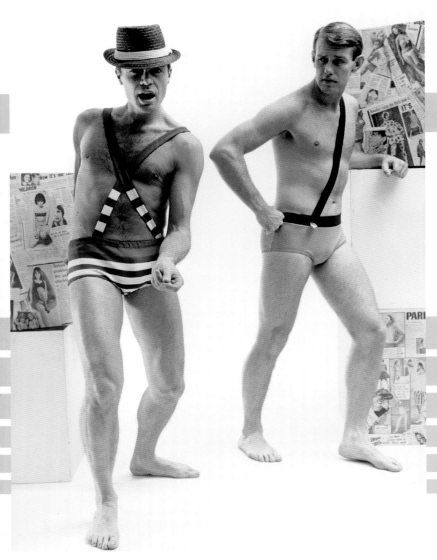

Brace yourselves

Swimming trunks with braces: two models gamely show off a fashion faux pas that, fortunately for men everywhere, never took off.

c.1963

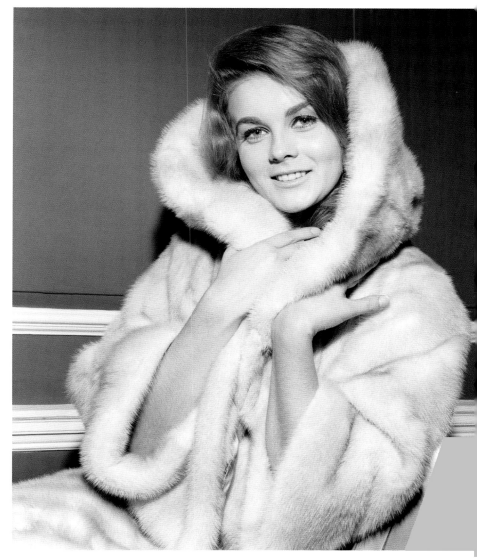

Global star

Swedish-American actress, singer and dancer Ann-Margret, pictured at the Mayfair Hotel in London, after she had flown in for the premiere of her latest film, *Bye Bye Birdie*. Subsequently, she would enjoy a long screen career in film and TV, and win a number of prestigious awards, including five Golden Globes.

6th November, 1963

Beatlemania

Right: Outside the Odeon Cinema in Cheltenham, excited fans await
the first gig of The Beatles' tour: one holds a Beatles magazine, while
a bemused policeman looks on. The screaming would never stop.

1st November, 1963

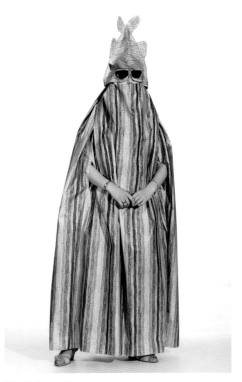

fur trimmed

A striking wool coat design by Mary Quant, trimmed with afro-style fur on
the collar, cuffs and matching hat.

c.1963

Fish head

Above: The Klu Klux Klan apparently branched into
designing beachwear in the early Sixties.

1963

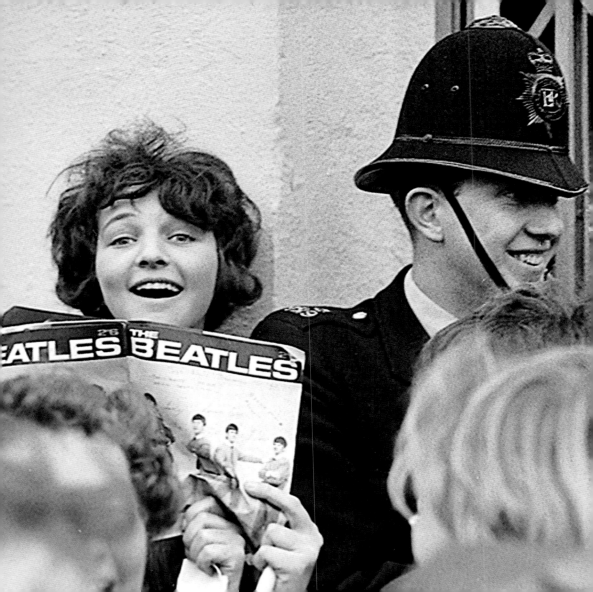

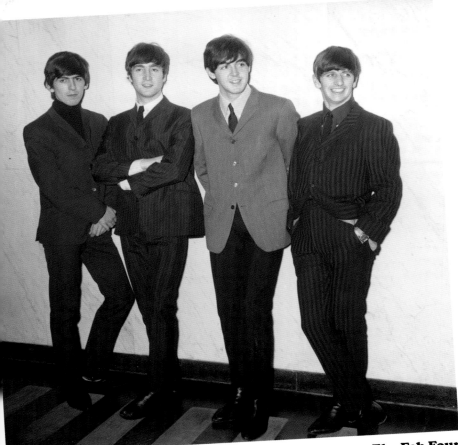

The Scream

Right: Excited fans of The
Beatles can't contain their
enthusiasm for their idols.

14th November, 1963

The Fab Four

The Beatles at an early stage in their career.
L–R: George Harrison, John Lennon, Paul
McCartney and Ringo Starr. They were
about to become huge international stars.

2nd December, 1963

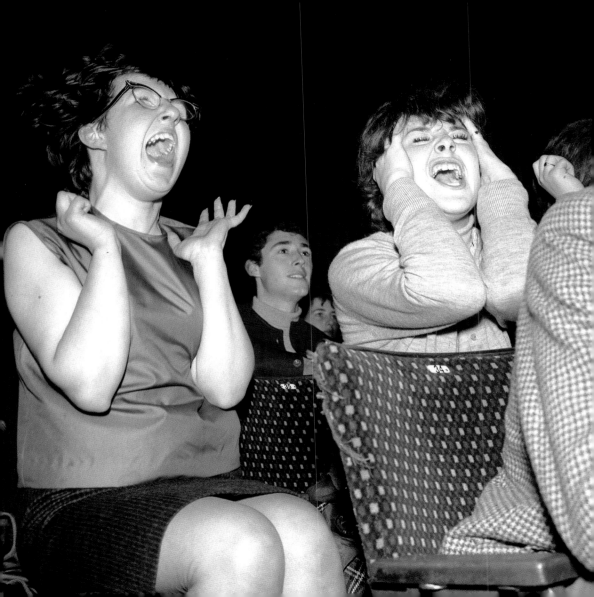

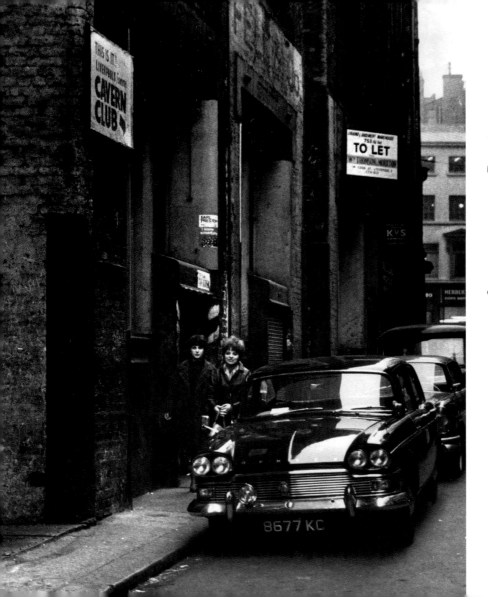

Down in The Cavern

Left and right: In a grimy back street of Liverpool, beat fans spend their lunchtime at the famous Cavern Club, listening to the latest local bands. The club was the springboard to success for many groups, the most famous being The Beatles. Adoring looks and polite applause typified the early reaction of fans.

20th December, 1963

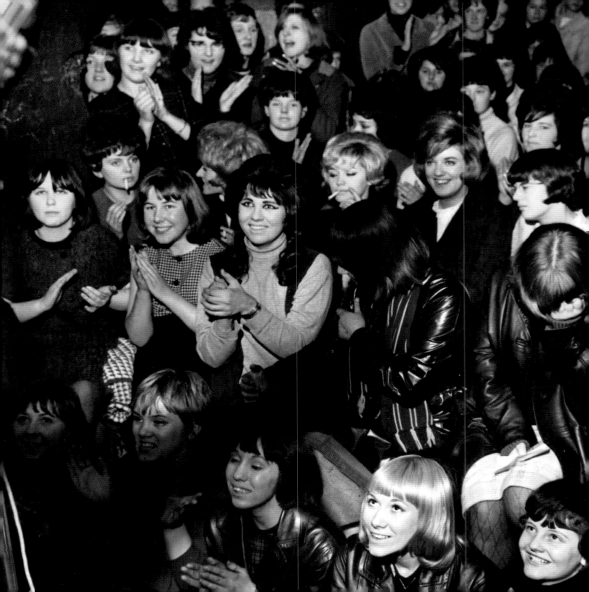

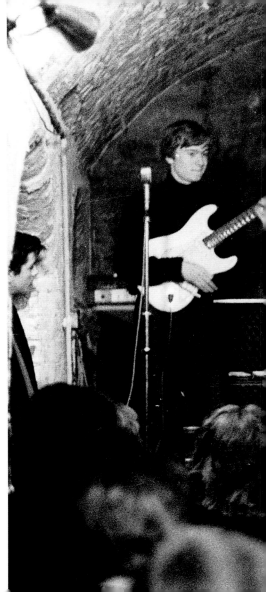

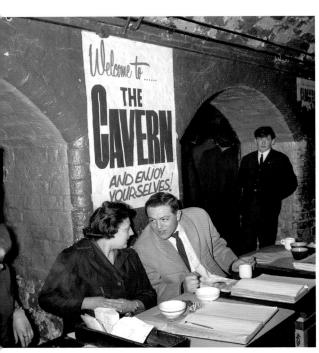

Meeter and greeter

Above: The entrance to Liverpool's Cavern Club. It cost a shilling (five pence) to enjoy a lunchtime session of live music in the cellar that once had served as an air-raid shelter.

20th December, 1963

Stage presence

The Escorts, voted ninth most popular band in Liverpool in 1963 in a poll by *Mersey Beat* magazine, play a lunchtime set on the cramped stage at The Cavern. The group released six singles, but never made the big time before splitting up in 1967.

20th December, 1963

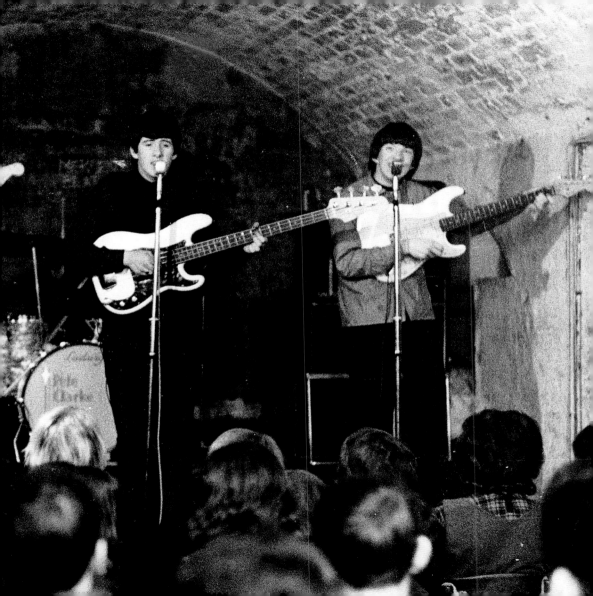

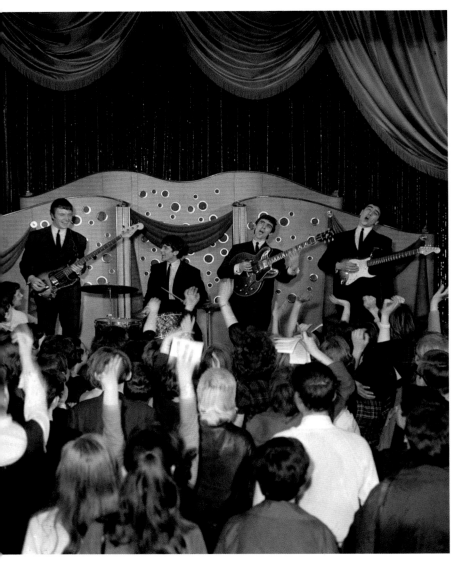

Playing the Empire

Left: Merseybeat band The Swinging Blue Jeans perform to an orderly crowd at the Empire Leicester Square in London. L–R: Les Braid, Norman Kuhlke, Ray Ennis, Ralph Ennis. Their single *Hippy Hippy Shake* made number two in the UK charts in 1963.

14th January, 1964

Dusty says...

Right: British soul singer Dusty Springfield demonstrates the Hitch Hike to fans at the Ilford Palais in Essex. In those early days, the stars were so much more approachable.

14th January, 1964

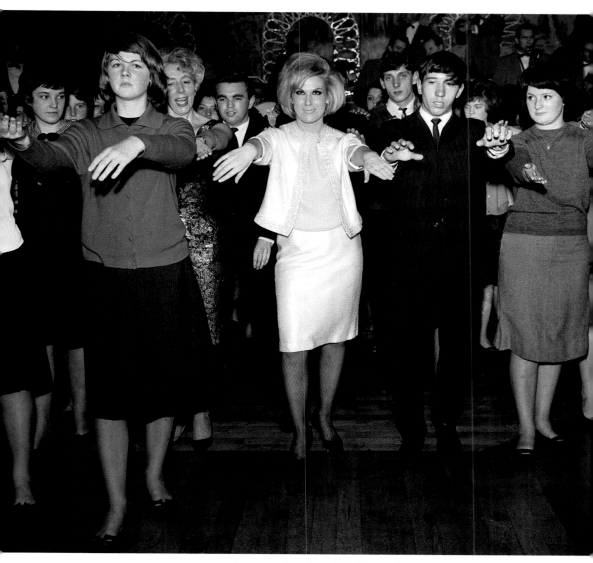

New York dolls

American female group The Ronettes at a reception in London during their first UK tour: (L–R) Ronnie Bennett, Nedra Talley and Estelle Bennett. Among their most well-known songs are *Be My Baby*, *Baby, I Love You* and *Walking In The Rain*. During their stay in Britain, Ronnie had brief affairs with John Lennon and Keith Richards, while Estelle dated George Harrison. Ronnie would later marry renowned American record producer Phil Spector.

16th January, 1964

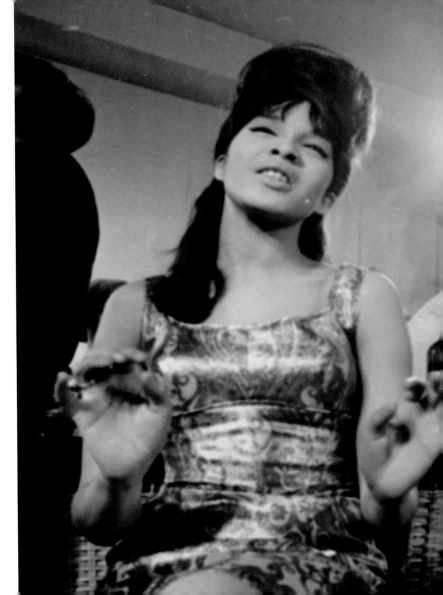

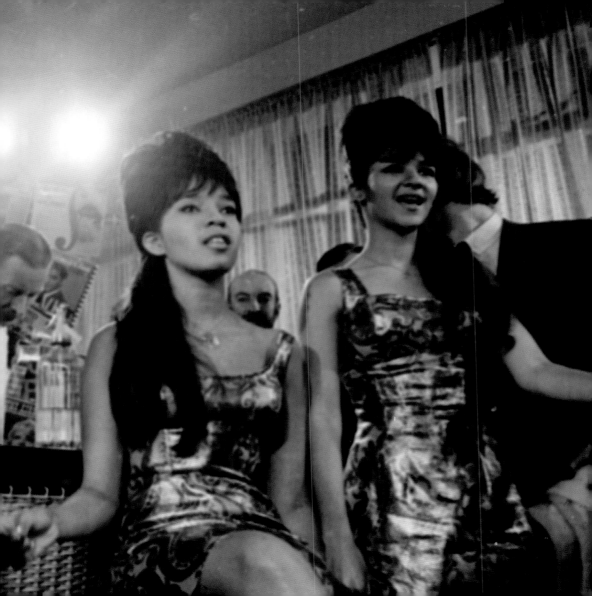

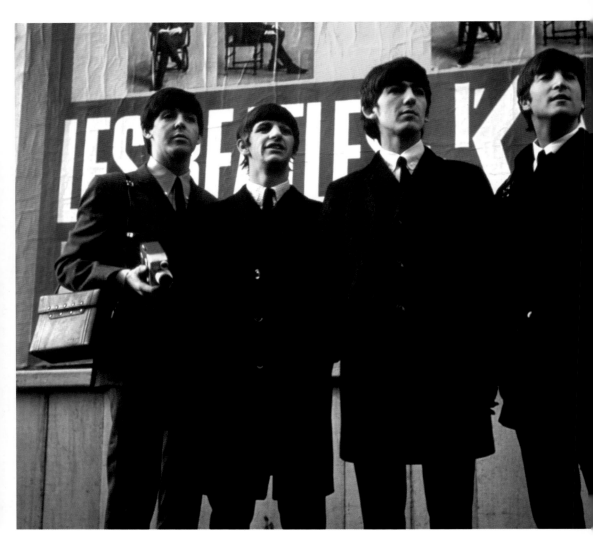

Les Beatles

Left: The Beatles go sightseeing in Paris.

17th January, 1964

Men of influence

L–R: Screenwriter Alun Owen, songwriter Lionel Bart and music impressario Brian Epstein at The Cavern Club in Liverpool. In 1964, Owen was commissioned to write the screenplay for The Beatles' first film, *A Hard Day's Night*.

1964

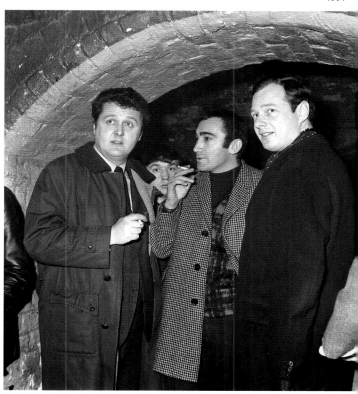

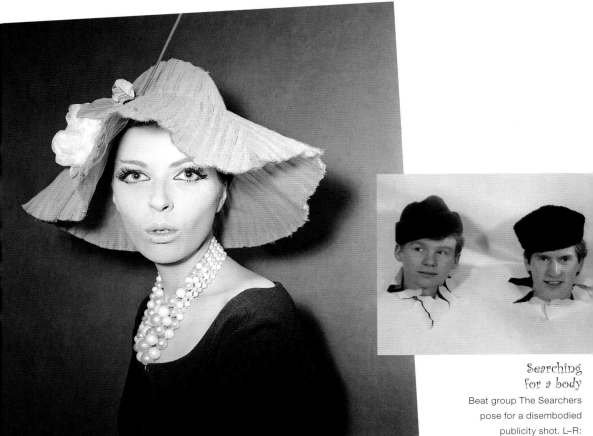

Head start

For a time in the Sixties, wide-brimmed
floppy hats were all the rage. This Reed
Crawford design is in pink tulle
decorated with a fabric rose.

1964

Searching for a body

Beat group The Searchers
pose for a disembodied
publicity shot. L–R:
John McNally, Chris
Chummey, Mike Pender,
Tony Jackson. They had
a number of hits in the UK
in the Sixties.

30th January, 1964

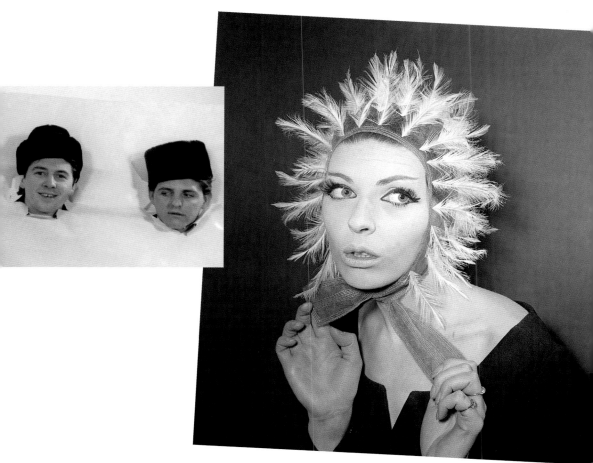

Plucked chicken?

Looking like a part-plucked chicken, this Reed Crawford creation takes the form of a tulle helmet with singed heron feathers for decoration.
1964

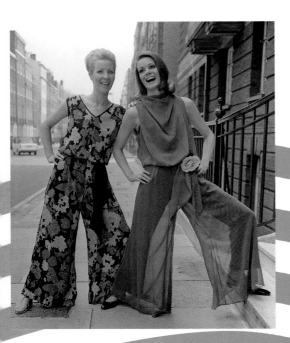

Flower power

Left: A fashion shoot on the streets of London: models Norma Swift (L) and Alexis Drury wear diaphanous, flared trouser suits in flower-print and plain materials.

c.1964

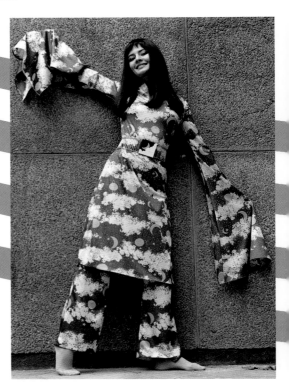

Sleeve notes

Element-print trouser suit with exaggerated outsize sleeves, worn with a matching chunky belt.

c.1964

The Swinging Sixties AN ICONIC DECADE IN PICTURES

Knitted jersey long
and short dungarees
by Marlborough make
striking statements;
short, curly blonde
wigs were optional.

c.1964

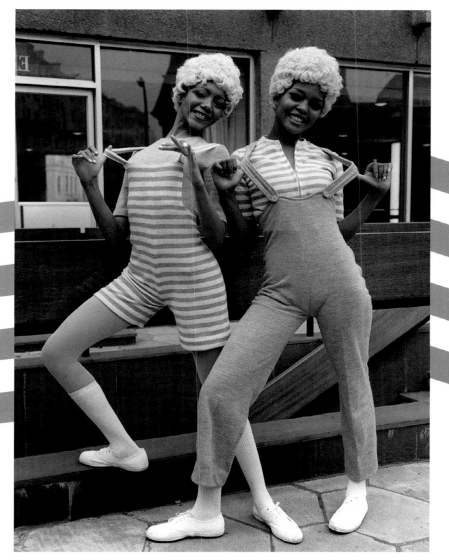

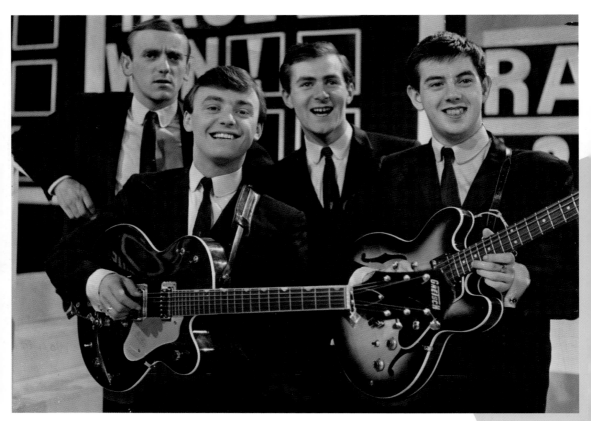

Chart toppers

Popular Sixties beat group Gerry and The Pacemakers were another band who came from Liverpool.
Each of their first three singles went to number one in the UK charts, the first time any band had achieved
such a feat. Their version of *You'll Never Walk Alone* went on to become an anthem for Liverpool Football Club.

c.1964

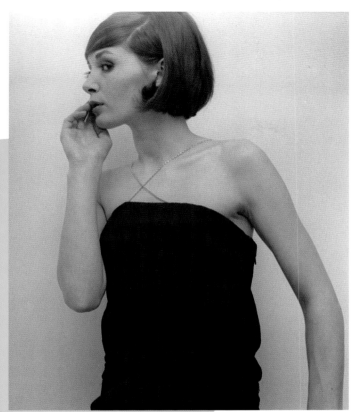

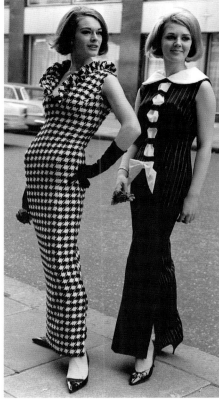

little black dress

A little black dress with chain halter-neck and low-slung bow, tied at the waist, from iconic Sixties designer Mary Quant.

c.1964

formal fashion

Formal maxi dresses designed by Hershelle: black and white houndstooth-check dress with ruffled collar (L); pinstripe dress with wide collar and organza detail, slotted through the front.

c.1964

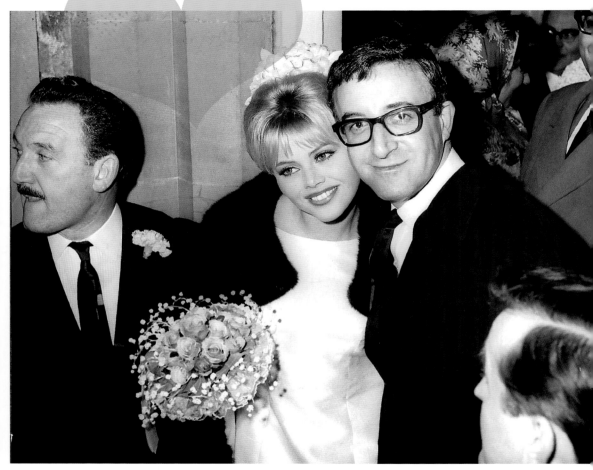

Whirlwind romance

Comedy actor Peter Sellers marries Swedish actress Britt Ekland at Guildford Register Office in 1964. She was 16 years his junior and the second of his four wives. They had met only 12 days before. They would have a daughter, Victoria, and divorce in 1968.

19th February, 1964

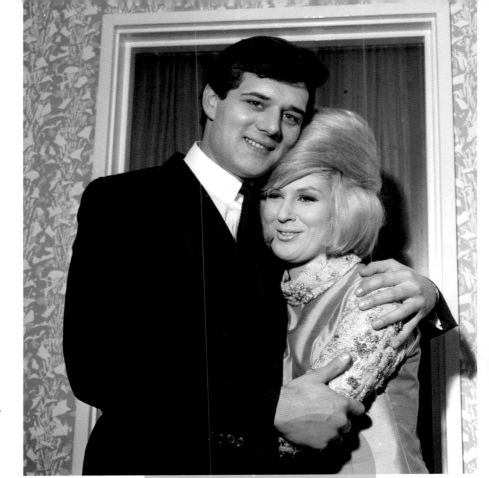

I only want to be with you

Singers Dusty Springfield and Eden Kane in her dressing room at the Fairfield Hall in Croydon in Surrey, just after they had announced that they were more than just good friends.

23rd February, 1964

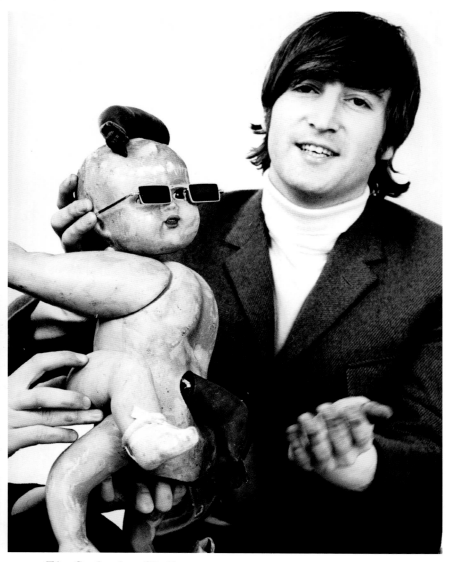

John's doll

Beatle John Lennon holds
a rather disturbing looking
doll that he had made
himself; a one-off – rather
like the man himself.
1964

Storming the barricades

A chaotic scene at a Kinks concert at the Majestic Ballroom in Newcastle, after teenage fans stormed the barriers trying to get to the band. One girl appears so overcome with emotion that she has fainted.

1964

The weekend starts here!

Above: The audience dance during ITV's live music show *Ready Steady Go!* Aired on Friday nights, the influential programme showcased many of the most successful rock and pop artists of the Sixties.

February, 1964

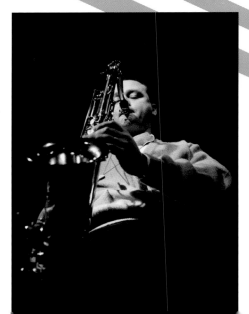

Final act

Left: The Beatles perform the finale for *A Hard Day's Night* at the Scala Theatre, London. The comic film, in the form of a 'mockumentary', was well received and a huge commercial success.

31st March, 1964

Stan's the man

Left: Master tenor jazz saxophonist Stan Getz performs at Ronnie Scott's club in Soho, London.

9th March, 1964

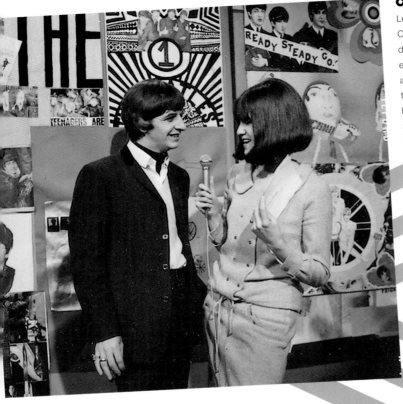

Chatty Cathy

Left: *Ready Steady Go!* presenter Cathy McGowan interviews Beatles drummer Ringo Starr. McGowan had ended up on the show after answering an advertisement for a 'typical teenager' to act as an advisor. She became a style icon and was known as the 'Queen of the Mods'.

20th March, 1964

Ready on stage

Rght: The Beatles perform on *Ready Steady Go!* in the studio at Television House, Kingsway, London: Paul McCartney (L), John Lennon (R), Ringo Starr (background). The performance netted the show its highest ever ratings.

20th March, 1964

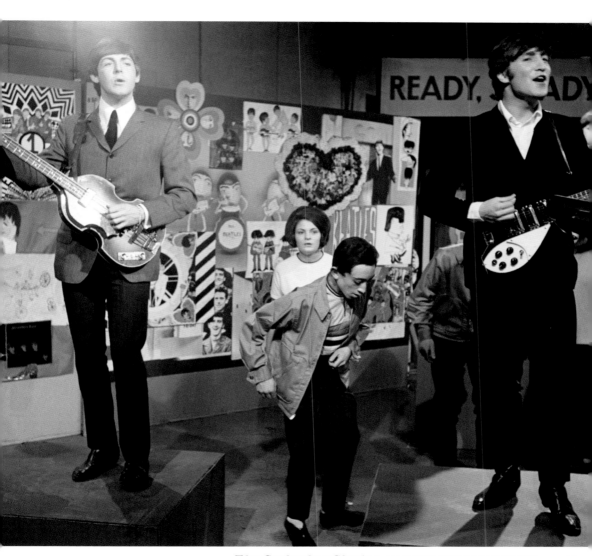

Would-be novelist

Jackie Collins, younger sister of actress Joan Collins. Her first novel, *The World is Full of Married Men*, published in 1968, became a best seller, and she went on to write another 27 racy novels in similar vein, selling over 400 million copies worldwide.

26th March, 1964

Wedding singer

Right: Singer Julie Rogers, whose biggest hit, *The Wedding*, went to number three in the charts in 1964. She wanted to become an international star, but her career never really hit the big time.

29th April, 1964

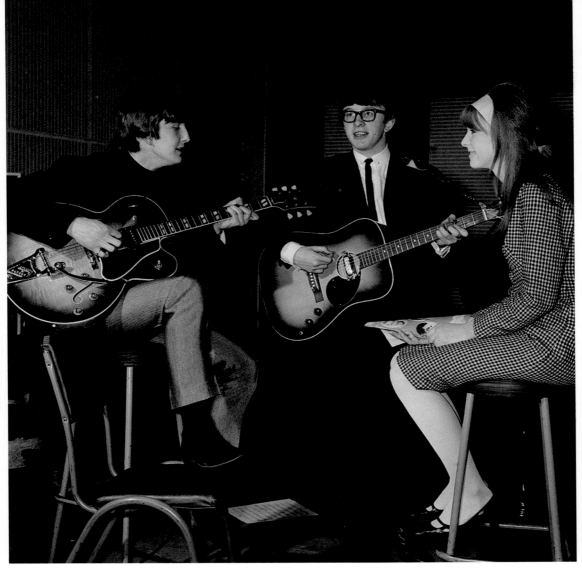

The Swinging Sixties AN ICONIC DECADE IN PICTURES

Two plus one

Left: Singing duo Peter and Gordon – Peter Asher (C) and Gordon Waller (L) – rehearse with Peter's sister, actress Jane Asher, for a charity tribute concert for singer Michael Holiday, who had committed suicide in October, 1963. Peter and Gordon would achieve success in 1964 with *A World Without Love*.

16th April, 1964

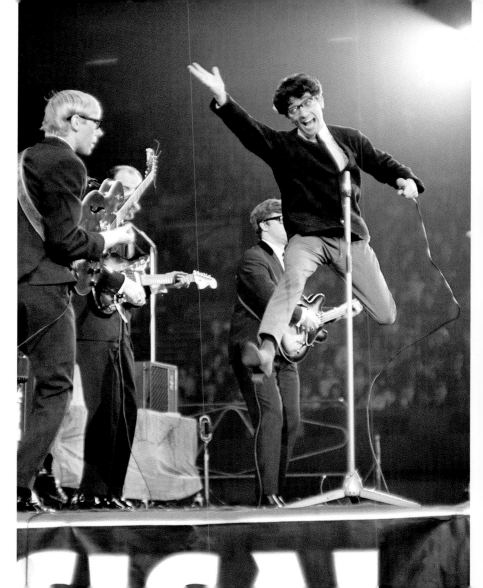

Doing The freddie

Right: Diminutive singer Freddie Garrity, of Freddie and The Dreamers, takes to the air during one of his numbers.

The band were known for their comic dance routines, one of which was called The Freddie.

27th April, 1964

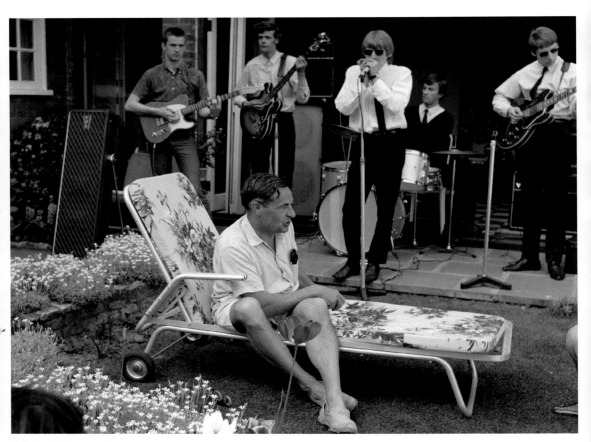

'Birds in the yard

The Yardbirds (L–R: Eric Clapton, Paul Samwell-Smith, Keith Relf, Jim McCarty, Chris Dreja) perform an impromptu gig for Lord Willis at his home in Kent. The band descended on the peer unexpectedly, following critical remarks he had made in the House of Lords about Mods.

18th May, 1964

The Mods' Ball

An interesting fashion mix displayed by dancers at the Mods' Ball, held at the Empire Pool, Wembley, London.

7th April, 1964

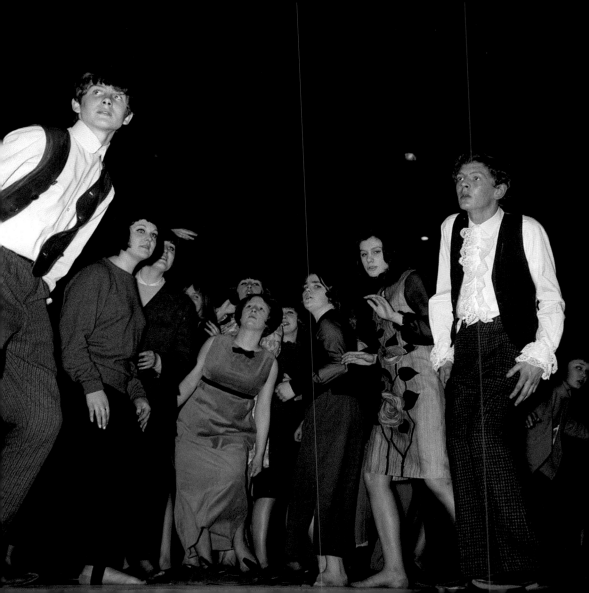

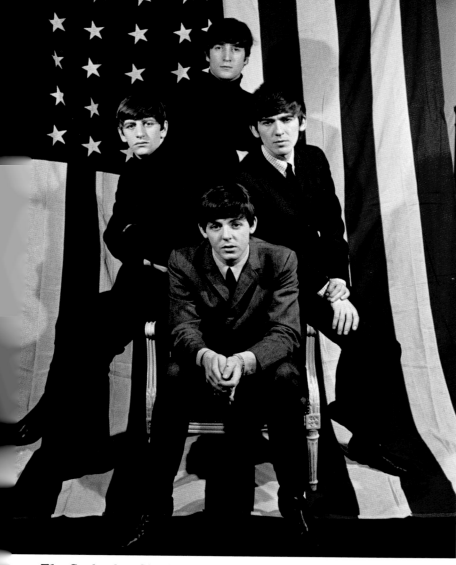

The British invasion

The Beatles pose for a formal portrait in front of the Stars and Stripes, ahead of the band's first American tour in August, 1964. They would play in 24 cities from coast to coast, during a tour that took in 32 shows in 34 days. They would be followed by many other British groups and artists.

26th April, 1964

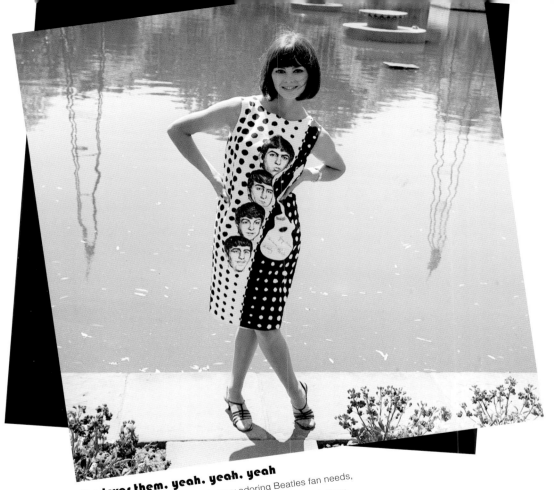

She loves them. yeah. yeah. yeah

Sandy Hilton models just what every adoring Beatles fan needs, a dress printed with the faces and autographs of the Fab Four.

9th June, 1964

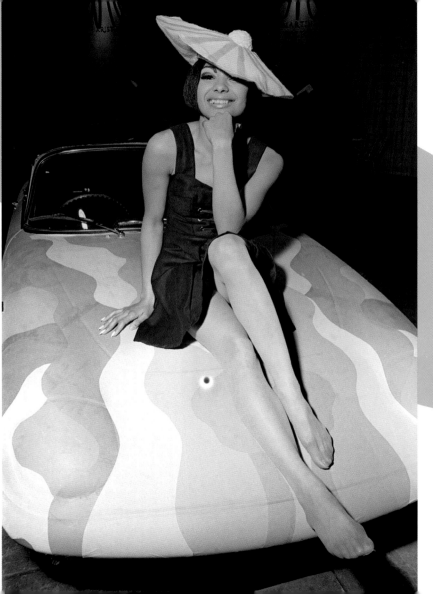

UFO hat

Left: Model Minerva Smith reclines on a psychedelically painted sports car while wearing a fetching flying saucer-shaped hat.

April, 1964

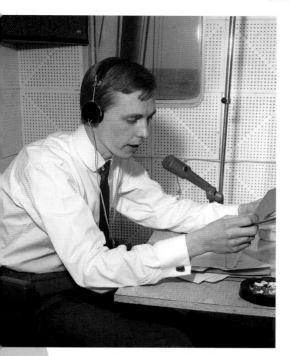

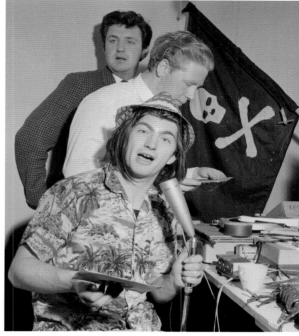

Pirates of the North Sea

Disc jockey Simon Dee broadcasts from the studio aboard Radio Caroline, the pirate radio ship anchored outside British territorial waters in the North Sea off Felixstowe. The station had begun transmitting a fortnight before and had been founded by Irish businessman Ronan O'Rahilly, to get around the record companies' control of pop music broadcasting.

15th April, 1964

Lord of the pirates

Musician and DJ Screaming Lord Sutch at the microphone of Radio Sutch, a pirate radio station based in one of the Thames Estuary Second World War anti-aircraft forts. Sutch sold the station to his manager, Reginald Calvert (white shirt), who renamed it Radio City. Calvert would be shot dead (in self-defence) by a director of Radio Caroline, Oliver Smedley, during a dispute over the ownership of a transmitter.

28th May, 1964

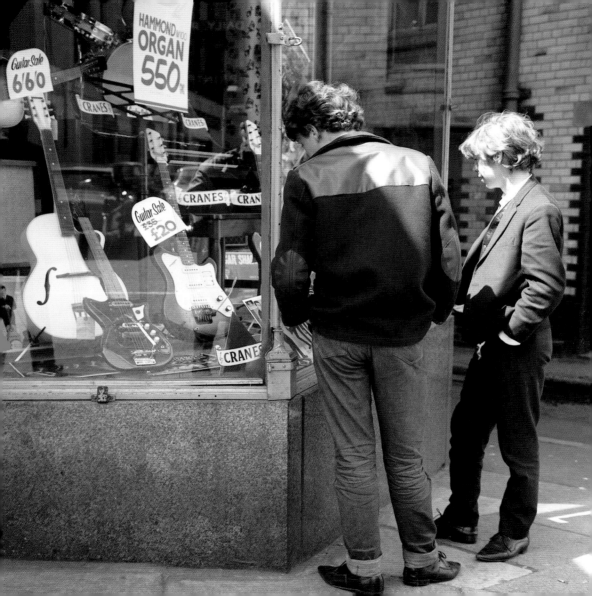

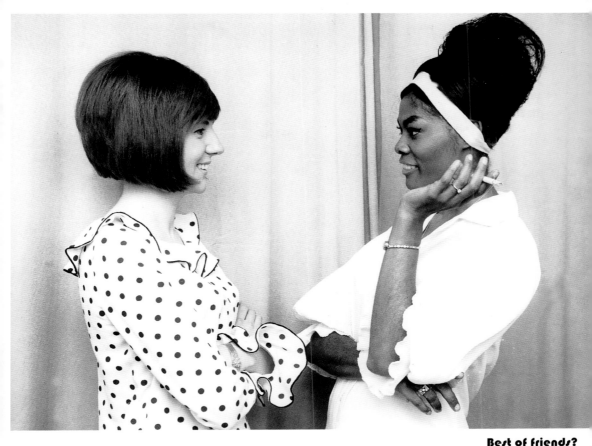

Best of friends?

Britain's Cilla Black (L) with American singer Dionne Warwick. Cilla covered several of Dionne's songs, usually immediately they were released and sometimes with greater chart success, much to Dionne's chagrin, a resentment that would fester for many years.

20th May, 1964

Wishing and hoping

Left: Young hopefuls in Liverpool study the bargains in a music-shop window. The success of The Beatles prompted many a teenager to pick up a guitar.

15th May, 1964

Rolling Stone style

Left: Rolling Stones guitarist Keith Richards goes for a conservative look in Beau Gentry, a store on North Vine Street in Hollywood, California, where the band's manager, Andrew Loog Oldham, had taken them shopping.

4th June, 1964

Up close and personal

Right: Honor Blackman as Pussy Galore and Sean Connery as James Bond during filming for a 'fight' scene from the latest 007 film, *Goldfinger*, in a barn on the Pinewood Studios back lot.

2nd June, 1964

The Swinging Sixties AN ICONIC DECADE IN PICTURES

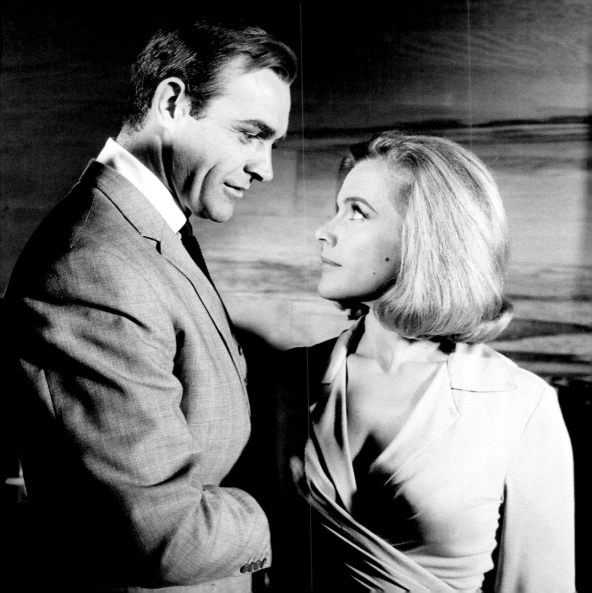

Wayne's world

Manchester group Wayne Fontana and The Mindbenders. Clockwise from top L: Eric Stewart, Wayne Fontana, Ric Rothwell, Bob Lang. Fontana had formed the group in 1963, but after they achieved a UK number two with *Game of Love* in 1965, he embarked on a solo career.

1964

Everybody shout now!

Pop singer Lulu, real name Marie Lawrie, started her career in 1964 when 15 and still a schoolgirl in Glasgow. That year, her first single, *Shout!*, performed with backing band The Luvvers, became a nationwide hit.

1964

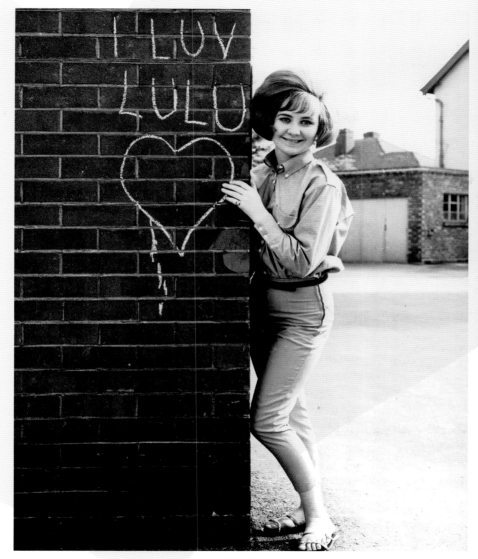

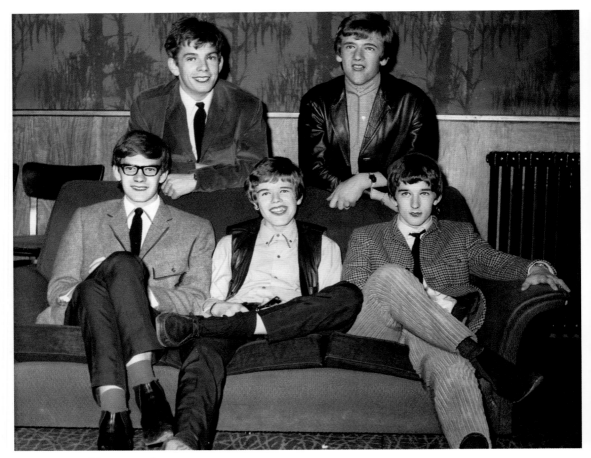

Into something good

A decidedly youthful looking Herman's Hermits, who had a UK number-one hit with *I'm Into Something Good* in 1964. The band's clean-cut image was promoted by record producer Mickie Most, and embellished here in this fine example of the pre-digital photo retoucher's art. Clockwise, from top L: Barry Whitwam, Karl Green, Keith Hopwood, Peter Noone (Herman), Derek Leckenby. Vocalist Noone was also an established actor.

c.1964

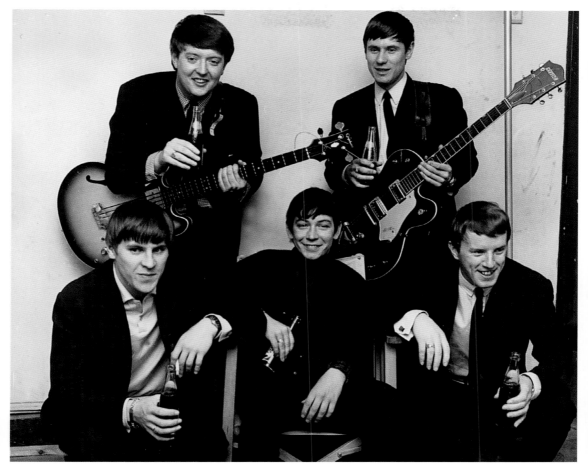

Geordie lads

Formed in Newcastle in the early sixties, The Animals enjoyed great success with a strong, bluesy sound.
Clockwise, from top L: Chas Chandler, Hilton Valentine, John Steele, Eric Burdon, Alan Price.

4th July, 1964

My name's Michael Caine

London-born actor Michael Caine, pictured early in his career, following his success in the 1963 film *Zulu*. He starred in a number of memorable British films, including *The Ipcress File* and *Alfie*, although his most memorable screen line probably came from the 1969 comedy classic *The Italian Job*: the words "You were only supposed to blow the bloody doors off!" have taken on a life of their own in the four decades since the film was made.

2nd July, 1964

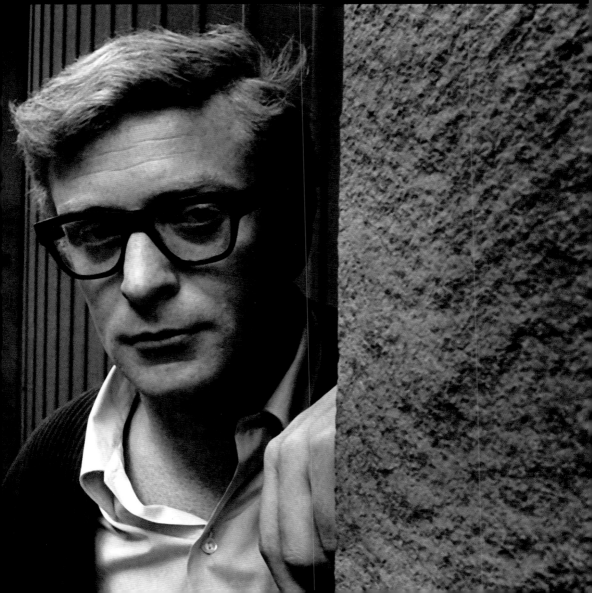

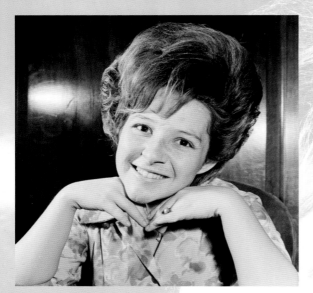

Little Miss Dynamite

American singer Brenda Lee, nicknamed 'Little Miss Dynamite' because of her diminutive height (4ft 9in) and best known in the UK for hits such as *I'm Sorry* and *Rockin' Around the Christmas Tree*. In 1964, she recorded the hit single *Is It True?* in London, featuring guitarist Jimmy Page and produced by Mickie Most.

18th August, 1964

Pint-sized pop star

Brenda Lee performs on the BBC's music chart show *Top of the Pops*.

19th August, 1964

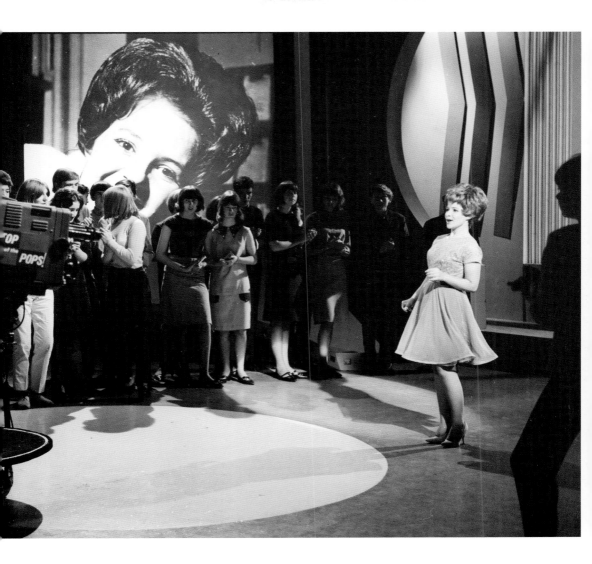

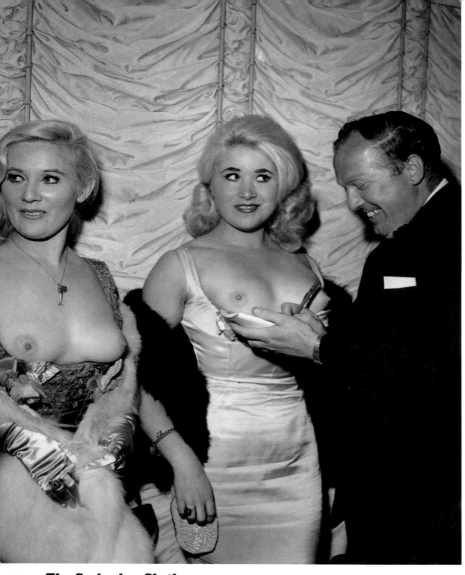

Staying abreast of the times

Left: The Sixties were an era of permissiveness, and topless dresses were a short-lived expression of that attitude. When sisters Marion (L) and Valerie Mitchell, wearing topless gowns, turned up in Piccadilly, London, for the premiere of the film *London in the Raw*, the police were quick to take down their particulars.

24th August, 1964

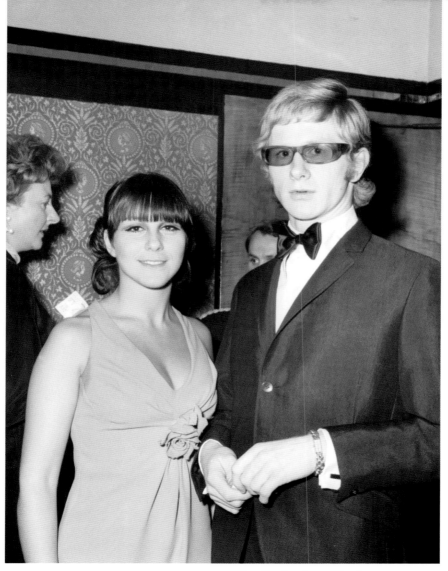

Bad image

Andrew Loog Oldham, manager of The Rolling Stones, and his wife Sheila attend the opening night of the musical *Maggie May* at London's Adelphi Theatre. Oldham deliberately promoted the Stones' 'bad boy' image as a direct contrast to the wholesome, clean-cut style of The Beatles.

22nd September, 1964

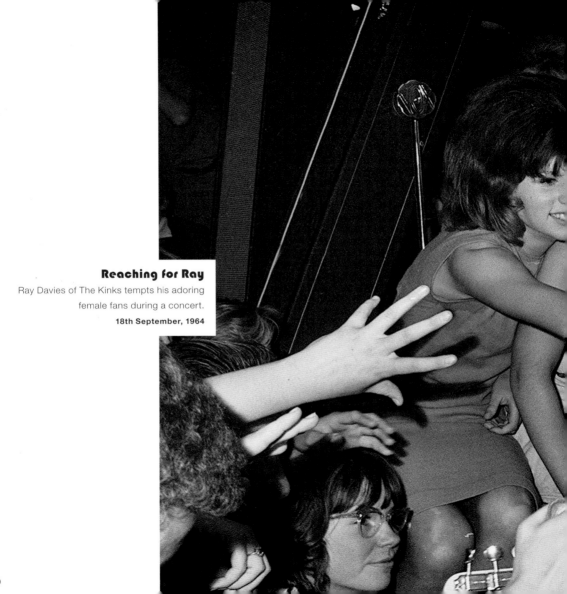

Reaching for Ray

Ray Davies of The Kinks tempts his adoring
female fans during a concert.

18th September, 1964

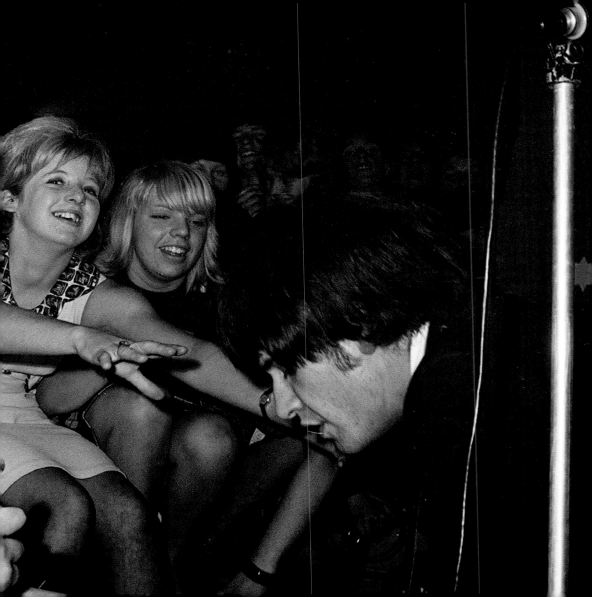

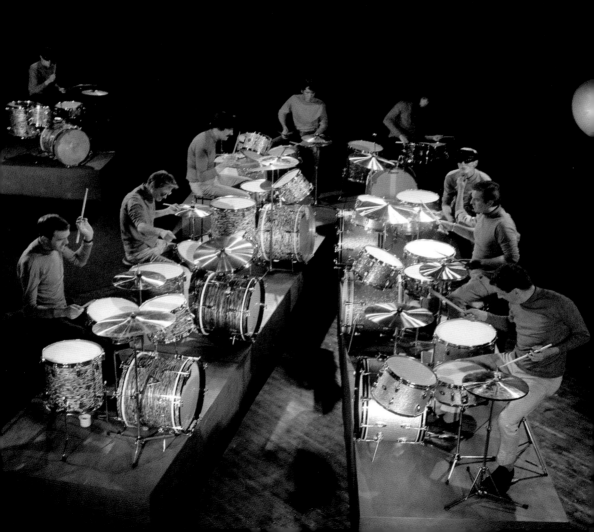

Drum roll

A scene from the fantasy musical film *Gonks Go Beat*, featuring Sixties drummers Ginger Baker (leather cap), Bobby Graham, Johnny Gregory, Alan Grinley, John Kearns, Bobby Richards, Ronnie Stephenson, Ronnie Verrell and Andy White. Filmed at Shepperton Sudios, the movie also starred Lulu, Jack Bruce and The Nashville Teens, as well as established comic actors Kenneth Connor, Arthur Mullard, Terry Scott and Frank Thornton. The film was a disaster when released originally, but since has achieved cult status, being considered 'so bad, it's good'.

24th September, 1964

Changing Fortunes

Two different pop groups, both called The Fortunes, meet at the Bull Ring shopping centre in Birmingham to come to an agreement over their names. The Fortunes (L) led by Rod Allen (third L) won the battle; the other Fortunes agreed to take the name Danny King and The Jesters.

20th October, 1964

America's own

The Beach Boys, noted for their unique surfing sound, at a photo call for EMI in London. L–R: Dennis Wilson, Brian Wilson, Mike Love, Al Jardine, Carl Wilson. The band enjoyed major international success in the Sixties and were the US answer to The Beatles.

2nd November, 1964.

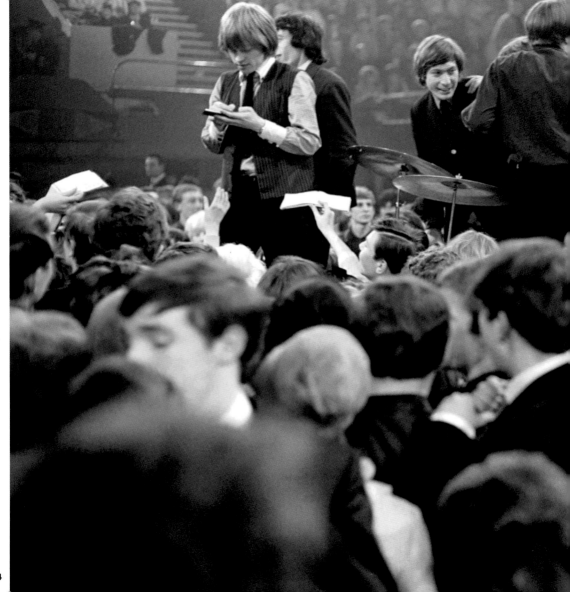

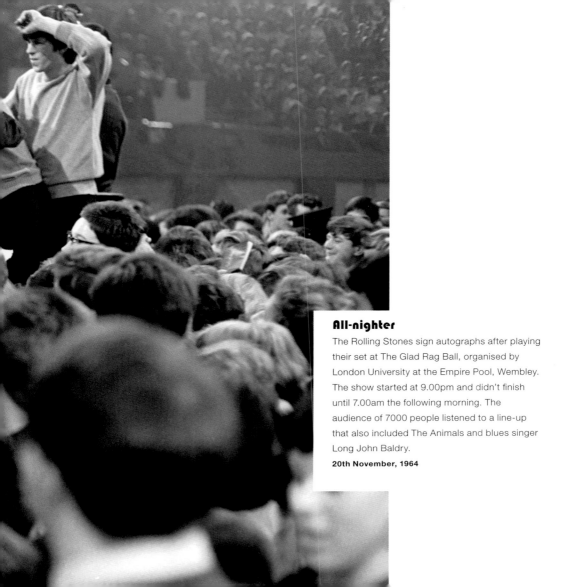

All-nighter

The Rolling Stones sign autographs after playing their set at The Glad Rag Ball, organised by London University at the Empire Pool, Wembley. The show started at 9.00pm and didn't finish until 7.00am the following morning. The audience of 7000 people listened to a line-up that also included The Animals and blues singer Long John Baldry.

20th November, 1964

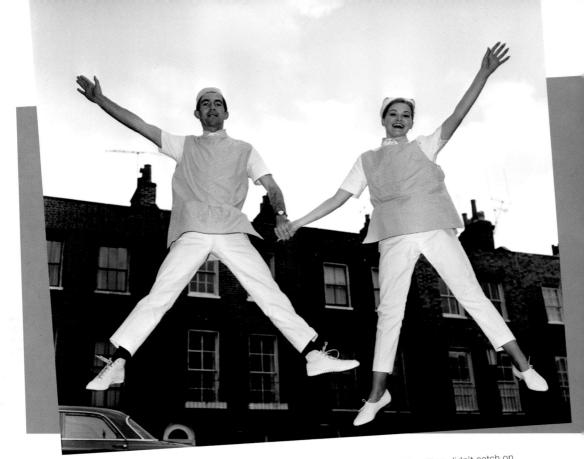

Model nurses

Nurses model new trendy uniform designs shown at the London Nursing Exhibition. They didn't catch on.

12th October, 1964

The Swinging Sixties AN ICONIC DECADE IN PICTURES

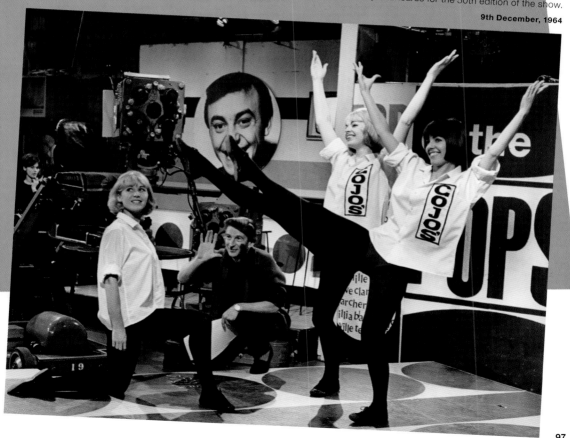

Dance trio

Under the watchful eye of *Top of the Pops* producer Johnnie Stewart, resident dance troupe The Gojos rehearse for the 50th edition of the show.

9th December, 1964

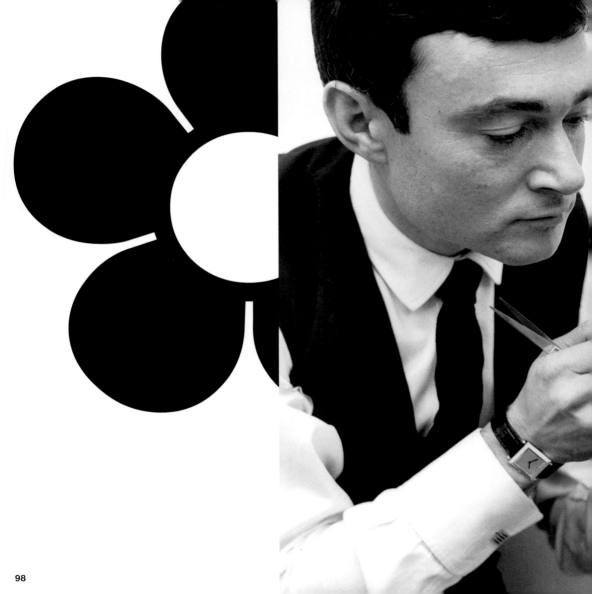

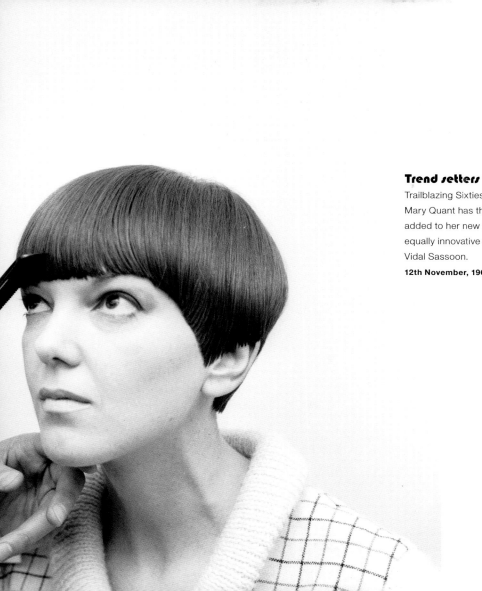

Trend setters

Trailblazing Sixties fashion designer
Mary Quant has the finishing touches
added to her new hairstyle by the
equally innovative celebrity hairdresser
Vidal Sassoon.

12th November, 1964

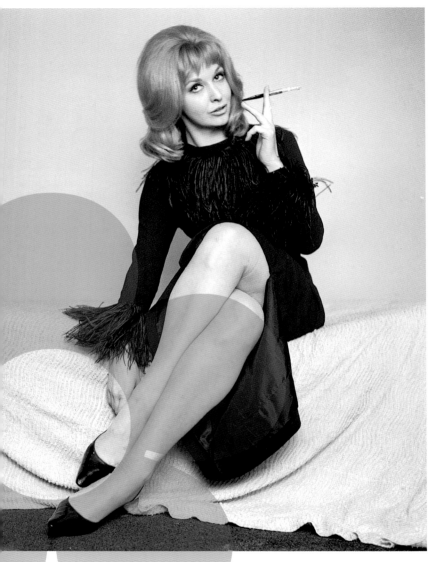

New Dawn

Left: New Zealand-born actress Nyree Dawn Porter, who appeared in a number of television dramas in 1964, including *Madame Bovary*, *Ghost Squad*, *Judith Paris*, *The Indian Tales of Rudyard Kipling* and *The Saint*. She would enjoy international fame in 1967, however, starring in the BBC TV drama *The Forsyte Saga*, a role that won her a BAFTA award.

3rd December, 1964

Odd one out

Left: In the mid-Sixties, pop music was usually presented, and played, by sober-suited gents with neat haircuts, such as BBC *Top of the Pops* DJs (L–R) Alan Freeman, Pete Murray and David Jacobs. Then, of course, there was Jimmy Saville (R)…

c.1965

Pondering Poets

The Poets, one of the best bands to come out of Scotland during the Sixties. They released a number of innovative singles between 1964 and 1967, but despite being represented by Rolling Stones manager Andrew Loog Oldham, they never really made it to the big time.

c.1965

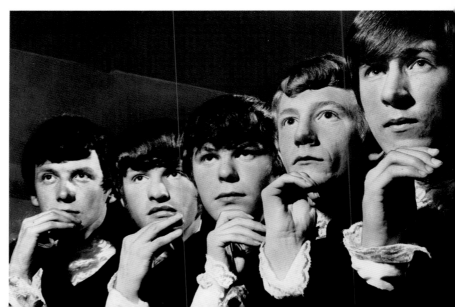

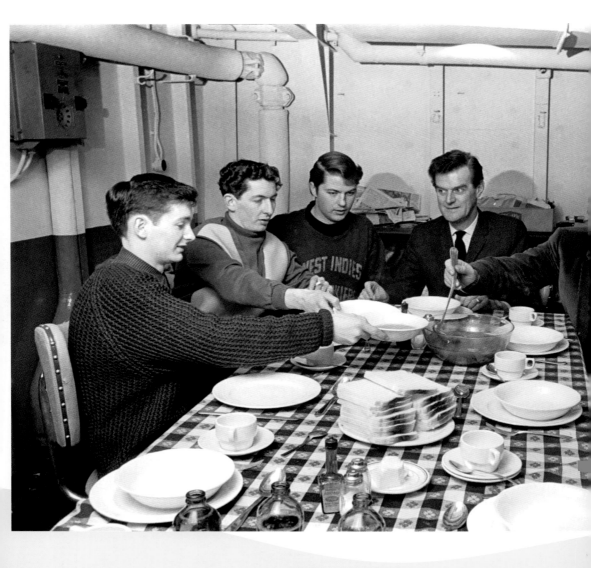

102

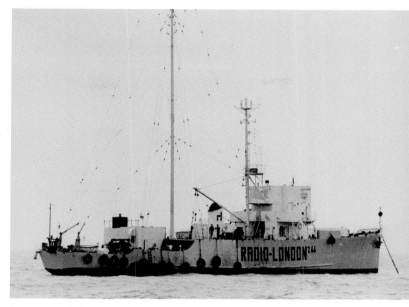

london calling

Disc jockeys aboard the American-owned pirate radio station Radio London, 'Big L',
enjoy a meal together in the spartan interior of the MV *Galaxy* (above), a former
US Navy minesweeper moored in the North Sea off Frinton-on-Sea. L–R: Kenny Everett,
Dave Cash, Pete Brady, Tony Windsor, Paul Kaye, Earl Richmond. Everett, Cash and Brady
would all go on to work at the BBC after the pirates were sunk by the British government.
1965

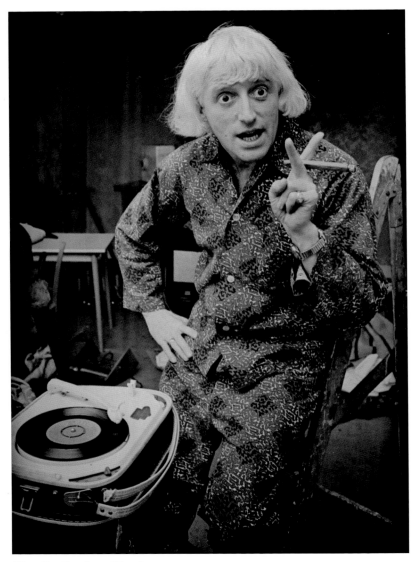

Hotel protest

Top disc jockey Jimmy Saville, dressed in pyjamas and smoking his trademark cigar, listens to music on his portable record player while work begins to pull down the Aland Hotel in Bloomsbury around him.

25th March, 1965

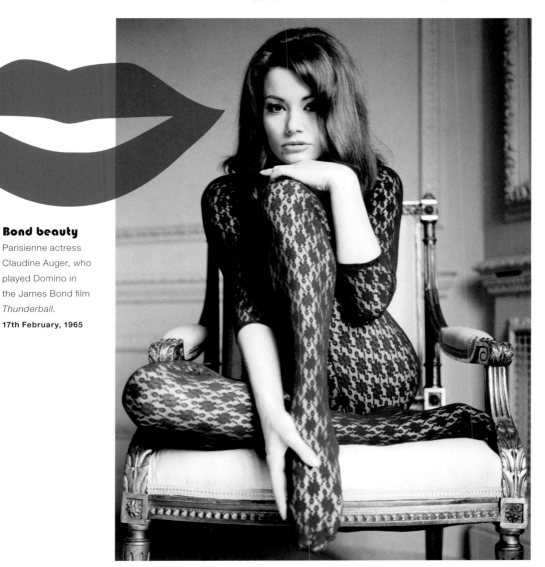

Bond beauty

Parisienne actress
Claudine Auger, who
played Domino in
the James Bond film
Thunderball.

17th February, 1965

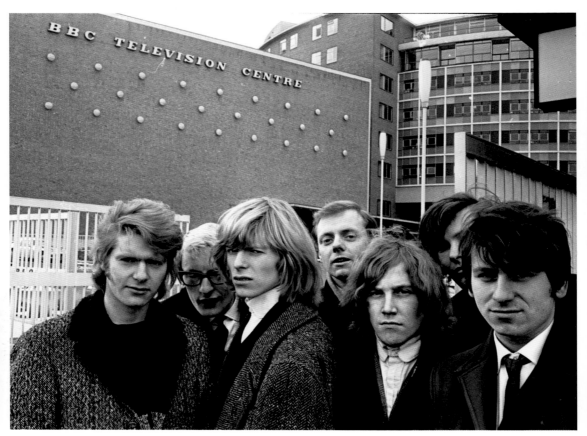

Hairy protest

David Bowie (third L), then known as Davy Jones, with his band The Mannish Boys outside the BBC's Television Centre in London, where they were to perform on the BBC2 show *Gadzooks! It's All Happening*. The show's producer had insisted that Bowie cut his hair, which he refused to do, organising demonstrations outside the building with banners saying 'Be Fair to Long Hair'. Eventually, the group were allowed to appear, but only on the condition that if there were complaints from viewers, their fee would go to charity. No complaints were received.

7th March, 1965

Motown movers

Right: American Motown artists including The Supremes, Martha and The Vandellas, Smokey Robinson and The Miracles, and a very young Stevie Wonder arrive in the UK for the Motown Revue Tour. Audience response was patchy, however, until Dusty Springfield helped convince ATV bosses to put on a *Ready Steady Go!* Motown Special. After that, hits in the UK just kept on coming.

15th March, 1965

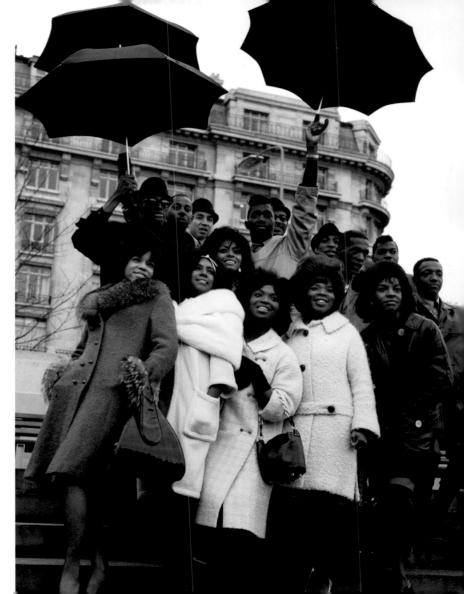

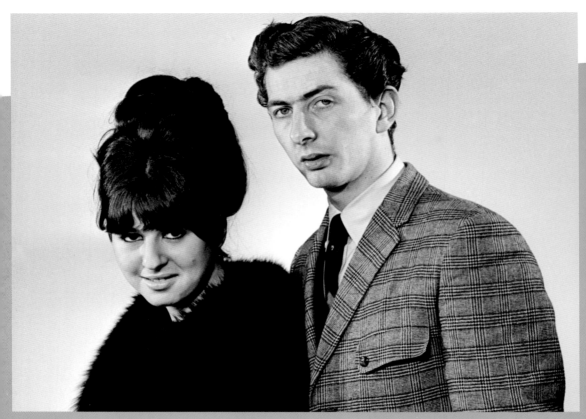

Brooks and Cash

Singer Elkie Brooks and Radio London disc jockey Dave Cash. Brooks had released her first single, *Something's Got a Hold On Me*, the year before. After the demise of the pirate radio stations, Cash went on to spend many years at London's Capital Radio before moving to the BBC.

2nd March, 1965

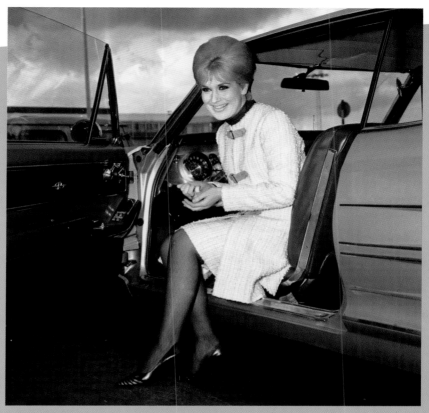

Soul Queen

Dusty Springfield, dubbed the 'White Queen of Soul', was voted Top Female British Artist for four years running, between 1964 and 1967, in the *New Musical Express* poll. By 1966, she had become the top selling female singer in the world. She is seen here arriving at Heathrow Airport before leaving for New York.

14th April, 1965

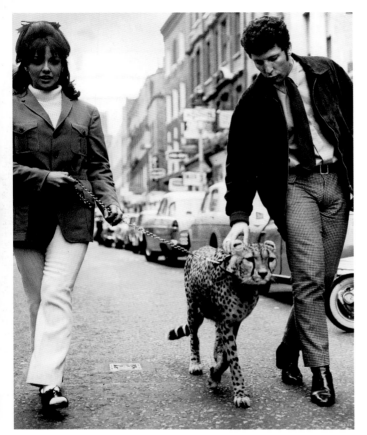

Avenging angel

Right: Actress Diana Rigg on the set of *The Avengers* television programme. Rigg's character, Emma Peel, epitomised the swinging Sixties in her youth and style, although after four series she insisted on her leather outfits being dropped in favour of clothing in a softer, more forgiving material – Crimplene.

4th April, 1965

What's new pussycat?

Singer Tom Jones with actress Christine Spooner and feline friend, on their way to open a new boutique in London's trendy Carnaby Street.

c.1965

The Swinging Sixties AN ICONIC DECADE IN PICTURES

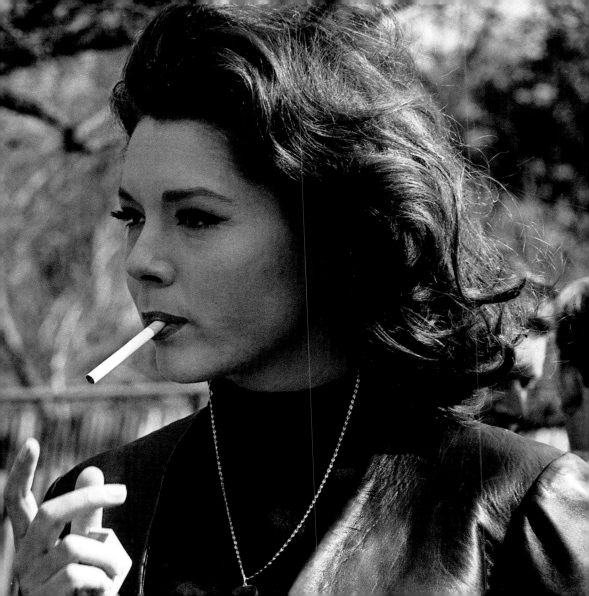

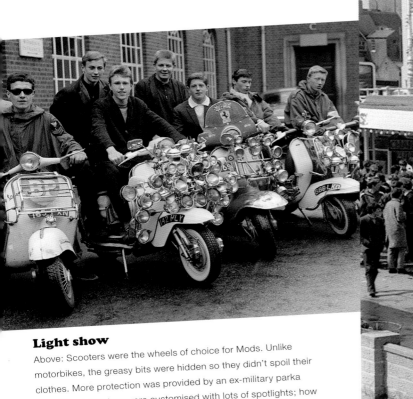

Light show

Above: Scooters were the wheels of choice for Mods. Unlike motorbikes, the greasy bits were hidden so they didn't spoil their clothes. More protection was provided by an ex-military parka coat. Many scooters were customised with lots of spotlights; how the poor little battery coped is anyone's guess.

7th May, 1965

Culture clash

Right: Mods run riot along the seafront in Brighton, Sussex, during a clash with a rival group of Rockers.

19th April, 1965

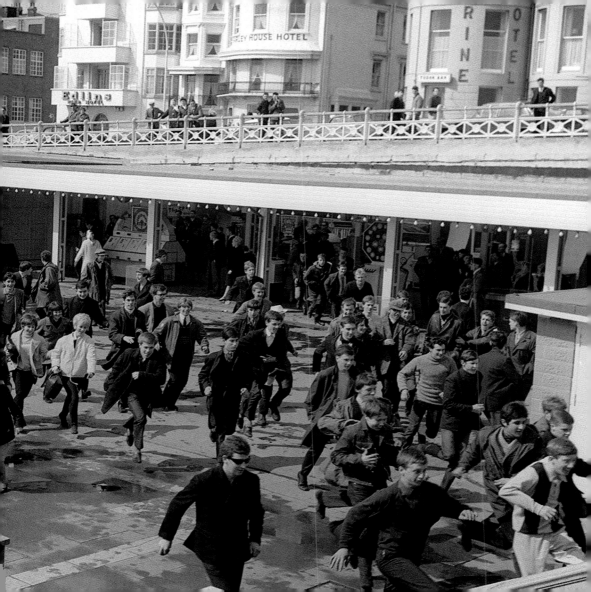

Most successful

Left: One of the most successful record producers in Britain in the Sixties, Mickie Most had a run of hit singles with performers who included The Animals, Herman's Hermits, Donovan and the Jeff Beck Group.

18th May, 1965

Space oddities

Right: In 1964, French designer André Courrèges introduced his Space Age collection of pvc clothing, including minidresses, goggles and his famous white 'go-go' boots. The collection inspired many imitators; these helmet-like hats were just some of the pvc oddities that resulted.

June, 1965

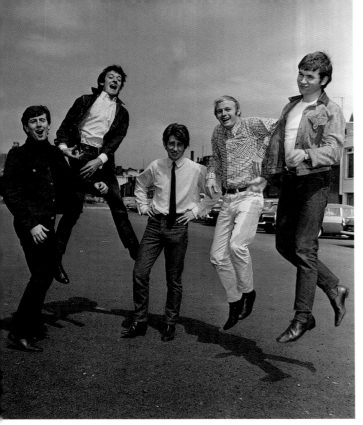

Jumping for joy

Above: The Hollies from Manchester, one of the leading groups of the Sixties, enjoyed a number of major hits, including *Just One Look*, *Here I Go Again*, *Look Through Any Window* and *Bus Stop*. L–R: Graham Nash, Allan Clarke, Tony Hicks, Bobby Elliott and Eric Haydock. Nash would go on to become a member of supergroup Crosby, Stills and Nash.

30th June, 1965

Not running

Below: The Spencer Davis Group, who had a UK number one with *Keep On Running* in late 1965. L–R: Spencer Davis, Peter York, Muff Winwood, Steve Winwood.

c.1965

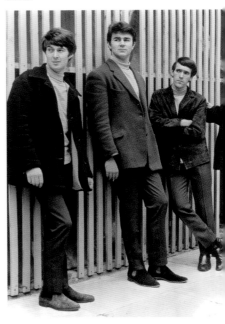

I Got You Babe

Right: American husband-and-wife singing duo Sonny and Cher, outside the Hilton Hotel in London with disc jockey Jimmy Saville (R). They were promoting their appearance on *Top of the Pops*, where they would sing their latest release, *I Got You Babe*.

6th August, 1965

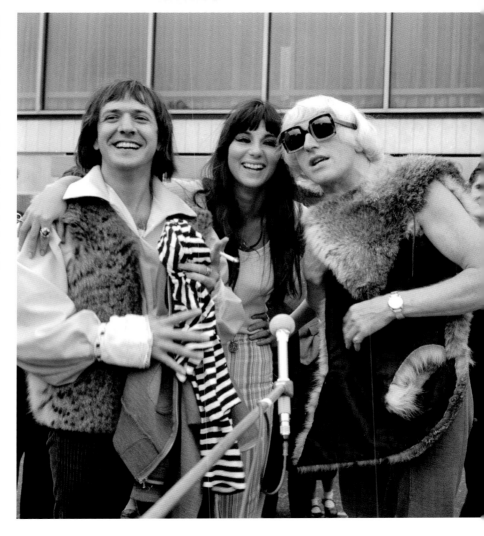

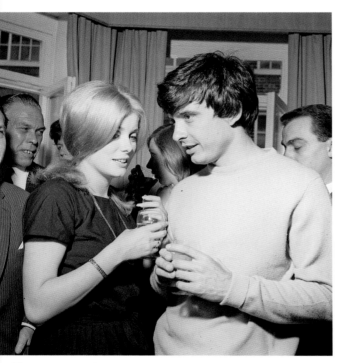

Happy couple

Above: Fashion photographer David Bailey and French actress Catherine Deneuve at their wedding reception.

18th August, 1965

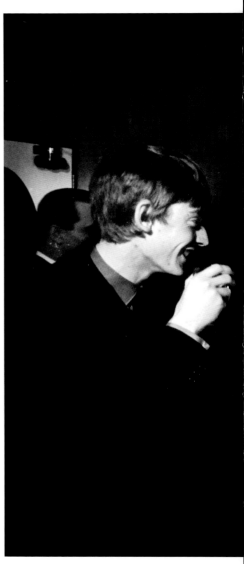

Best man

The Rolling Stones' Mick Jagger (C) during a party to celebrate David Bailey's marriage to Catherine Deneuve. He had acted as best man. At right is Chrissie Shrimpton, sister of fashion model Jean Shrimpton.

18th August, 1965

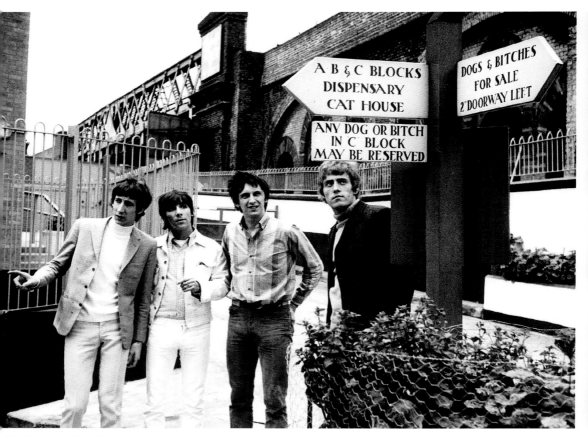

Going to the dogs

Mod group The Who visit Battersea Dogs Home. L–R: Pete Townshend, Keith Moon, John Entwistle and Roger Daltrey. At this stage, they were at the beginning of their career, but would go on to sell 100 million records worldwide. They were renowned for Moon's frenetic drumming and Townshend's destruction of his instruments on stage.

3rd September, 1965

Stamp and Shrimp

Left: Brooding actor Terence Stamp with his girlfriend, model Jean Shrimpton, one of the classic fashion faces of the Sixties. Known as 'the Shrimp', Shrimpton had been discovered by photographer David Bailey and was one of the world's first supermodels.

1st October, 1965

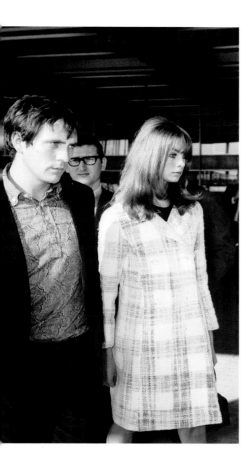

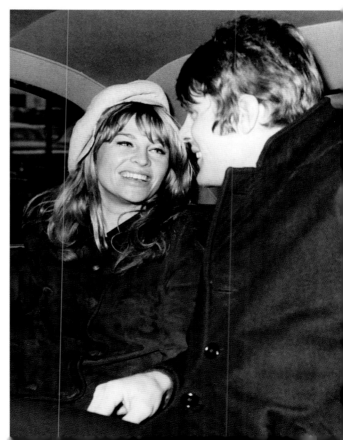

Julie and Don

Right: British actress Julie Christie and boyfriend Don Bessant. In 1965, she won an Oscar for Best Actress for her role as Diana Scott in the film *Darling* and also starred as Lara in *Doctor Zhivago*.

1965

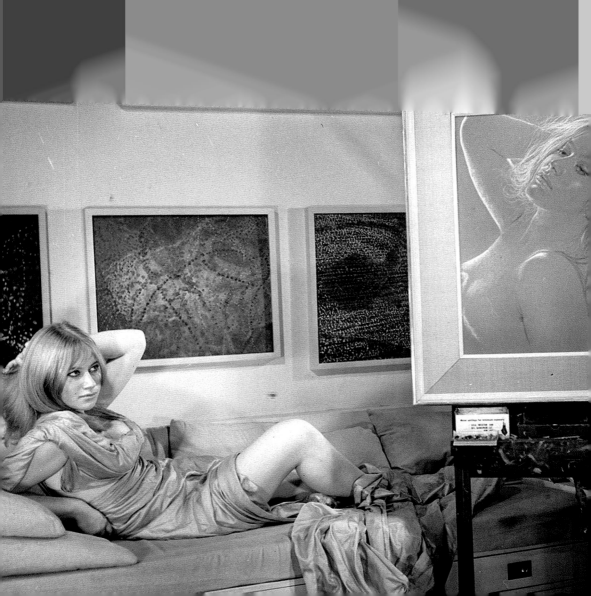

Mirren as muse

Left: Up-and-coming British actress Helen Mirren (20) poses for artist Nicholas Egon in his Hampstead studio. That year, she had starred as Cleopatra in the National Youth Theatre's production of *Antony and Cleopatra* at the Old Vic.

5th October, 1965

Time for Tarby

Riding the wave of Liverpudlian talent spearheaded by The Beatles, mop-headed comedian Jimmy Tarbuck was a regular on British television throughout the Sixties. His career would span more than four decades.

31st October, 1965

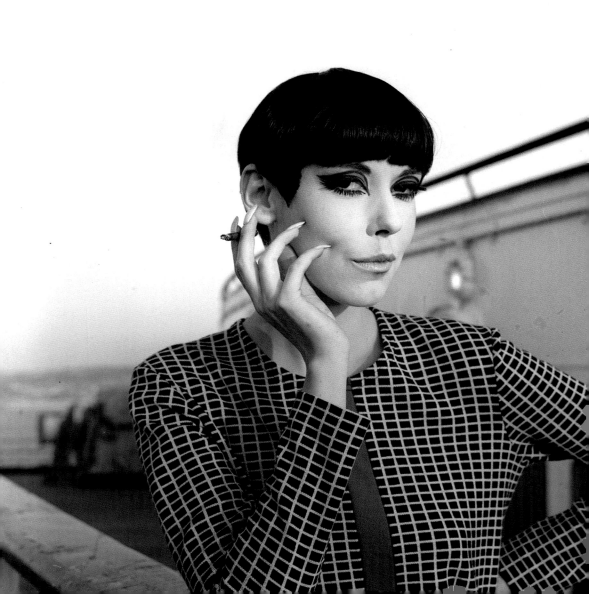

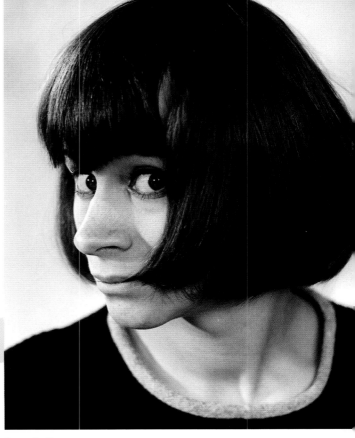

Eyes right

Left: Top American fashion model Peggy
Moffitt, pictured on the *Queen Elizabeth*,
arriving at Southampton. Sporting the
short, chic hairstyle of the period, she was
due to appear in a fashion awards show at
the Hilton Hotel, London. Moffitt was known
for her unique look, which relied on false
eyelashes and heavy eye make-up.

October, 1965

Eyes left

Rita Tushingham had begun her career
on the stage, but by 1965, at the age of
23, had become an established presence
on the big screen. That year she could be
seen in *The Knack…and How to Get It* and
Doctor Zhivago.

October, 1965

The Swinging Sixties AN ICONIC DECADE IN PICTURES 125

Pop artist

Although not part of Britain's swinging Sixties scene, American artist Andy Warhol, as a leader of the Pop Art movement, had a profound effect on artwork styles that were prevalent at the time. He is shown in his studio in New York.

27th October, 1965

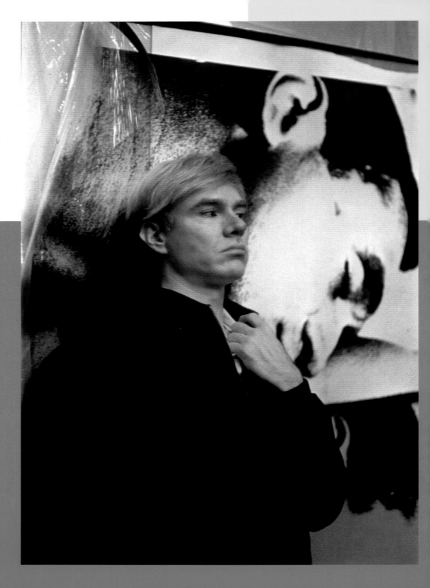

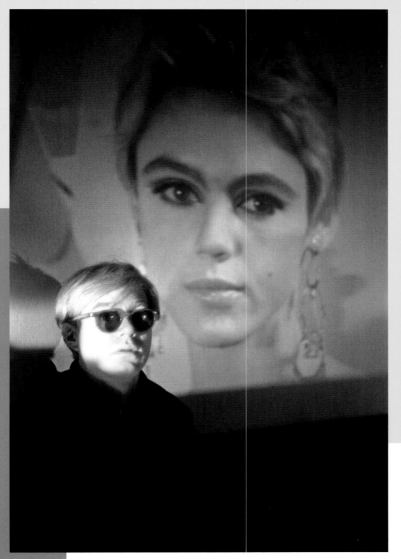

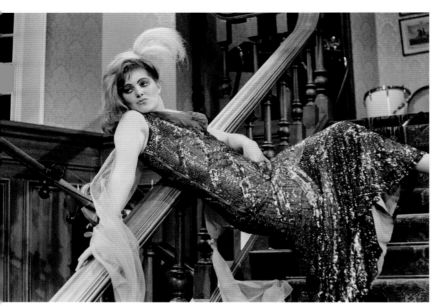

Georgy Girl

Left: Lynn Redgrave during the filming of *Georgy Girl*, a ground-breaking movie that was one of the first to deal with the sexual revolution of the Sixties. The film's frank and ultra-modern portrayal of complex relationships helped it to become a worldwide box-office success. It also starred Alan Bates, James Mason and Charlotte Rampling.

8th December, 1965

Blonde ambition

Right: Kathy Kirby, who adopted the 'blonde bombshell' look, was one of the highest paid female singers of the Sixties. Best known for her cover of Doris Day's *Secret Love* in 1963, she also represented the United Kingdom in the Eurovision Song Contest in 1965. Thereafter, though, her releases failed to make the charts and her career declined.

24th November, 1965

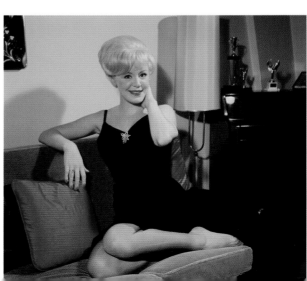

Sparklers

Silver lamé knee-length,
socks worn with a miniskirt and knitted top.

30th November, 1965

Biker chic

Below: Dressed in fashionable minidress and
'go-go' boots, young actress Susannah York
dodges the traffic on London's King's Road on
her bicycle. She appeared in a number of hit
films in the Sixties. In her obituary in 2011, the
Daily Telegraph described her as epitomising
"the sensuality of the Swinging Sixties."

25th October, 1965

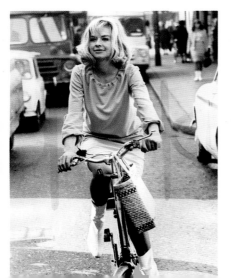

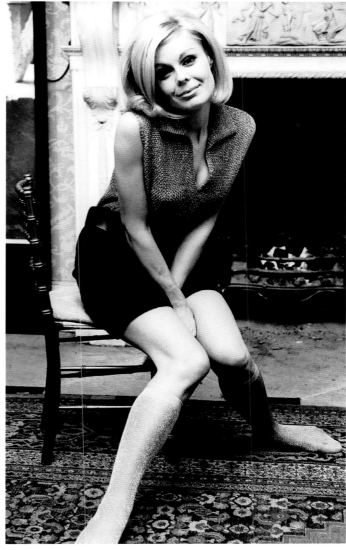

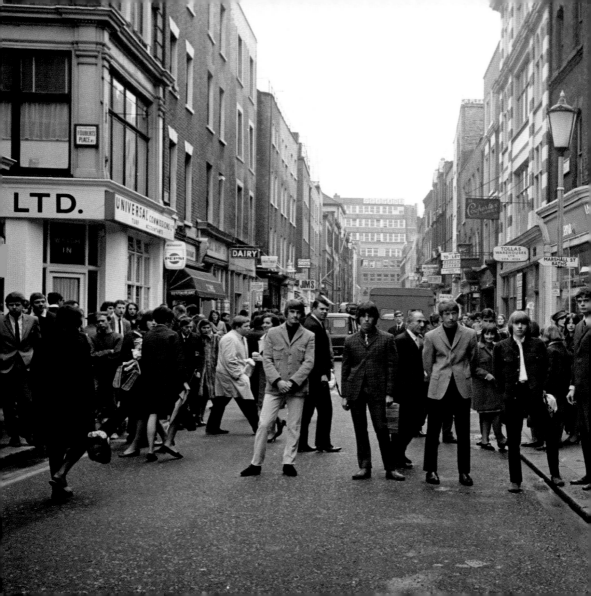

Street musicians

Rock band The Yardbirds bring London's Carnaby Street to a standstill for a photo shoot. By this time, Jeff Beck had taken over from Eric Clapton. L–R: Jim McCarty, Beck, Chris Dreja, Keith Relf and Paul Samwell-Smith. In addition to Clapton and Beck, the group also helped launch the career of guitarist Jimmy Page.

8th November, 1965

Hip cats

Fur fashions were still acceptable in the Sixties. This model is wearing an ocelot fur coat and matching hat. Many people might feel that a fur coat looks better on the lion cub.

31st December, 1965

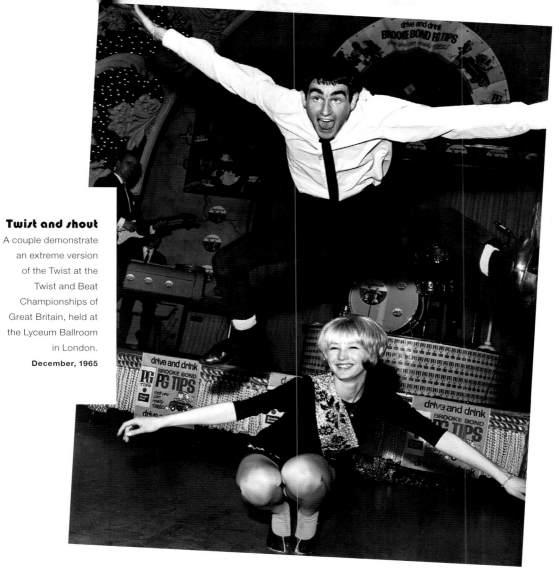

Twist and shout

A couple demonstrate an extreme version of the Twist at the Twist and Beat Championships of Great Britain, held at the Lyceum Ballroom in London.

December, 1965

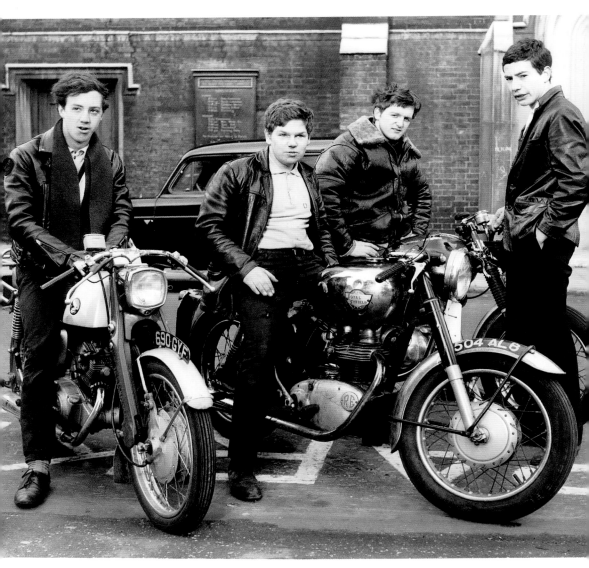

Ton-up boys

Left: Leather-jacketed Rockers look mean for the camera. Sartorial style was not their forte, but they were always ready for a 'burn-up' on their bikes, hoping to make the magic 'ton' (100mph). Rockers loved rock 'n' roll and hated Mods. Large groups of them famously clashed in seaside towns throughout the Sixties.

c.1966

Four Faces

Right: The Small Faces produced some of the most acclaimed mod and psychedelic music of the Sixties. Among their hits were *Itchycoo Park*, *Lazy Sunday* and *All or Nothing*. Clockwise from top L: Ian McLagan, Kenney Jones, Ronnie Lane, Steve Marriott.

1966

Snoozin' the blues

Right: Pioneering English blues singer and musician John Mayall takes a nap while resting on the shoulder of his wife, Pamela. He was between appearances with his group, The Bluesbreakers, during an all-night gig at the Flamingo Club in Wardour Street, Soho, London. At one time or another, the band counted among its members Eric Clapton, Jack Bruce, Peter Green, John McVie, Mick Fleetwood and Mick Taylor.

January, 1966

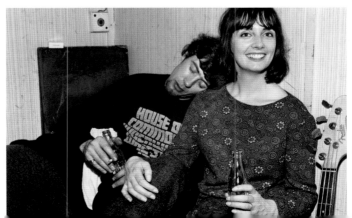

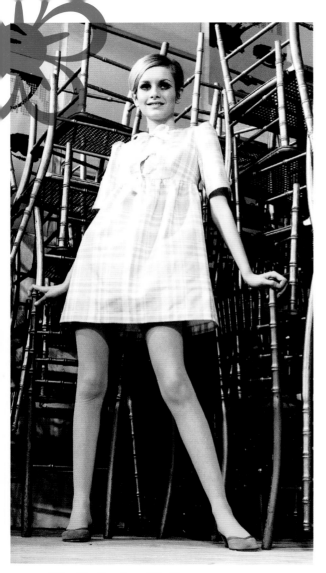

Fashion icon

Left: Waif-like model Twiggy, real name Lesley Hornby, the iconic face of Sixties fashion, adopts a classic pose.

c.1966

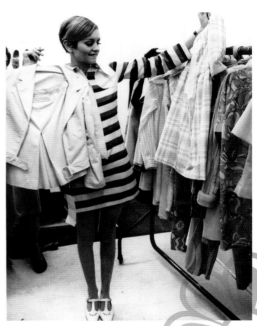

Twiggy's togs

Above: Twiggy shows off a fashion collection bearing her name; Twiggy Look had been designed by Pamela Proctor and Paul Babbs, although Twiggy supplied many of the ideas herself.

c.1966

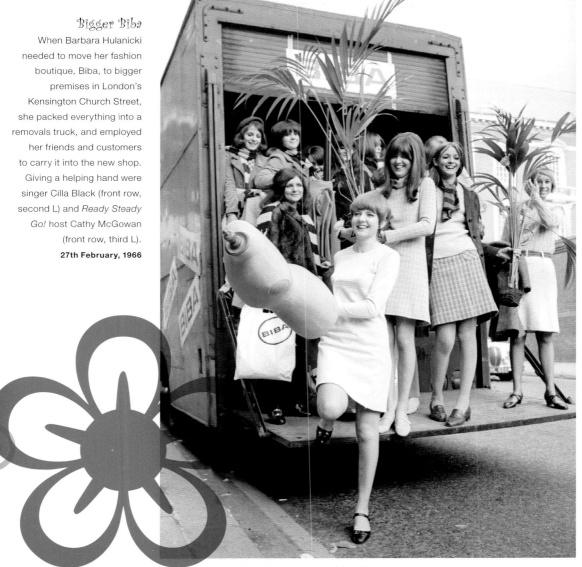

Bigger Biba

When Barbara Hulanicki needed to move her fashion boutique, Biba, to bigger premises in London's Kensington Church Street, she packed everything into a removals truck, and employed her friends and customers to carry it into the new shop. Giving a helping hand were singer Cilla Black (front row, second L) and *Ready Steady Go!* host Cathy McGowan (front row, third L).

27th February, 1966

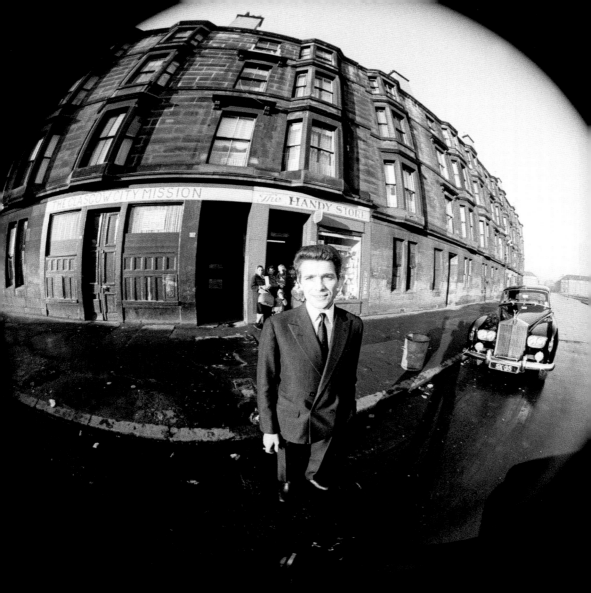

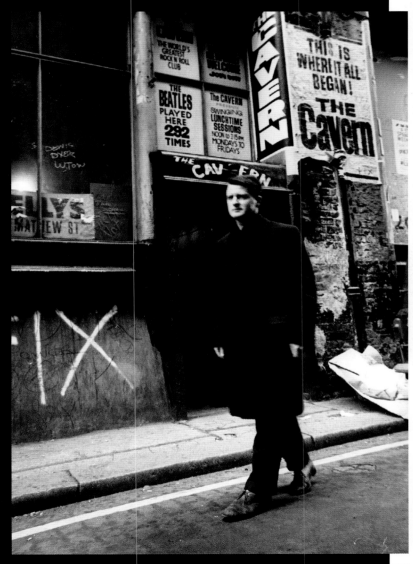

Stephen in the round

Left: Fisheye-lens view of fashion entrepreneur John Stephen. Known as the 'King of Carnaby Street' and the 'Million-pound Mod', Stephen had 15 shops on Carnaby Street and was instrumental in making it the heart of 'Swinging London'. His clothes were worn by such leading bands as The Who, The Kinks, The Rolling Stones and The Small Faces.

1966

Cave man

Right: Ray McFall outside Liverpool's Cavern Club, which he took over in 1959 and changed from a purely jazz venue to one that showcased blues and beat groups, including The Beatles.

20th February, 1966

Jazzy shirt

Left: Jazz and rhythm and blues keyboard player Georgie Fame tries on a new shirt at Hung On You, a boutique in Cale Street, London. Fame's manager, Ronan O'Rahilly, couldn't get his first record played by the BBC or Radio Luxembourg, so he started his own radio station, the pirate broadcaster Radio Caroline.

16th March, 1966

Matching minis

Right: A Mini given the op art treatment with self-adhesive tape, while a model wears a similarly inspired minidress by Shubelle. Mary Quant claimed to have invented the miniskirt in 1964, naming it after her favourite car, the Mini.

24th March, 1966

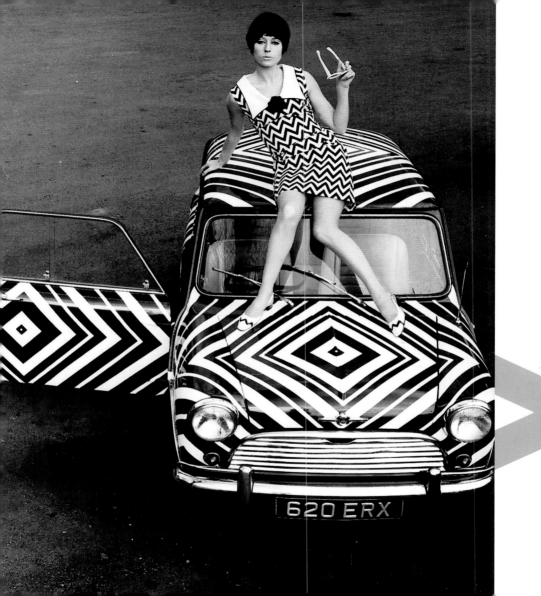

620 ERX

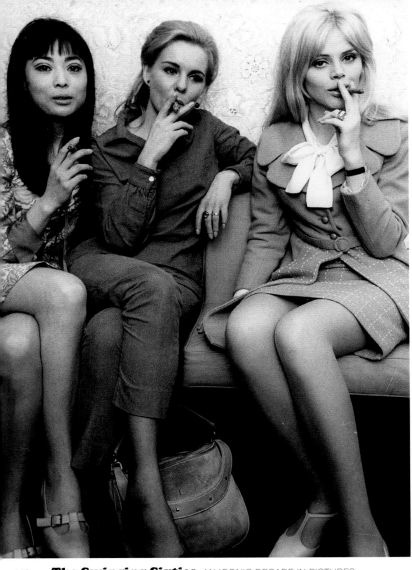

Smokin'

Left: Young actresses (L–R) Poulet Tu, June Ritchie and Britt Ekland relax with a cigar.

8th March, 1966

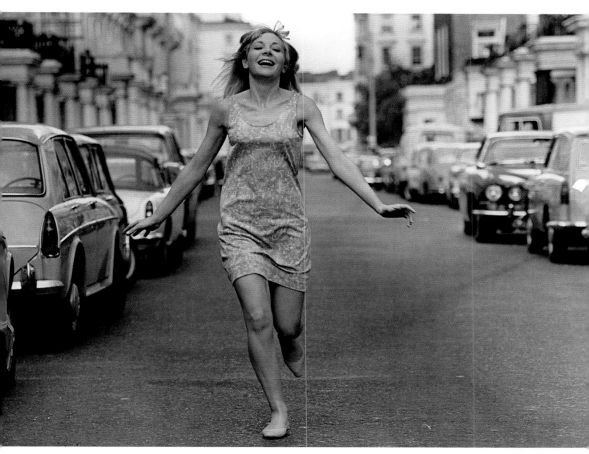

Road runner

British actress Barbara Ferris, who starred with the Dave Clark Five in the film *Catch Us If You Can* in 1965. In the same year, she also played the female lead in Edward Bond's controversial play, *Saved*.

23rd June, 1966

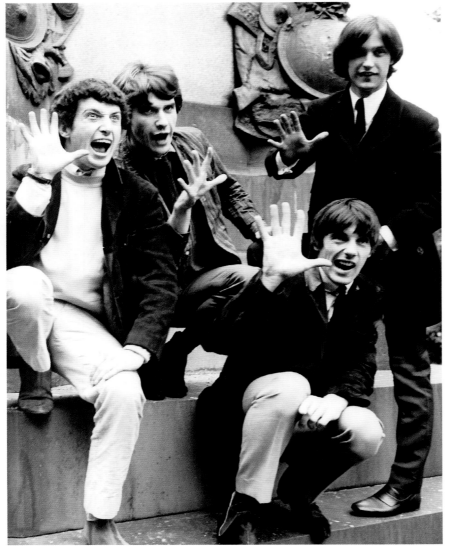

Influential men

Left: The Kinks, one of the most important and influential rock groups of the Sixties. Their song-writing style would inspire a legion of other bands over the following decades. L–R: Pete Quaife, Ray Davies, Mick Avery, Dave Davies.

1966

Lunchtime fun

Right: A Variety Club lunch brings together a group of familiar Sixties faces. L–R: comedian and TV show host Norman Vaughan (whose catch-words were 'swinging' and 'dodgy'), holiday camp entrepreneur Billy Butlin, comedian Jimmy Tarbuck and comedian/singer Harry Secombe.

14th June, 1966

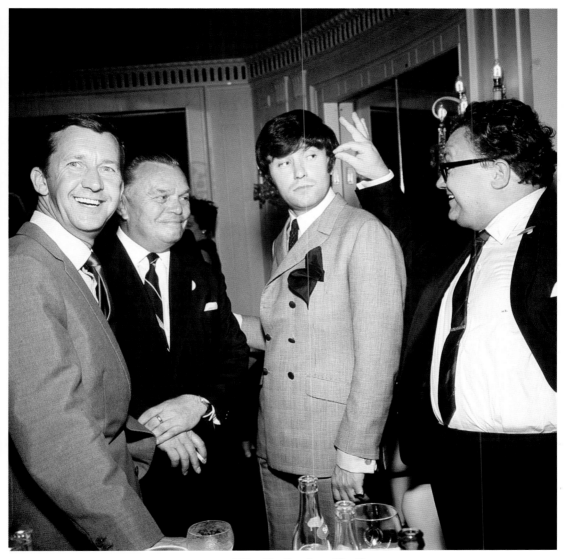

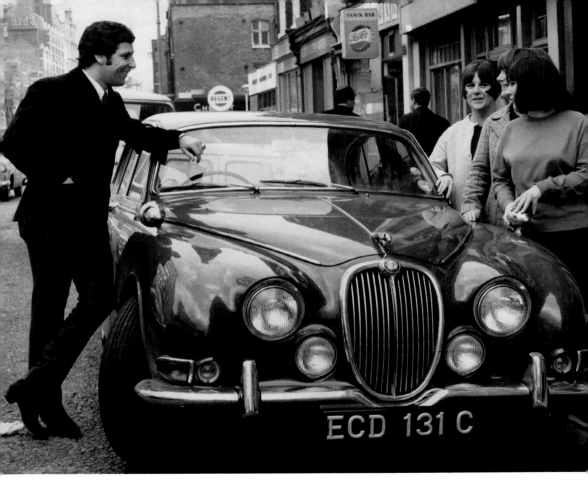

Babe magnet

Welsh singing sensation Tom Jones shows off his Jaguar S-type saloon to three young female fans. Jones would enjoy a long and successful career that continues to this day.

27th April, 1966

Babe magnet too

Manchester United's star player George Best with every man's dream: a flash car and a flash bird, in this case a Jaguar Mk2 saloon and Miss UK, Jennifer Lowe.

c.1966

Trappings of success

L–R: Gail Meredith, Anne Earnshaw and Sue Hellowell, joint owners of a boutique called Googl-Eye in the village of Luddenfoot near Halifax in Yorkshire. To celebrate the success of their shop, the three working mothers all bought matching Triumph Spitfire sports cars.

April, 1966

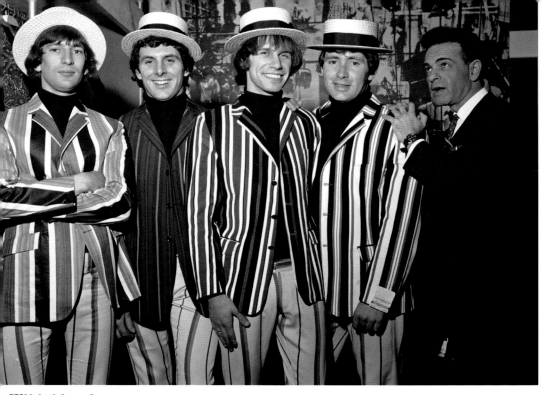

Wild things?

The Troggs – (L–R) Ronnie Bond, Peter Staples, Chris Britton and Reg Presley – with Sid Brent, the owner of the Take Sir boutique in London's Wardour Street, who rather rashly promised the group £1000 worth of clothes if they released a single that made the top five in the charts. *Wild Thing* subsequently made it to number two in Britain and number one in the United States.

27th May, 1966

Times a-changin'

Iconic American singer/songwriter Bob Dylan, in London during a world tour. He had emerged from the folk scene in the early Sixties, but by 1966 his music had taken a different direction and was more folk rock and pop orientated. This, and his use of electric instruments, displeased many of his established fans.

3rd May, 1966

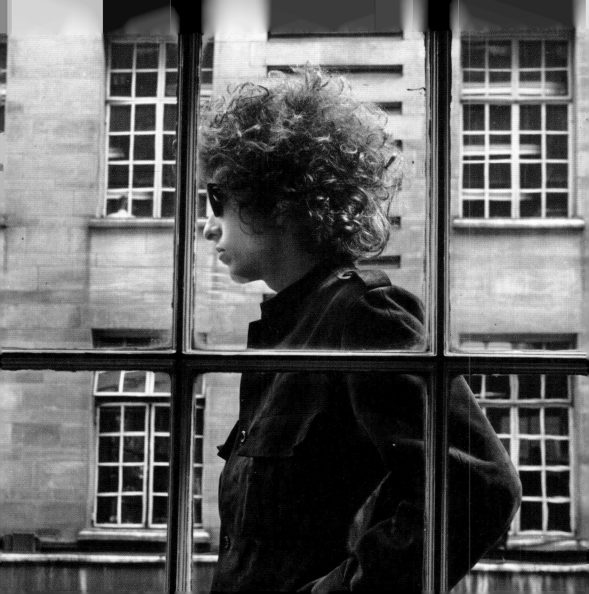

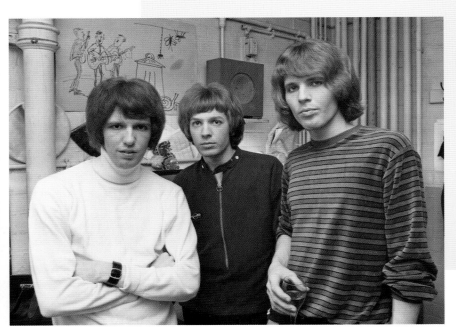

What's in a name?

One of the first boy bands, Californian trio The Walker Brothers before going on stage in Coventry. The band, who were not related, enjoyed greater success in the UK than in the USA, and in March, 1966, went to number one in the charts with *The Sun Ain't Gonna Shine Anymore*. L–R: Gary Leeds, John Maus, Scott Engel.

1st May, 1966

Nightingale in the park

Right: Ann Nightingale, aged 25, who was due to appear on the BBC's *Juke Box Jury*, was a partner in two Brighton boutiques. She had been beaten to the presenter's job at ATV's *Ready Steady Go!* by Cathy McGowan, but would go on to become an established DJ on BBC Radio 1.

15th June 1966

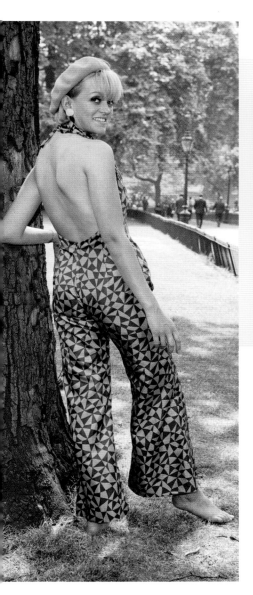

Saintly work

Above: Actor Roger Moore shows Princess Muna al-Hussein of Jordan around the set of the popular Sixties television mystery spy series *The Saint* at Elstree Studios in Hertfordshire. Moore played suave hero Simon Templar in the show, which was based on the Leslie Charteris novels.

26th July, 1966

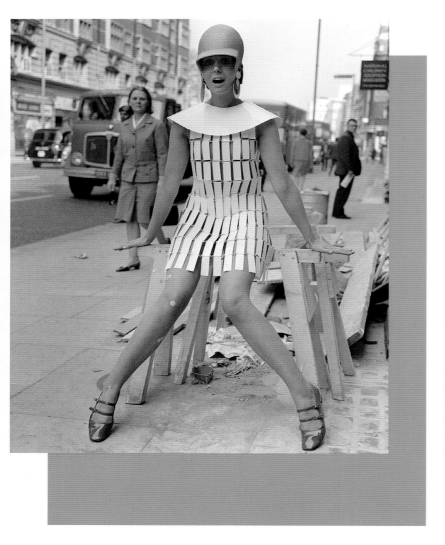

Hi, ho, Silver!

Right: Silver sparkly stockings designed by Mary Quant and worn with a silver bikini by South, accessorised with an orange feather boa for that Sixties beach look.

August, 1966

Ooh la la!

Left: A space-age outfit courtesy of Medway Bagagerie, London's only all-French boutique, disproving at a stroke the premise that French fashion is always stylish and chic.

May, 1966

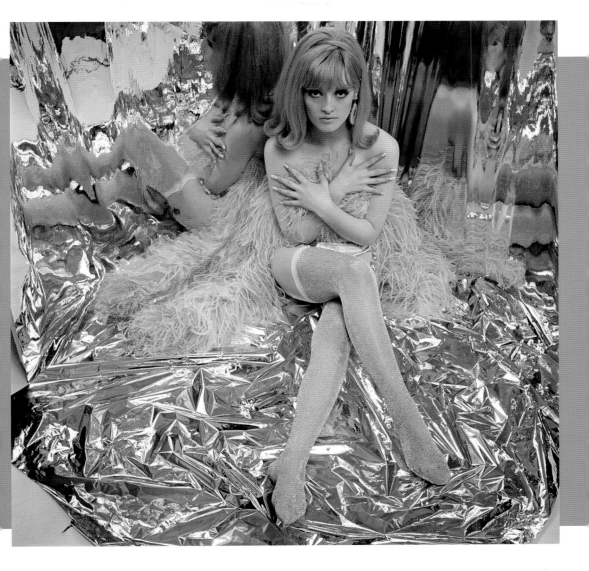

Live on stage

The Beatles perform *Paperback Writer* on the BBC's *Top of the Pops* chart show. It was the only live appearance the band ever made on the programme.

16th June, 1966

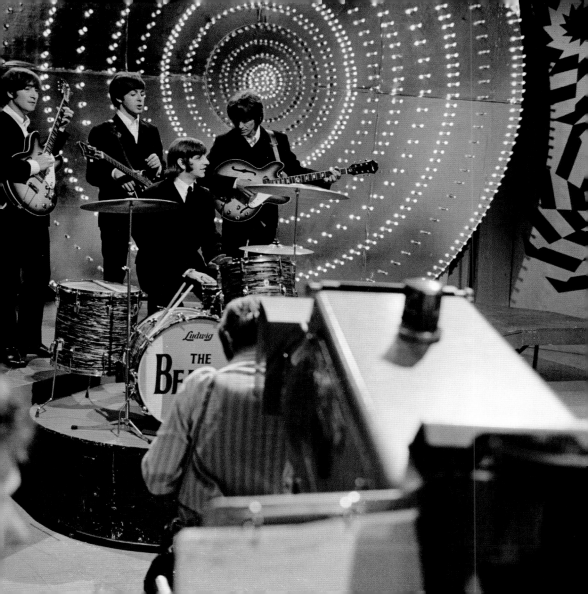

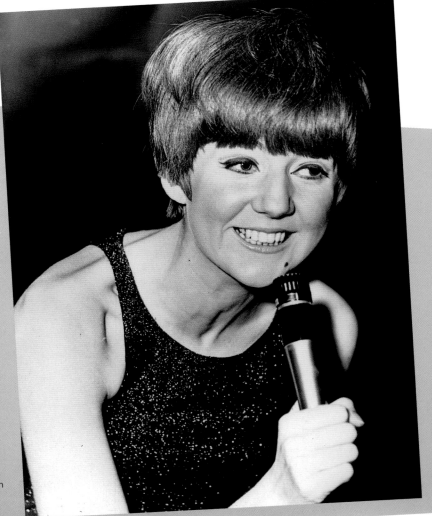

Black is White

Cilla Black, real name
Priscilla White, worked at
Liverpool's Cavern Club
as a cloakroom attendant,
but her impromptu singing
performances impressed
The Beatles, who urged
Brian Epstein to sign her
up. Subsequently, she
enjoyed a successful
recording career and
became a major television
personality.

1966

Act of charity

Tom Jones performs at a concert in aid of the Aberfan Fund, held at the Sophia Gardens Pavillion in Cardiff. The fund had been set up to help victims and their families affected by the disaster in the Welsh mining village of Aberfan in October, 1966. A colliery spoil tip had collapsed after heavy rain and swept through the village, destroying the school and many houses, and killing 116 children and 28 adults.

24th June, 1966

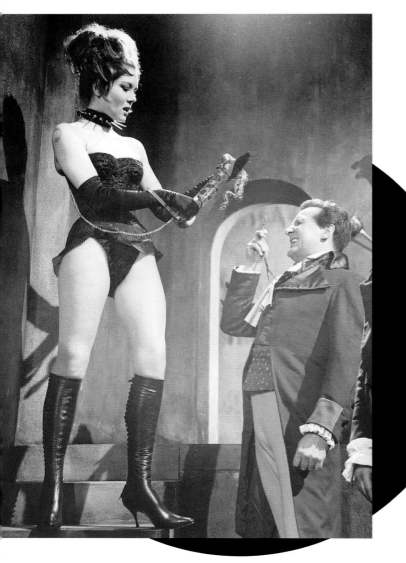

Man appeal

Left: A scene from an episode of the cult TV series *The Avengers*. Actress Diana Rigg, who took over from Honor Blackman, wears an alluring outfit while playing with a snake, to the fascination of co-star Patrick Macnee. Rigg's character was named Emma Peel, apparently because the writers wanted a woman with 'man appeal'.

1966

Playboy of the Western World

Right: Hugh Hefner, boss of the Playboy empire, is greeted by a throng of Bunny girls at London's Heathrow Airport. Heff was in Britain to open his 16th Playboy Club, located on Park Lane in London.

25th June, 1966

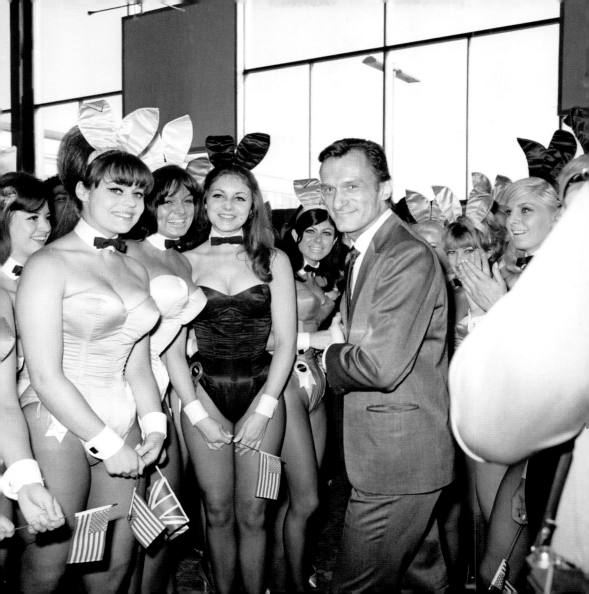

**Every picture
tells a story**

The scoreboard at
Wembley Stadium
in London says it all:
England have beaten
West Germany at the
World Cup Final.

30th July, 1966

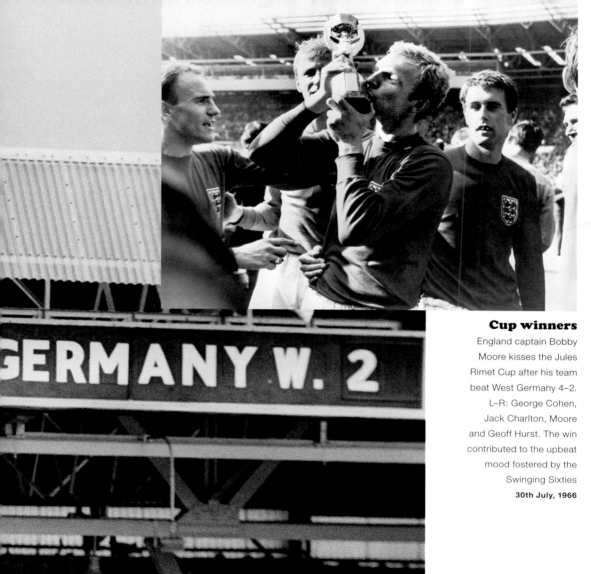

Cup winners

England captain Bobby
Moore kisses the Jules
Rimet Cup after his team
beat West Germany 4–2.
L–R: George Cohen,
Jack Charlton, Moore
and Geoff Hurst. The win
contributed to the upbeat
mood fostered by the
Swinging Sixties
30th July, 1966

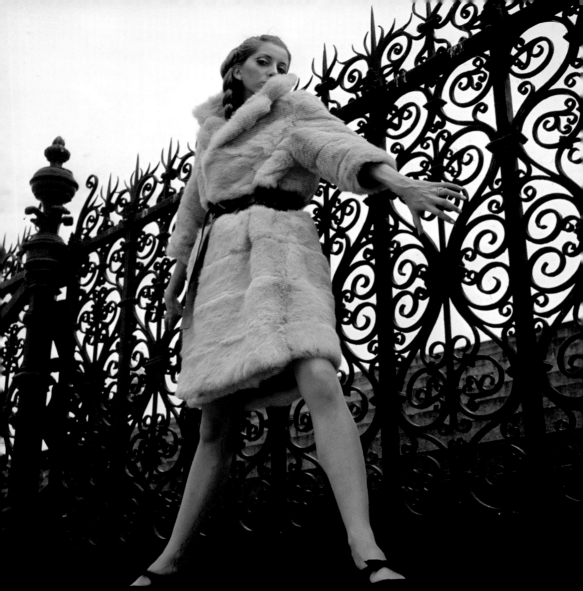

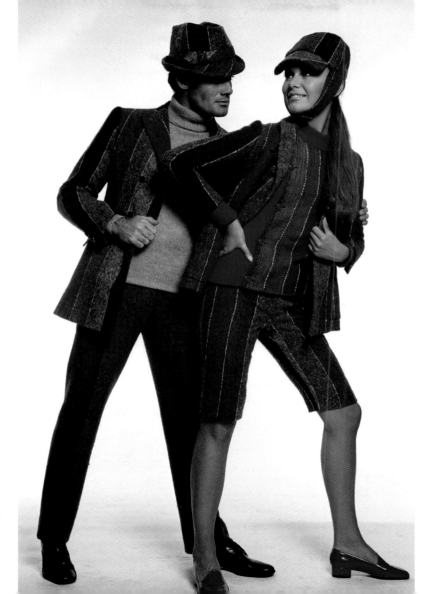

In the pink

Left: A pink faux fur coat worn with a large black belt, designed by Alan Fischelis.

12th August, 1966

His and hers

Right: His and hers striped tweed suits and hats by Ted Lapidus: so wrong in so many ways.

1st August, 1966

165

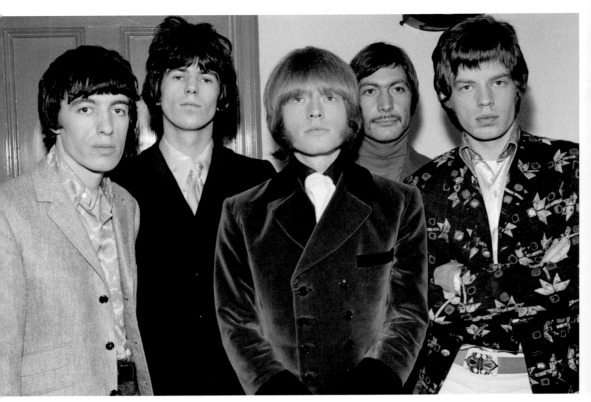

Transatlantic success

The Rolling Stones before going on stage at The Royal Albert Hall. L–R: Bill Wyman, Keith Richards, Brian Jones, Charlie Watts and Mick Jagger. In terms of singles chart success in both the UK and USA, 1966 was a peak year for the band, four of their songs making the top ten, two making number one in the UK and one in the USA.

23rd September, 1966

Carnaby King and Queen

Right: London's Carnaby Street was the fashion Mecca of the Swinging Sixties, many of the young flocking to the area to see and be seen in the latest styles – The Kinks even sang about the 'Carnabetian Army' in their song *Dedicated Follower of Fashion*. However, the Pearly King and Queen look was one of the less successful trends.

2nd October, 1966

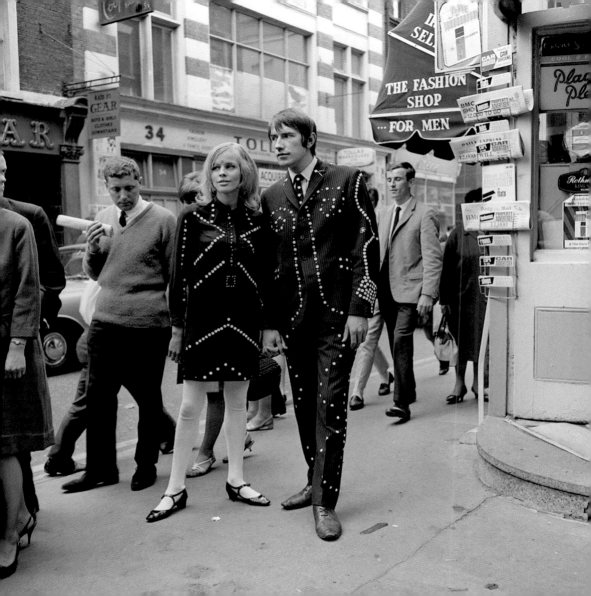

Caroline's main man

Left: Irish entrepreneur Ronan O'Rahilly, the man behind offshore pirate radio station Radio Caroline. Prior to getting into the broadcasting business, O'Rahilly had run The Scene club in London's Soho and managed a number of artists, including Georgie Fame.

9th September, 1966

Rocking the Hall

Below: The Rolling Stones perform at London's Royal Albert Hall during a tour with American rhythm and blues singers Ike and Tina Turner.

23rd September, 1966

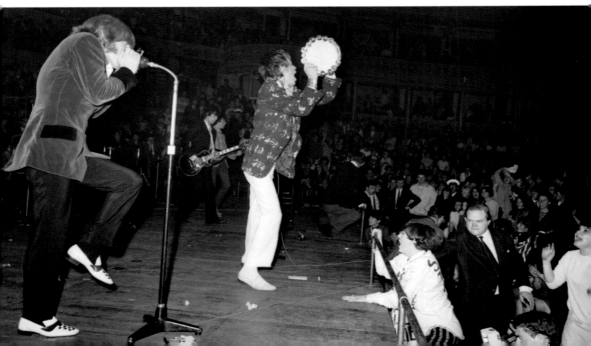

Not a number

Left: Patrick McGoohan (second R) filming on the set of the surreal cult Sixties TV series *The Prisoner*. The plot revolved around a secret agent who had been kidnapped and held in a mysterious seaside village where everyone was known only by a number.

28th September, 1966

Uh huh, it's the Manfreds

Rhythm and blues and beat band Manfred Mann aboard the cruise ship *Chusan* before sailing from Southampton. In addition to entertaining the passengers, they were set to play concerts at the various ports of call on the voyage. L–R: Klaus Voorman, Mike Hogg, Manfred Mann, Tom McGuiness and Mike D'Abo. The band enjoyed a string of successes in the Sixties.

5th November, 1966

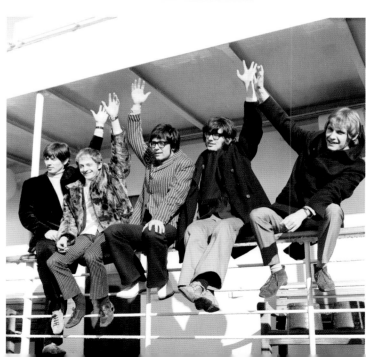

Eyes wide shut

Novelty eye make-up,
giving the impression
that the eyes were wide
open when in fact they
were shut.

24th December, 1966

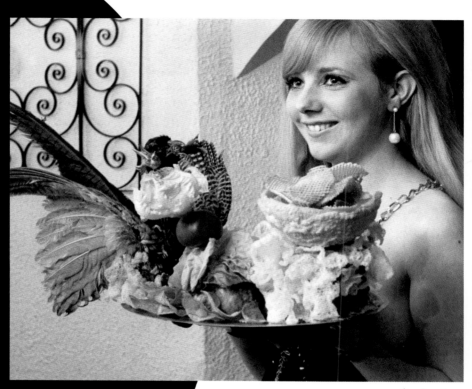

Peek-a-boo

For a very short while in the Sixties, topless dresses made the headlines. La Carreta Club, in London's Carnaby Street, dressed its waitresses in these revealing garments, but tastefully arranged plates of food helped protect a girl's modesty … some of the time.

19th December, 1966

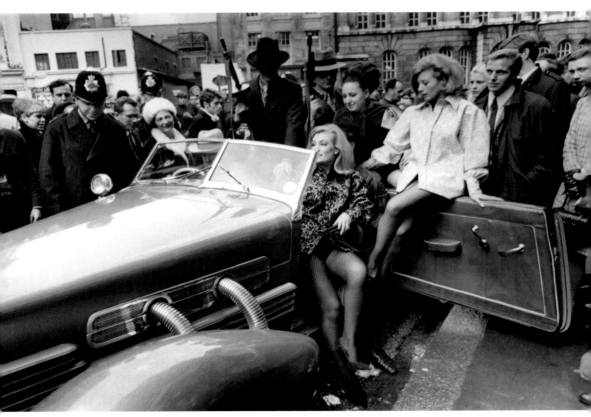

Mob handed

To promote the opening of the second Take Six Boutique, in Great Marlborough Street, London, machine gun-toting 'gangsters' in Al Capone suits, with scantily-clad 'molls', turned up in a vintage 1936 Cord roadster, much to the consternation of the local bobby.

8th December, 1966

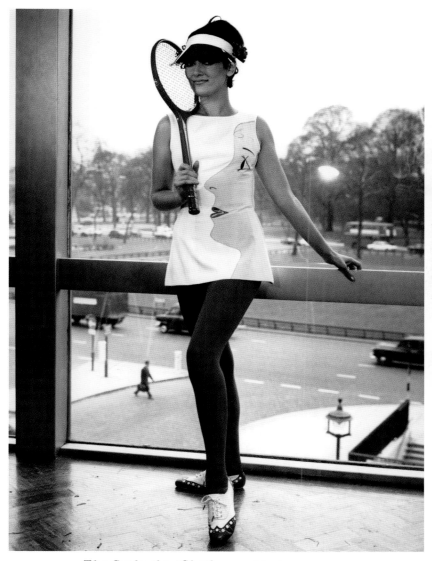

Anyone for tennis?

Trend-setting tennis fashions designed by Teddy Tinling: this polyester cotton shift dress is printed with a pop-art face design.

6th January, 1967

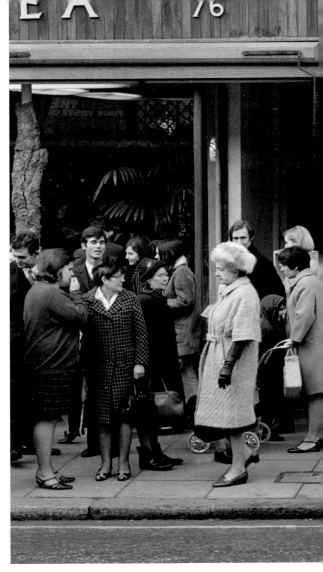

Cool customers

Hardy models, wearing swimsuits for a fashion shoot, brave winter temperatures to sit outside the Guys & Dolls café in the King's Road, Chelsea, much to the bemusement of wrapped-up passers-by.

17th January, 1967

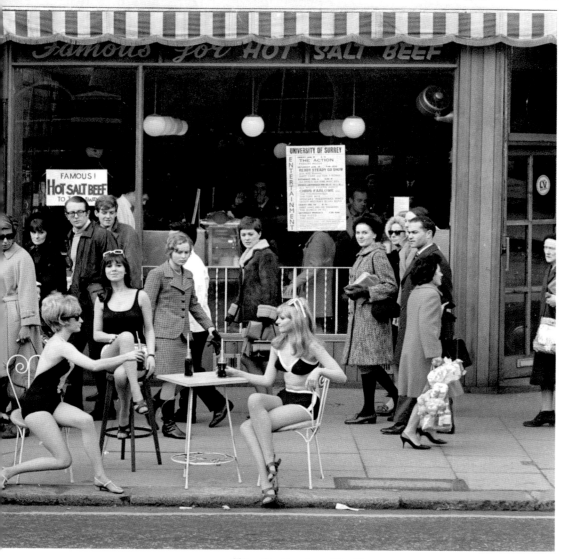

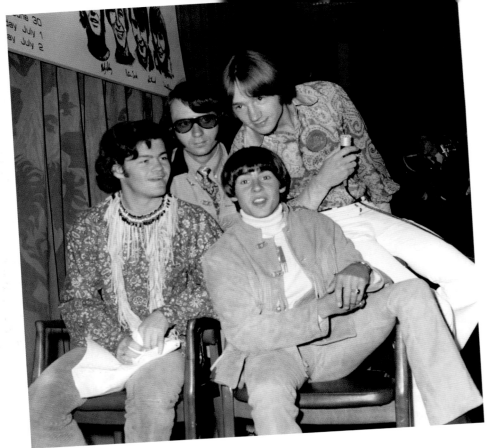

Hey, hey, we're The Monkees

Probably the first 'manufactured' boy band, The Monkees had their own comedy/music show on American TV. They are shown at a press conference in London prior to playing a concert at Wembley. L–R: Micky Dolenz, Mike Nesmith, Davey Jones, Peter Tork. Only Nesmith had a musical background; the other three were actors who had to learn fast.

19th January, 1967

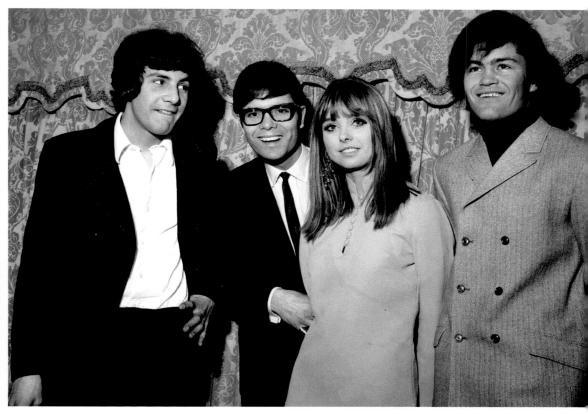

Record makers

L–R: Cat Stevens, Cliff Richard, Samantha Juste and Micky Dolenz at the *Disc and Music Echo* awards. Stevens would forsake his musical career and convert to Islam in 1977, taking the name Yusuf Islam. Juste, a former model, was famous as the *Top of the Pops* disc girl, spinning the records on the BBC1 chart show. She would marry Monkees drummer Dolenz in 1968.

13th February, 1967

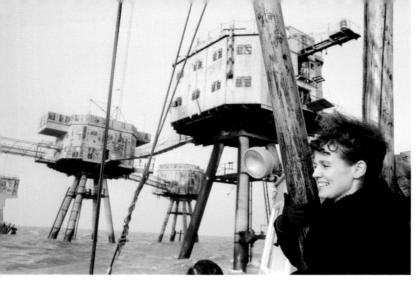

flower girl

Below: Adam Faith greets Eurovision Song Contest winner Sandie Shaw at London's Heathrow Airport. She had just won the 1967 contest for the UK with *Puppet on a String*. Faith had spotted her potential in a charity concert and introducd her to his manager, Eve Taylor. She commonly sang barefoot and enjoyed several major hits in the UK, including three number ones.

10th April, 1967

A pirate sunk

Above: Dorothy Calvert, widow of Reg Calvert, the late owner of Radio City, arrives at the station's base, Shivering Sands Fort in the Thames Estuary. She had continued to run the pirate station after her husband's death in June, 1966, but the operation had been stopped in early February, 1967, after she had been prosecuted for broadcasting illegally. Because the fort was within British territorial waters, it was subject to existing British laws on illegal broadcasting, unlike the other pirate stations, which were moored outside territorial waters.

15th February, 1967

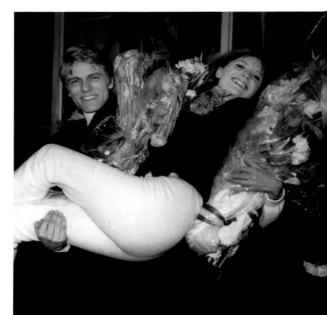

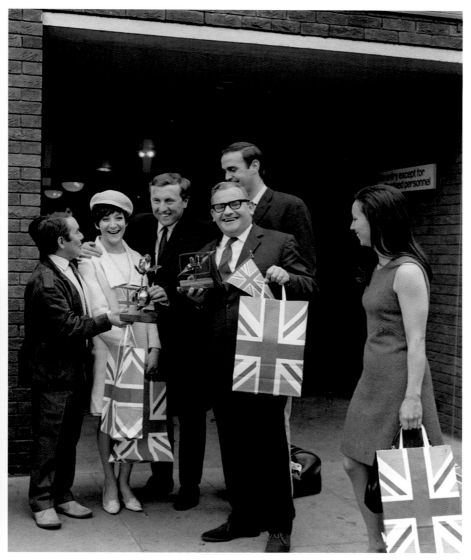

Frosty reception

David Frost and members of the cast of satirical TV comedy show *The Frost Report*, with trophies won by the programme at the Montreux Festival. L–R: Ronnie Corbett, Sheila Steafel, Frost, Ronnie Barker, John Cleese, Julia Felix.

29th April, 1967

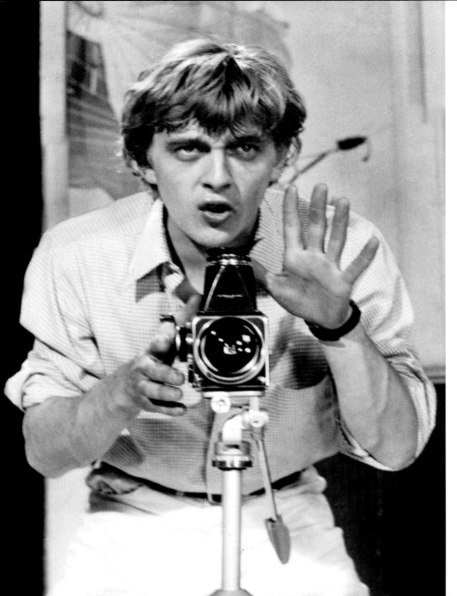

Camera man

Left: Actor David
Hemmings does
a convincing job
of impersonating
'Swinging London'
photographer
David Bailey in
the film *Blow-Up.*
1st March, 1967

It's a dog's life

Right: Even dogs
had to be suitably
attired if they wanted
to be seen in
Carnaby Street.
1st March, 1967

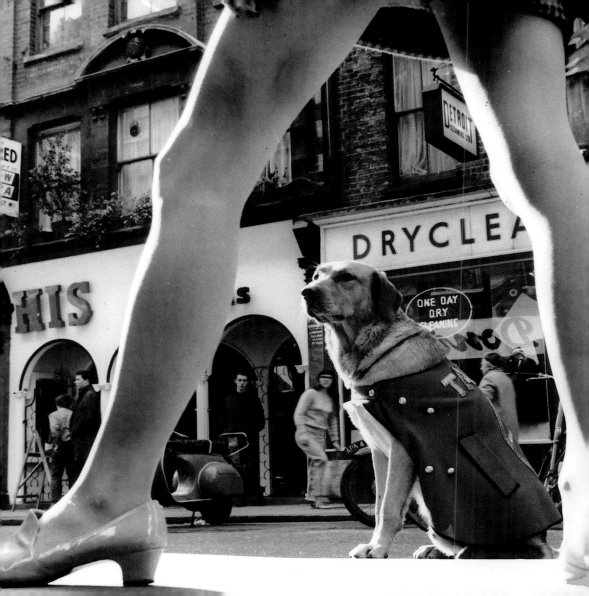

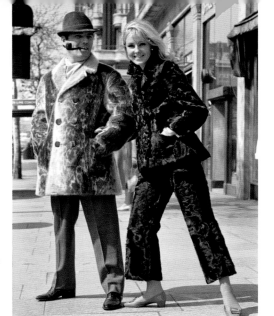

Focus on fur

Left: Fur fashions by designer Anthony Miller: (L) a sealskin men's coat; (R) black kidskin trouser suit. It would be another couple of decades before ethical objections led to a drastic reduction in the use of fur in the fashion industry.

26th April, 1967

A walk in the park

Paisley-style, shell-printed minidress designed by Simon Massey and photographed in London's Hyde Park.

17th May, 1967

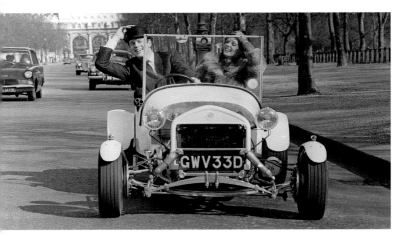

Homemade hot rod

Left: An Opus hot rod kit car with smartly attired driver and passenger, driving up Th Mall from Admiralty Arch in central Londor

2nd March, 1967

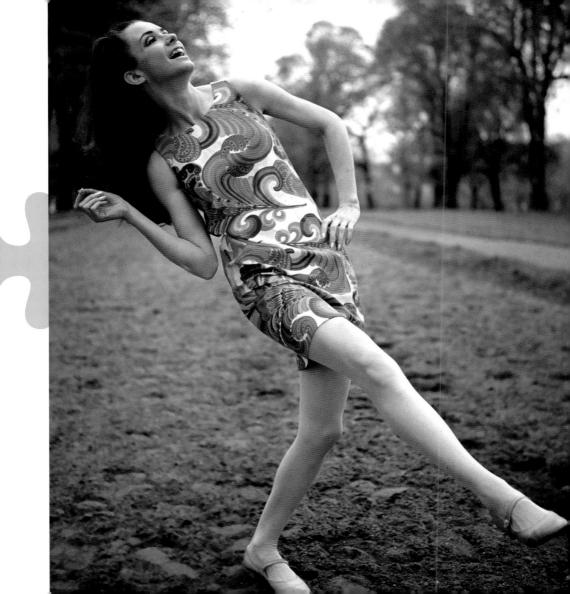

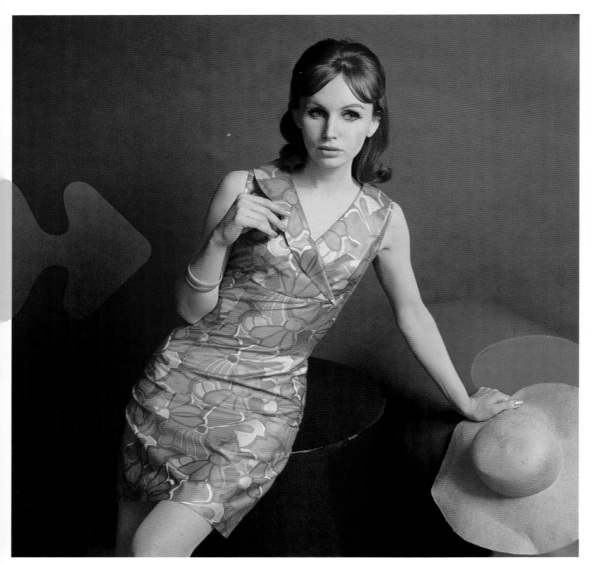

The Swinging Sixties AN ICONIC DECADE IN PICTURES

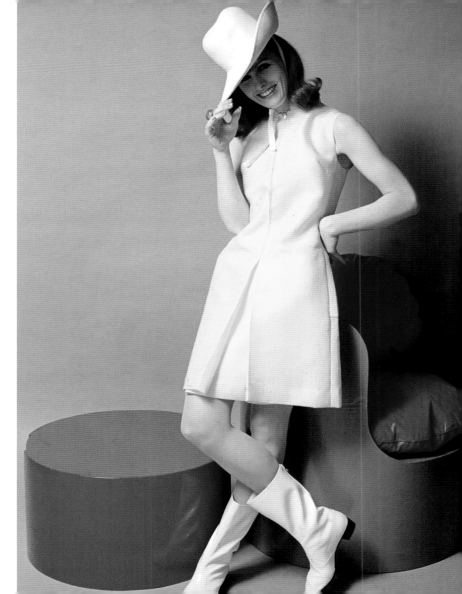

Bold statement

Left: Bold patterns
and clashing colours
became the norm in
some fashion circles.
This satin minidress has
a bold, flowery purple
and gold pattern and is
accessorised with an
orange hat: not for the shy
retiring type.

1st May, 1967

Canary cowgirl

Right: A canary yellow,
linen A-line dress with zip
front and large front pleat,
giving a culotte effect,
worn with a stetson hat
and white cowboy boots.

1st May, 1967

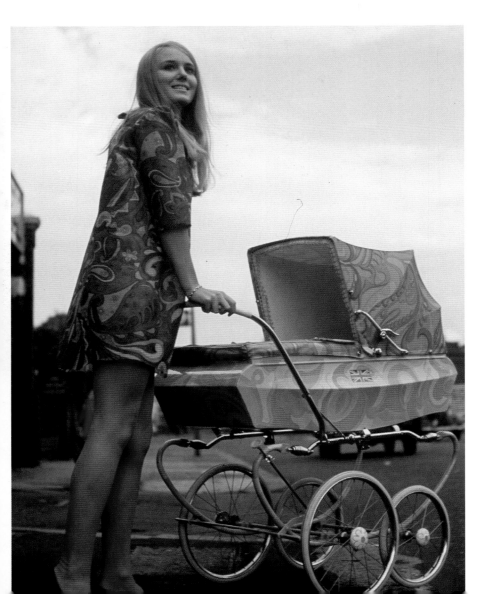

Patterned pram

Left: The increasing use of hallucinogenic drugs in the mid-Sixties led to artists trying to recreate the experience in their work, with bold abstract patterns in bright colours. This psychedelic art soon found its way into the mainstream, most notably in fashion, but in other areas of life, too, as demonstrated by this pram.

19th September, 1967

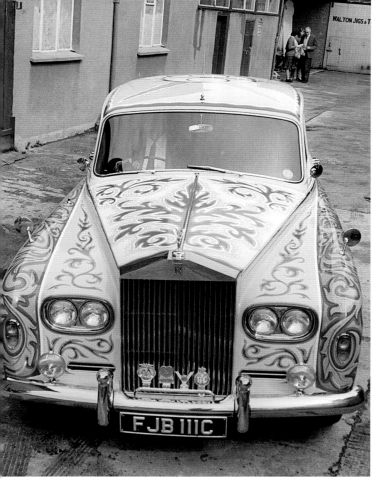

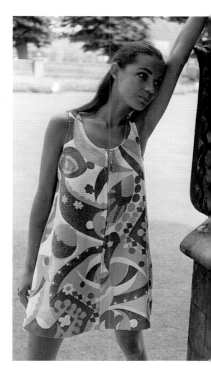

Bond girl

Actress Virginia North, who played one of the James Bond girls in the film *On Her Majesty's Secret Service*, wearing a psychedelically patterned dress. The film was the only outing in the role of 007 for Australian actor George Lazenby.

12th June, 1967

Psychedelic Roller

John Lennon's Rolls-Royce at J.P. Fallon Coachworks in Chertsey, Surrey, after receiving a £2,000 psychedelic paint scheme. Reportedly, a woman attacked the car with an umbrella, yelling, "You swine! How dare you do this to a Rolls-Royce!"

25th May, 1967

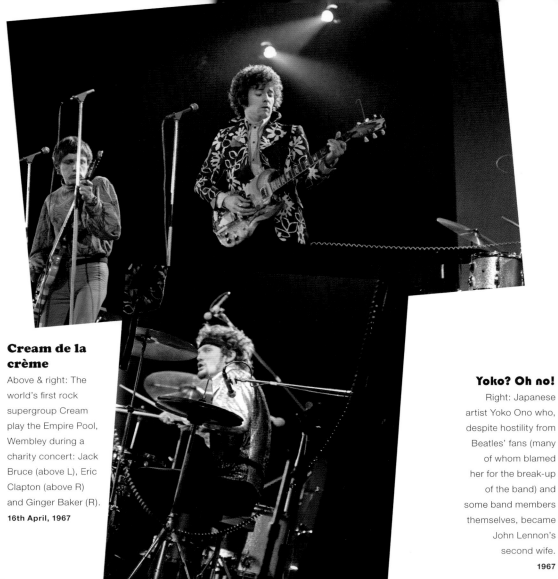

Cream de la crème

Above & right: The world's first rock supergroup Cream play the Empire Pool, Wembley during a charity concert: Jack Bruce (above L), Eric Clapton (above R) and Ginger Baker (R).

16th April, 1967

Yoko? Oh no!

Right: Japanese artist Yoko Ono who, despite hostility from Beatles' fans (many of whom blamed her for the break-up of the band) and some band members themselves, became John Lennon's second wife.

1967

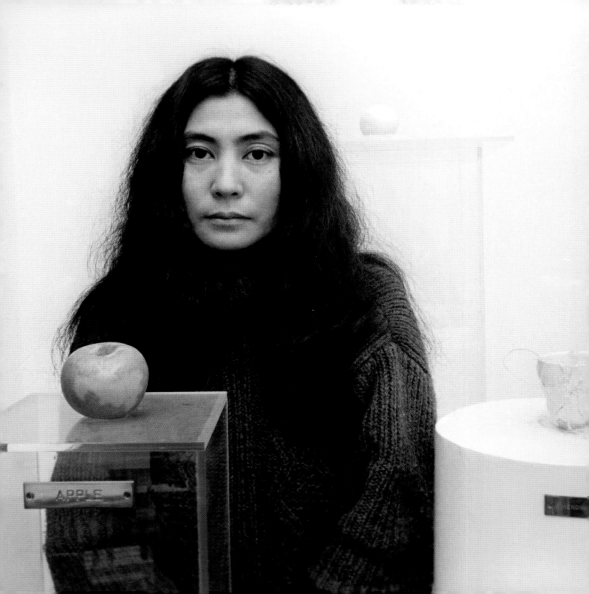

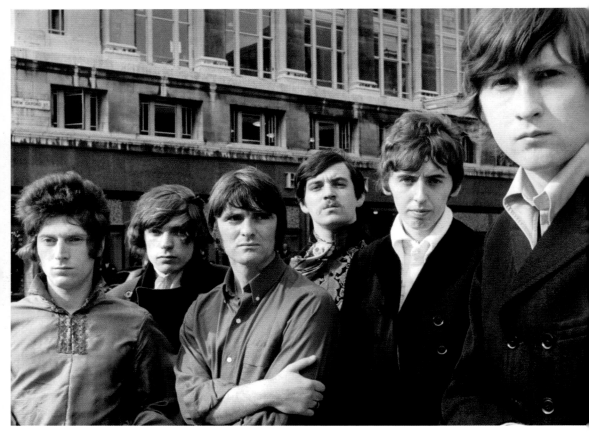

Pale faces

Formed in 1967, Procul Harum released their best-known single, *A Whiter Shade Of Pale*, the same year; despite its baffling lyrics, it reached number one in the charts and enjoyed international success.

7th June, 1967

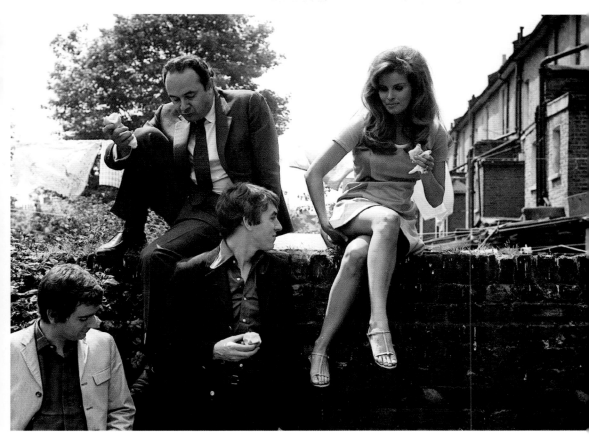

Bedazzling

Raquel Welch with Peter Cook (C) and
Dudley Moore (L) on location during
filming of the comedy *Bedazzled*. Cook
seems to be enjoying the view up the
American star's skirt as they take a
break for lunch.

5th June, 1967

191

Keeping it simple

Above: A plain white bikini in a simple, timeless style.

June, 1967

Below: American paper fashion. There is an obvious design flaw associated with making swimwear out of paper, which the designer appears to have overlooked.

3rd May, 1967

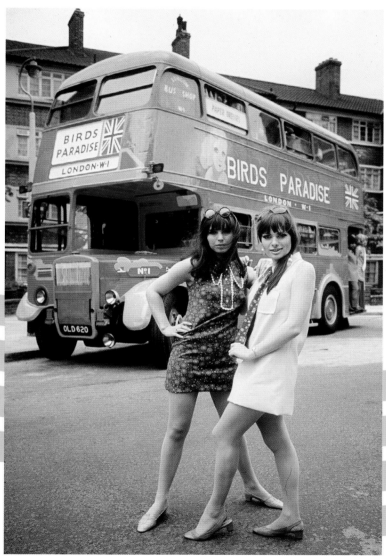

Fashion on the move

A former London Transport double-decker bus converted into a mobile boutique and called, without apparent irony (or punctuation), Birds Paradise. Models wearing minidresses show off some of the styles being offered.

1967

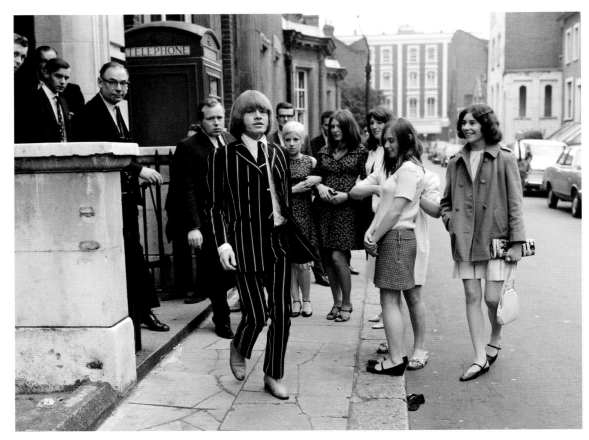

On bail

Founder member and one-time leader of the Rolling Stones, guitarist Brian Jones (C) leaves court after being remanded on bail on drug possession charges. His drug and alcohol abuse gradually spiralled, leading to his estrangement from the band and, ultimately, his untimely death at the age of 27, in July, 1969.

2nd June, 1967

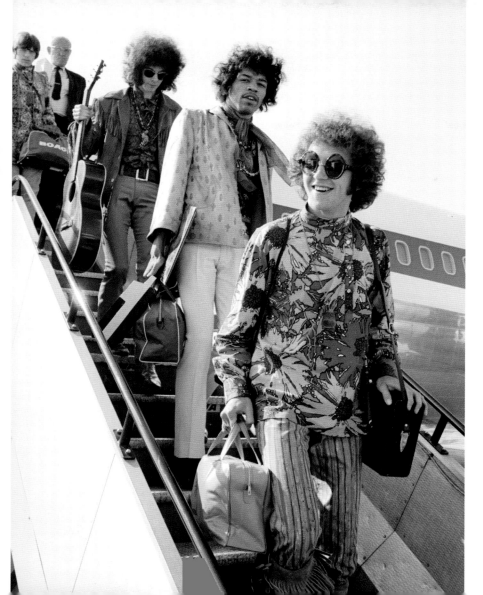

The airport experience

Jimi Hendrix (C) arrives at London's Heathrow Airport with other members of The Jimi Hendrix Experience. They were detained for an hour and a half when a Customs officer confiscated a tear-gas gun from the band's drummer, Mitch Mitchell (R).

20th August, 1967

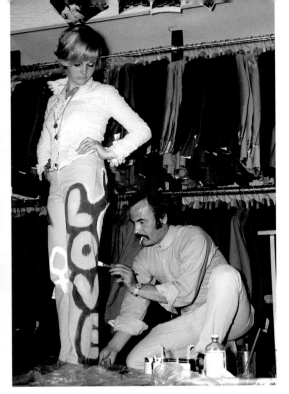

Love jeans?

Artist Vere Smith, from Hammersmith, London, customises jeans by painting slogans on them for his customers. Here Familly Fogg singer Jayne Harries gets the treatment.

July, 1967

Flower man

Model Conrad Cockburn at London's Heathrow Airport, wearing one of a number of floral-design suits that were due to be shown at Cologne Fashion Week.

25th August, 1967

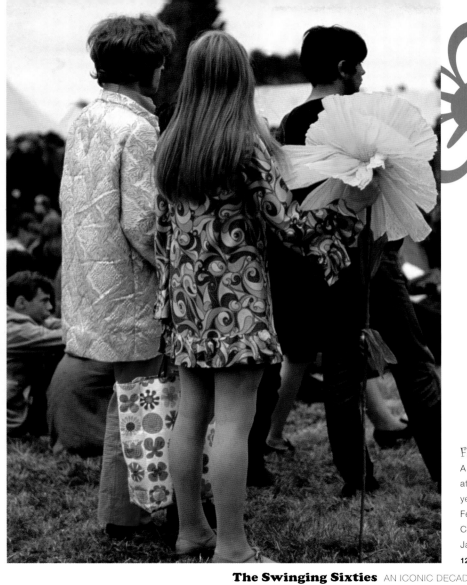

Flower festival

A couple in full hippy attire, complete with giant yellow flower, attend the Festival of the Flower Children at the Windsor Jazz Festival.

12th August, 1967

The Beeb goes pop

Below: Disc jockey Tony Blackburn, a veteran of pirate radio on Radio Caroline and Radio London, launches Radio 1, the BBC's answer to the popularity of the pirate stations, which were outlawed in August, 1967 by the Marine Broadcasting Offences Act.

1st October, 1967

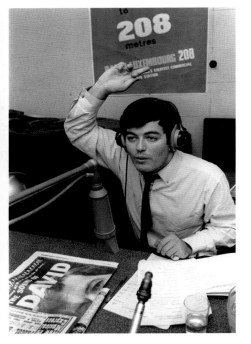

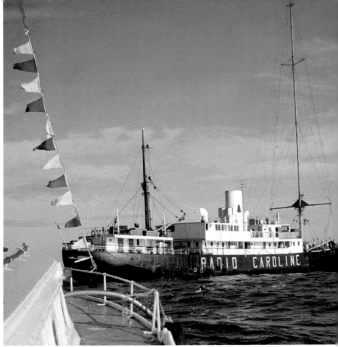

Ship-to-shore radio

Above: Radio Caroline, which began broadcasting in 1964, epitomised the spirit of pirate radio. By 1967, there were two ships: Radio Caroline North (above), anchored in the Irish Sea off Ramsay in the Isle of Man, and Radio Caroline South, broadcasting from a ship anchored in the North Sea, off Frinton-on-Sea. Both ships were in international waters to avoid the need for a licence. Many well-known disc jockeys, among them John Peel, Tony Blackburn and Dave Cash, owed their careers in broadcasting to the start that the pirate stations gave them. Both ships continued to broadcast illegally until 1968.

1st August, 1967

Two-seater

The launch of the Skol
six-day cycle race,
at Earls Court in
London, attracted
models wearing
patterned minidresses
nd multi-coloured tights,
produced by London-
based designer Falcon
Stuart – not the best of
outfits for riding a bike.

2nd September, 1967

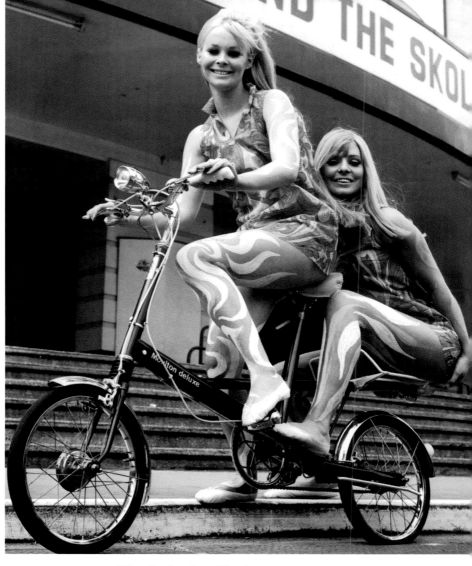

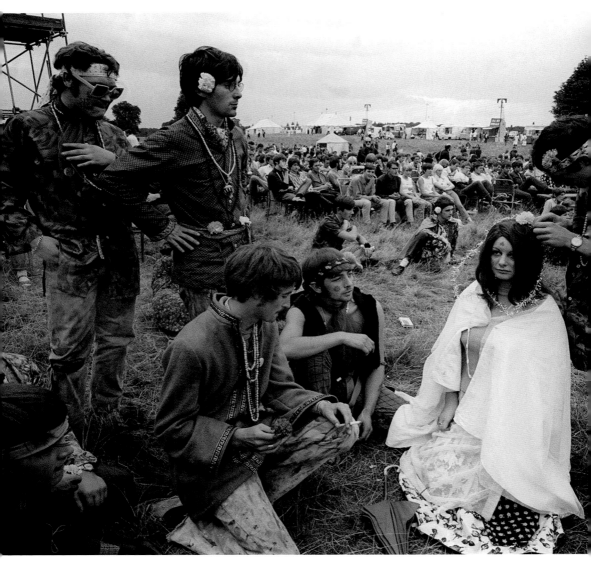

Hair peace

Left: During the Flower Power Festival at Woburn Abbey, hippies decorate their hair with flowers dropped from a hot-air balloon.

30th August, 1967

Flower power

Right: Flowers and beads were essential ingredients of the hippy look, as epitomised by this festival goer at the Flower Power Festival, Woburn Abbey. Wacky sunglasses, and a matching colourful paisley shirt and tie complete the look.

27th August, 1967

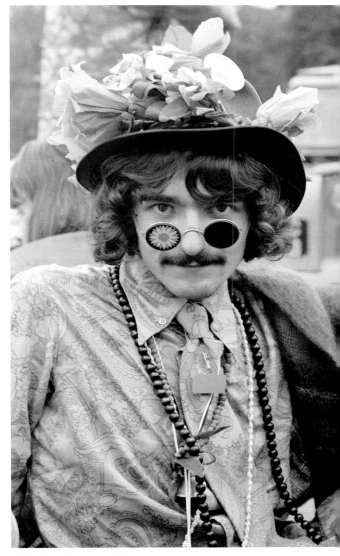

Bespoke boots

Below: Ray Phillips of The Nashville Teens pop group tries on some hand-made shoes in Chelsea. Despite their obvious talent, a combination of circumstances denied the Teens long-term success and they only had one major hit: *Tobacco Road* in 1964.

7th September, 1967

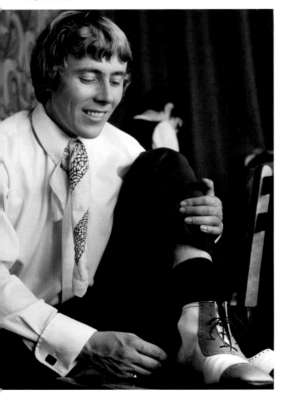

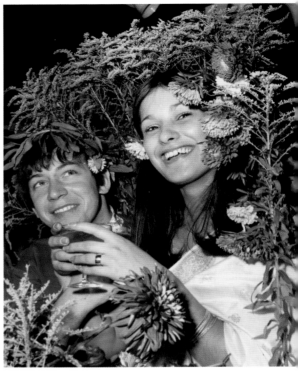

Floral tribute

Above: Eric Burdon, lead singer of The Animals, married 20-year-old model Angela King at Caxton Hall in London. Here, the couple sip champagne during the reception while seated in a flowery bower bui by their friends.

8th September, 1967

School break

Above: Bubbly singer Lulu made her acting debut in the 1967 film *To Sir With Love*, taking the part of a schoolgirl alongside American actor Sidney Poitier. She had a US number-one hit with the movie's title song and is seen here on a break during the first day of filming.

1967

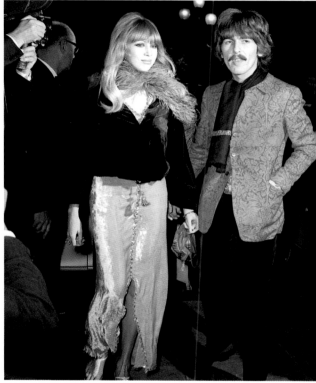

She's my baby

George Harrison and wife Pattie Boyd arrive at the London Pavillion, Picadilly Circus for the premiere of the film *How I Won the War*, which starred fellow Beatle John Lennon.

18th October, 1967

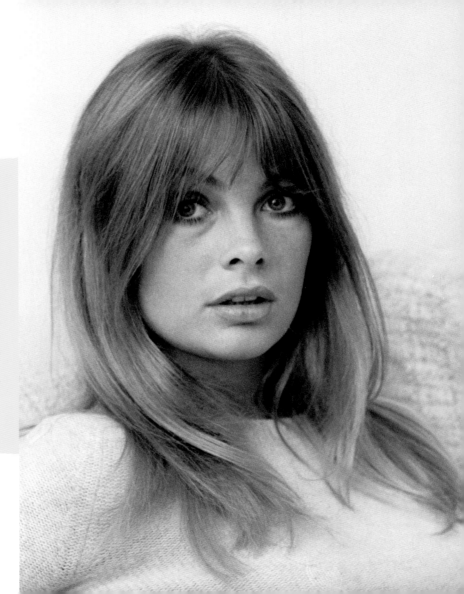

The face

Jean Shrimpton's long hair, fringe, doe eyes, long eyelashes and pouty lips epitomised the Swinging Sixties look. In 1967, she took a break from modelling to star opposite former Manfred Mann singer Paul Jones in the film *Privilege*.

25th October, 1967

Thinking cap

A men's flat cap designed by Mary
Quant and sold at the Bazaar Shop in
Knightsbridge, London.

November, 1967

Great future

Right: Formed in 1965, Pink Floyd would go on to become one of the most commercially successful and influential bands of all time. L–R: Syd Barrett, Richard Wright, Roger Waters, Nick Mason.

2nd September, 1967

Moody mob

Above: Progressive rock group The Moody Blues, best known for their hit singles *Go Now* and the classic *Nights In White Satin*, pose as gangsters. L–R: John Lodge, Justin Hayward, Graeme Edge, Mike Pinder, Ray Thomas.

18th October, 1967

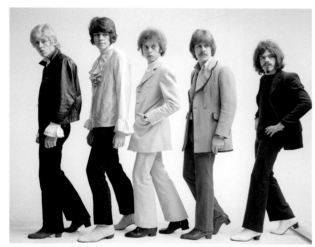

On the move

Birmingham band The Move, who made their chart debut in January, 1967, with *Night of Fear*. This was quickly followed by *I Can Hear the Grass Grow* and *Flowers in the Rain* (the first chart single to be played on the newly launched Radio 1), both top-ten hits. L–R: Chris 'Ace' Kefford, Carl Wayne, Bev Bevan, Trevor Burton, Roy Wood.

1st December, 1967

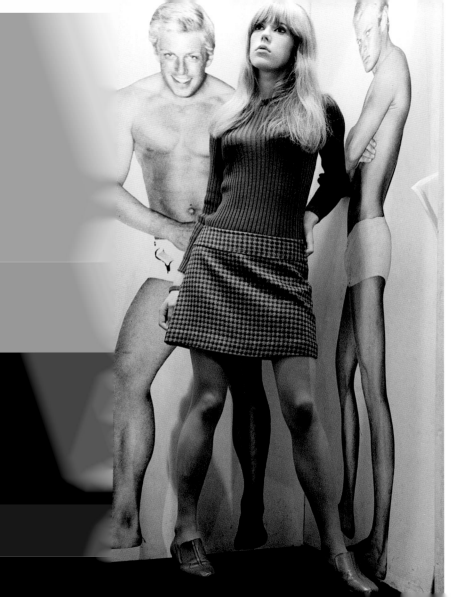

Two-timer

Left: Jenny Boyd, 18-year-old sister of model Pattie Boyd, in a changing cubicle at Tre Camp, John Stephen's boutique for women in Carnaby Street. Like her sister, Jenny was a model. She had an affair with folk-rock singer Donovan, but eventually married and divorced Fleetwood Mac drummer Mick Fleetwood, twice.

c.1967

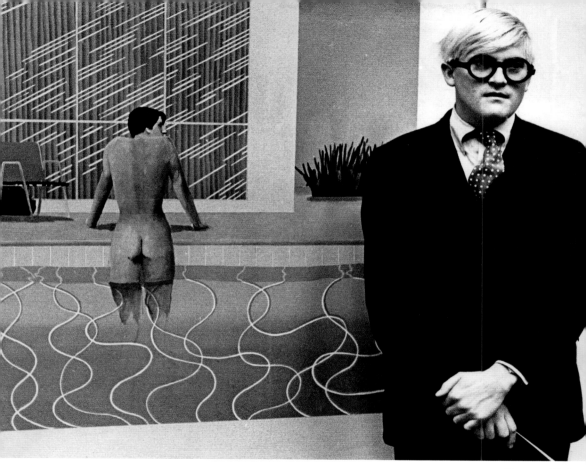

Pop artist

David Hockney with his painting entitled 'Peter Getting Out of Nick's Pool', one of a series of swimming-pool pictures inspired by his time spent living in California. Hockney played an important role in the Pop art movement of the Sixties and since has come to be considered one of the most influential British artists of the 20th century.

25th November, 1967

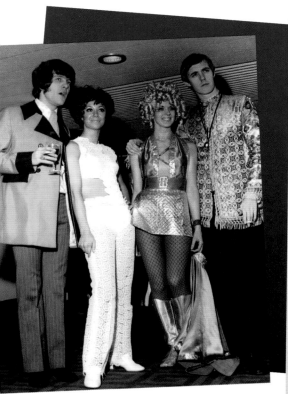

Party gear

Above L–R: Dave Dee, Nicki Hamilton, Suzy Bryant and Simon Dee dressed in their finery for the Pop Ahead to 1977 party at the Royal Lancaster Gate Hotel, London.

November, 1967

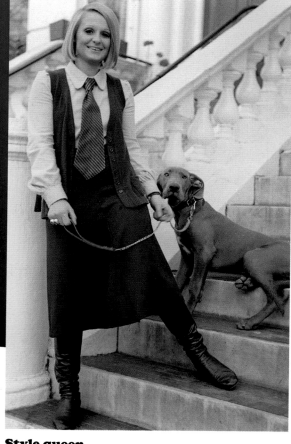

Style queen

Barbara Hulanicki, founder of influential fashion store Biba, outside her Kensington home. With decadent decor, Biba was regularly frequented by artists, film stars and rock musicians.

December, 1967

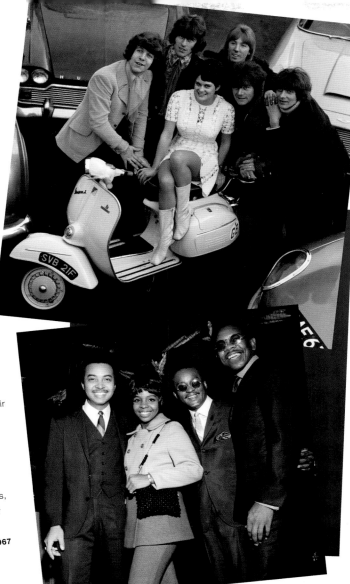

Name check

Dave Dee, Dozy, Beaky, Mick & Tich, who spent more time in the UK singles chart than The Beatles between 1965 and 1969, scoring a number-one hit with *The Legend of Xanadu* in 1968. Clockwise from L: Dave Dee, Michael Wilson (Mick), Ian Amey (Tich), Trevor Ward-Davies (Dozy), John Dymond (Beaky) and Ann Bridger, Dozy's girlfriend.

1st December, 1967

Soul music

Right: American soul group Gladys Knight and The Pips at the Beachcomber Mayfair Hotel in London. L–R: William Guest, Gladys, Edward Patten and Merald 'Bubba' Knight. They had many hits, including *Midnight Train to Georgia*.

30th November, 1967

festive mood

Above: Footballers George Best (R) and Mike Summerbee make a
start on the festive decorations at their men's boutique in Manchester.

4th December, 1967

Fool's errand

Right: The Beatles' Apple boutique in Baker Street, London, being
painted with psychedelic murals created by The Fool design collective.
The brightly coloured, elaborate designs were not appreciated locally,
however, and the council insisted they be covered with white paint.
Managed by John Lennon's friend, Pete Shotton, and Pattie Boyd's
sister, Jenny, the store opened on 7th December, 1967.

4th December, 1967

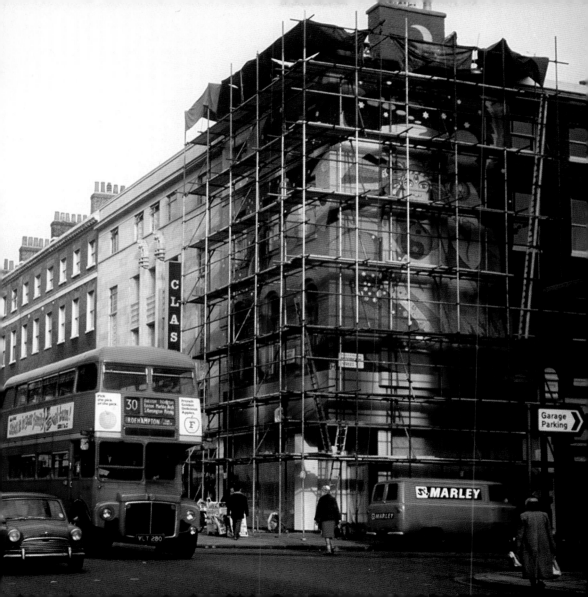

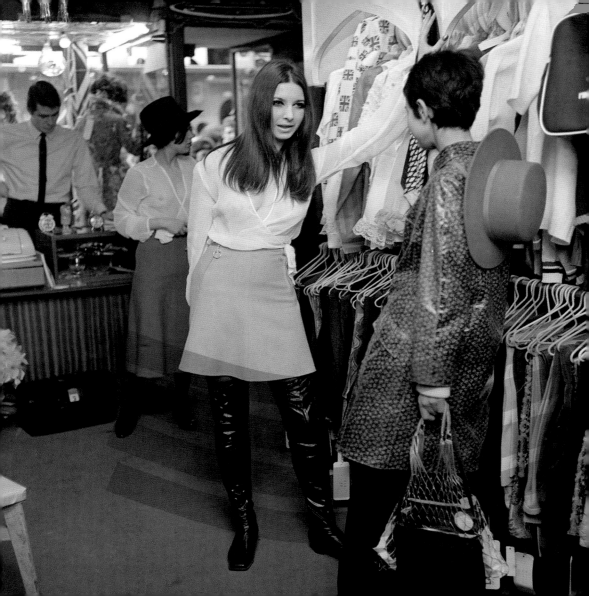

Lady Jane

Left: Having opened in 1966, and with sales assistants dressed in see-through tops, Lady Jane was the first women's fashion boutique in London's Carnaby Street. It was patronised by stars from around the world, including Jayne Mansfield.

February, 1968

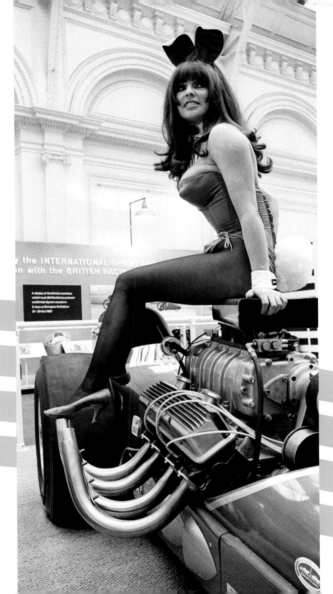

fast cars and fast women

The usual mix of fast cars and scantily-clad models on show at Autospeed, the racing car show, held at the Royal Horticultural Halls in London. This Playboy Bunny is perched precariously on the engine of a dragster in the record breakers section.

2nd January, 1968

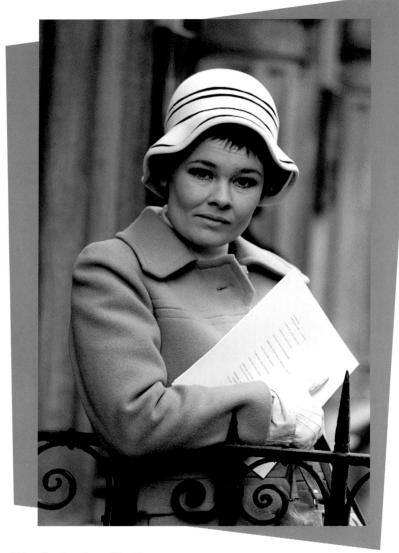

Cabaret star

Known for playing classical roles, actress Judi Dench was a surprise choice to play Sally Bowles in the West End musical *Cabaret* in 1968. At first reticent, she made the role her own to critical acclaim, and the production enjoyed a long run. Here, appropriately, she models a Christian Dior hat called 'Cabaret'.

27th February, 1968

Sounds of the Sixties

BBC Radio 1 and 2 disc jockeys with the controller of both stations, Robin Scott. Back row, L–R: John Peel, David Symonds, Dave Cash, Stuart Henry, Johnny Moran, Alan Freeman; Middle row, L–R: Peter Myers, Mike Ravon, Terry Wogan, Keith Skues, Kenny Everett, Ed Stewart; Front row, L–R: Barry Aldis, Chris Denning, Scott, Tony Blackburn, Sam Costa.

1968

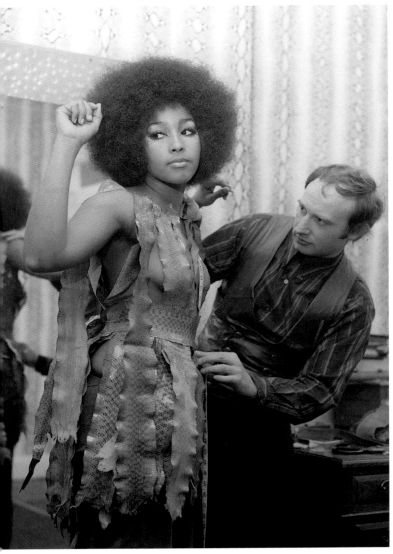

Hunt for a top

Left: American singer Marsha Hunt tries a new top. She had moved to Britain in 1966 and married Soft Machine's Mike Ratledge to obtain a visa extension to be able to stay. She sang with Alexis Korner's band Free at Last in 1967 and, after a spell with Ferris Wheel, achieved national fame when she joined the cast of hit West End musical *Hair*; her silhouette appeared on the official poster for the production. Hunt's most high-profile relationship was with Mick Jagger, with whom she had a daughter, Karis, in 1970.

c.1968

lash-up

Right: False eyelashes were an essential part of the Swinging Sixties look, but these may have been a step too far. Officially, they were the longest eyelashes in the world.

1968

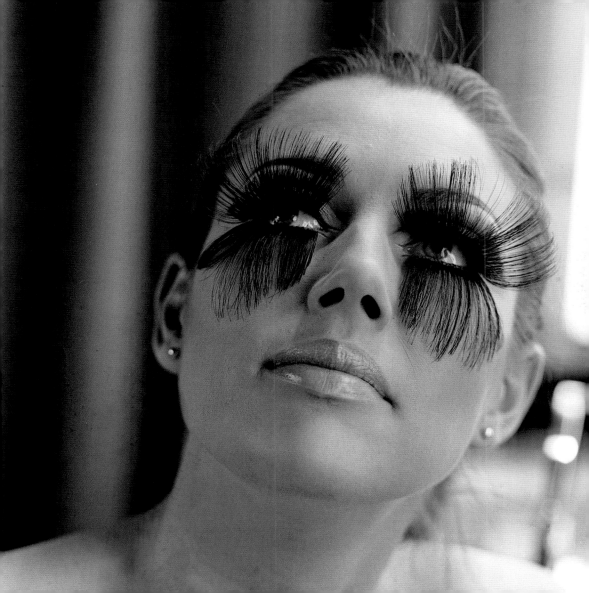

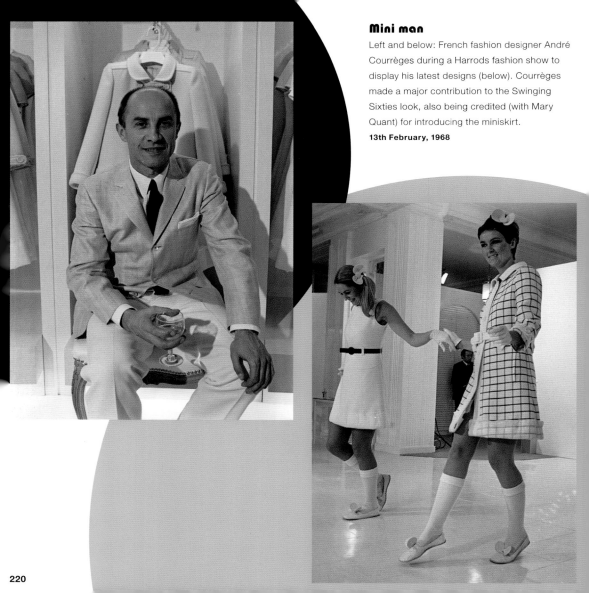

Mini man

Left and below: French fashion designer André Courrèges during a Harrods fashion show to display his latest designs (below). Courrèges made a major contribution to the Swinging Sixties look, also being credited (with Mary Quant) for introducing the miniskirt.

13th February, 1968

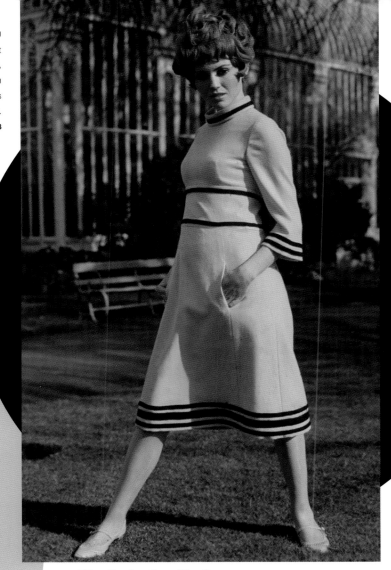

Mellow yellow

The Sixties were all about bright colours. This yellow, tweed, A-line knee-length dress with black trim was designed by Emor.

March, 1968

Left: White minidress with lattice-style bodice, scalloped neckline and flower detailing at the hem, worn with matching shorts.

1st March, 1968

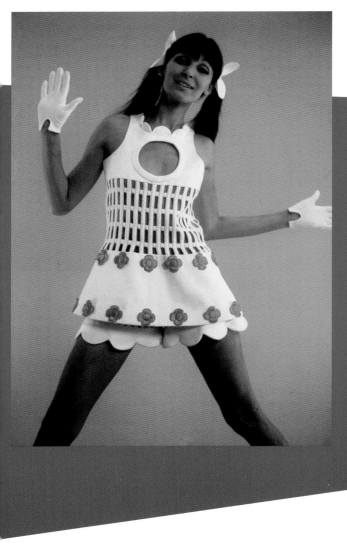

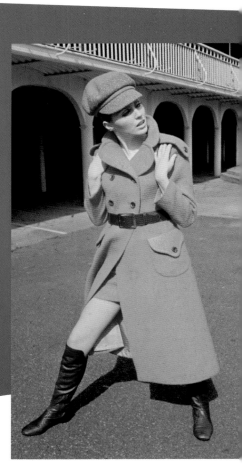

Plaid poncho

Right: A plaid-patterned, fringed poncho, designed by JP Fashion and teamed with red tights.

1st March, 1968

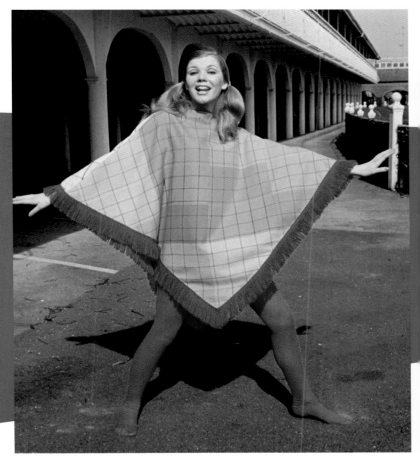

Maximum impact

Left: A burnt orange maxi coat and miniskirt in hand-woven tweed with a matching hat, designed by Jimmy Hourihan, and worn with a wide belt and knee-length boots.

1st March, 1968

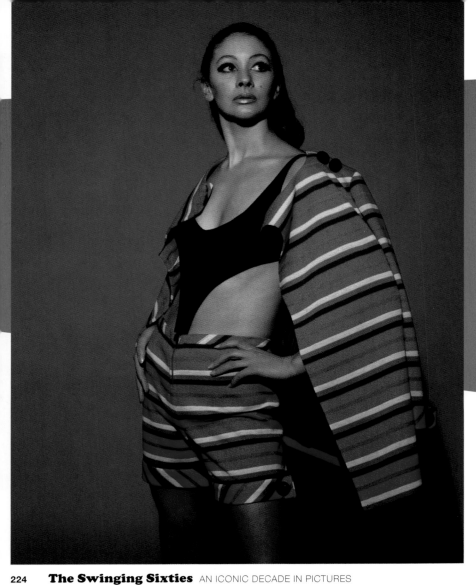

Rainbow stripes

Striped jacket and matching shorts designed by Glynis Miller, worn over a cut-away blue swimsuit.

14th March, 1968

The Swinging Sixties AN ICONIC DECADE IN PICTURES

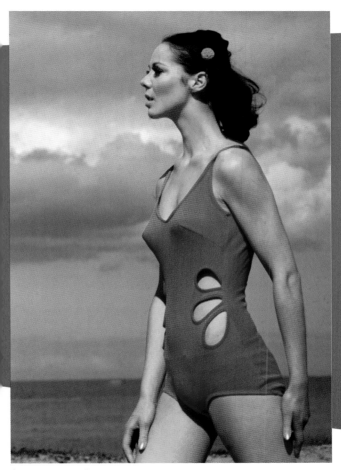

Pretty in pink

Hot pink swimsuit with cut-out detailing, designed by Sunbeam.

10th May, 1968

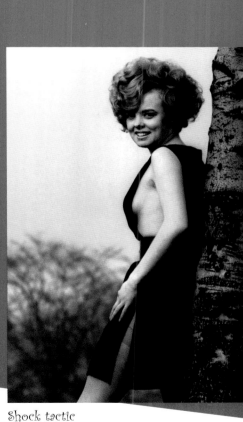

Shock tactic

A Mary Quant design entitled 'Shock': a daring pinafore minidress with a thigh-length side split.

11th March, 1968

Congratulations, a winner!

Singers Cliff Richard and Cilla Black help count the votes to decide Britain's entry in the Eurovision Song Contest. The selection show had been presented by Cilla, while Cliff had sung the songs. The winner was *Congratulations*, which came second in the contest.

8th March, 1968

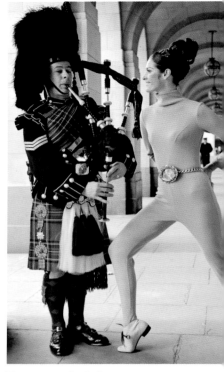

Two-way stretch

Model Philippa Wakeham, wearing a figure-hugging, stretchy Romeo catsuit, designed by Gibi of Rome, tries to distract a Scots Guards piper at the Knitwear of Italy Fashion Fair, being held at the Savoy Hotel in London.

18th March, 1968

Not so little drummer boys

In the Sixties, it seemed as though no self-respecting group could go for long without making a film. Here, The Bee Gees' original line-up are seen with top comedy writer Johnny Speight, who wrote the screenplay for their first feature film, *Lord Kitchener's Little Drummer Boys*. The plot concerned the lads joining the army as bandsmen during the Boer War, and to drum up publicity before shooting began, Speight was seen marching them through London. L–R: Vince Melouney, Colin Petersen, Robin Gibb, Barry Gibb, Maurice Gibb, Johnny Speight.

29th March, 1968

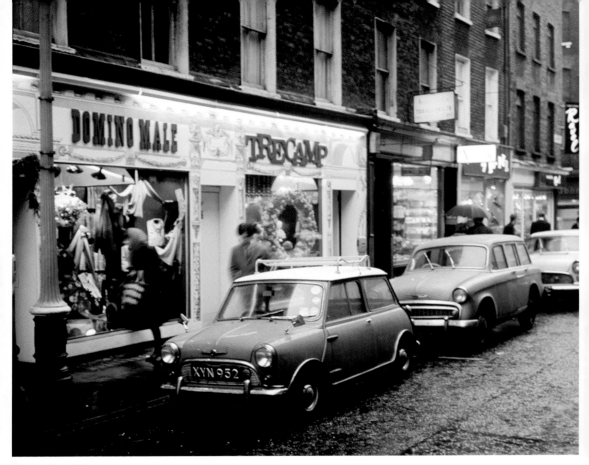

Carnaby vista

A scene that epitomises the Swinging Sixties: a view of Carnaby
Street in London, with its trendy boutiques, including Domino
Male and Tre Camp (both owned by 'King of Carnaby Street' John
Stephen), and the iconic car of the decade, the Mini.

April, 1968

Pop shop

Right: Pop Boutique, part of the swinging fashion
scene in Carnaby Street, London.

24th May, 1968

The eyes have it

The message of the hippy movement throughout the Sixties, printed on a pair of novelty sunglasses.

24th April, 1968

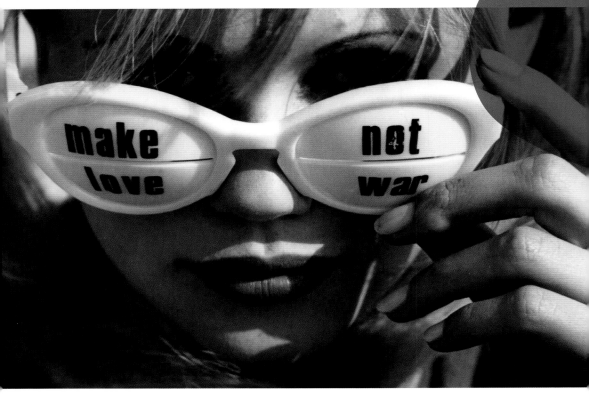

Where are you?

Right: John Lennon and Yoko Ono release 365 white helium balloons to celebrate the opening of their first joint art exhibition, entitled 'You Are Here', at the Robert Fraser Gallery in Duke Street, London.

1st July, 1968

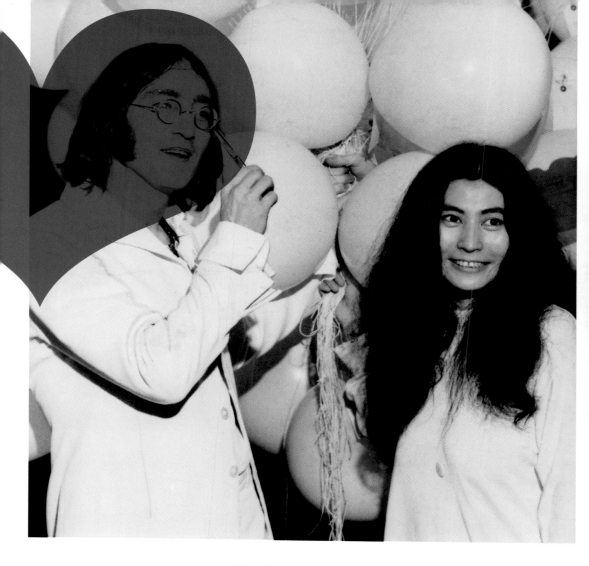

Submarine crew

Right: At the premiere for the new Beatles film, *Yellow Submarine*, at the London Pavilion, Piccailly Circus, police officers struggle to hold back the crush of fans waiting for the stars.

18th July, 1968

Flock of Byrds

After a three-year absence, revamped American band The Byrds return to Britain for a charity concert at the Royal Albert Hall in London. L–R:- Roger McGuinn, Kevin Kelley, Gram Parsons and Chris Hillman. At the time, the band were moving away from their psychedelic rock base into country rock. Today, The Byrds are considered one of the most influential bands of the Sixties.

July, 1968

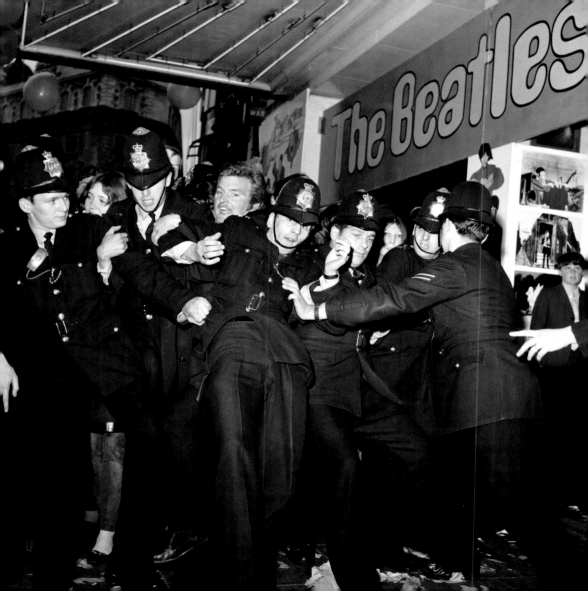

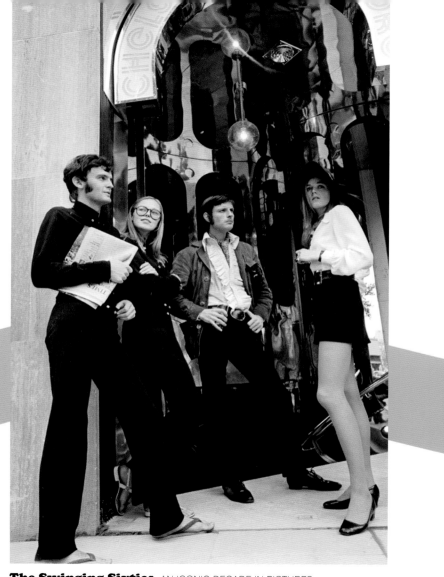

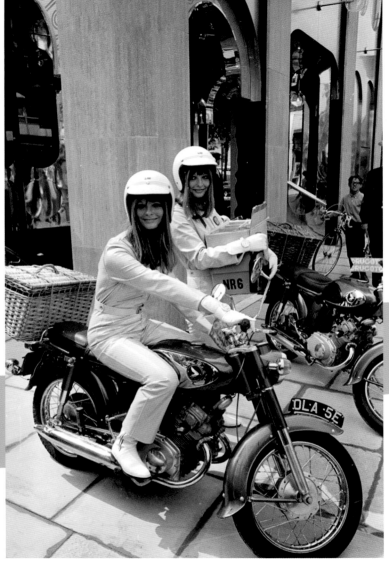

Shop front

Left and far left: Opening day at the Chelsea Drugstore in London's King's Road. Modelled on Le Drugstore on the Boulevard St Germain in Paris, the three-storey building was open for up to 16 hours a day. It incorporated bars, a pharmacy, newsstands and record shops. The store also ran a popular delivery service known as the 'flying squad': customers' purchases could be delivered by young women wearing purple catsuits and riding motorbikes.

28th July, 1968

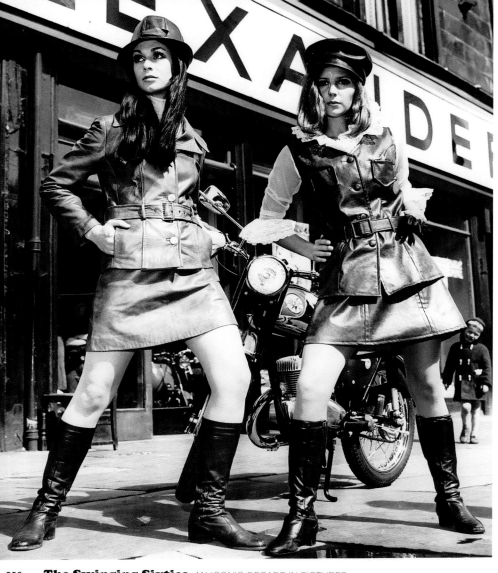

leather girls
Left: Leather gear
jackets, miniskirts
boots and hats
– a schoolboy's
dream come true.
22nd August, 1968

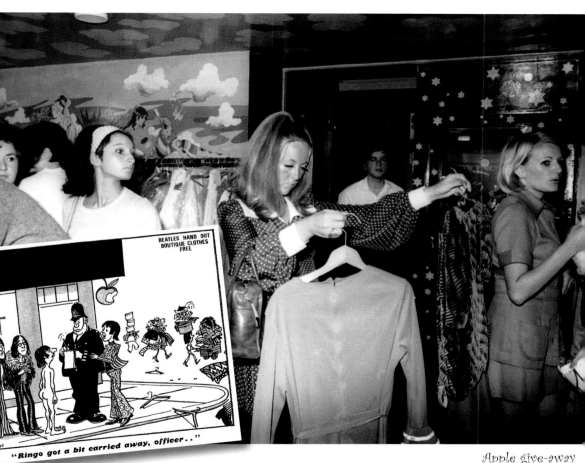

"BEATLES HAND OUT BOUTIQUE CLOTHES FREE"

"Ringo got a bit carried away, officer . . "

Apple give-away

Opened by The Beatles in December, 1967, the Apple boutique, according to Paul McCartney, was a "beautiful place where beautiful people [could] buy beautiful things." Unfortunately, the business lost money at an alarming rate and it was closed eight months later, when all the stock was simply given away (pictured).

31st July, 1968

Doors men

American rock band The Doors arrive at Heathrow Airport, London, to play their first overseas gig. L–R: drummer John Densmore, guitarist Robby Krieger, keyboard player Ray Manzarek and lead singer Jim Morrison.

3rd September, 1968

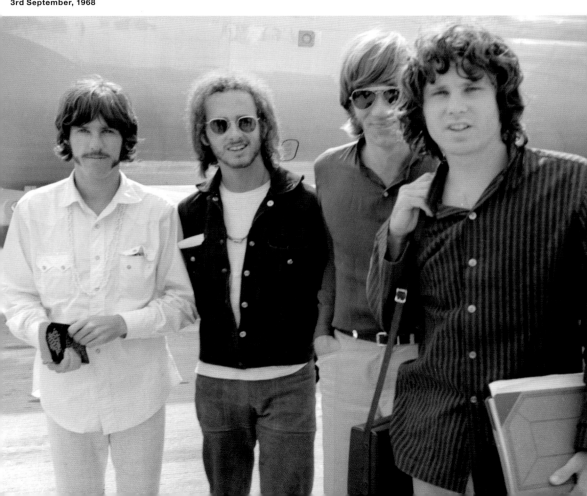

What's so funny?

Below: Famous model Twiggy (R) with Welsh folk singer Mary Hopkin. One of the first artists to sign to The Beatles' Apple label, Hopkin had a number-one hit with *Those Were The Days*.

13th September, 1968

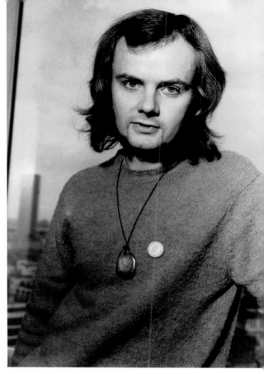

Champion jockey

Disc jockey John Peel, voted top DJ in a *Melody Maker* readers' poll; his Radio 1 show, *Top Gear*, was also voted Best Radio Show. Having grown up in Burton, Cheshire, Peel began his radio career in the USA and spent time on pirate station Radio London before moving to the BBC. He championed an eclectic mix of music and was responsible for giving many unsigned bands their first major exposure. He was the longest serving of the original Radio 1 DJs, broadcasting regularly from the station's launch in 1967 to his death in 2004.

19th September, 1968

Self-destructive DJ

Left: Well-known former pirate and Radio 1 disc jockey Simon Dee opens a jewellery boutique in London's Carnaby Street. Dee moved to television as a chat-show host, but was famously sacked by the BBC. He switched to ITV, but soon fell out with the hierarchy and eventually ended up on the doll, before becoming a bus driver. He never succeeded in reviving his broadcasting career.

6th December, 1968

Hair today

Right: Rolling Stone Mick Jagger and singer Marianne Faithfull with Lord Montague of Beaulieu at the premiere of the musical *Hair*.

4th December, 1968

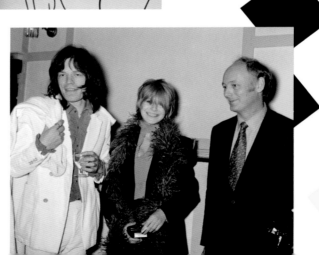

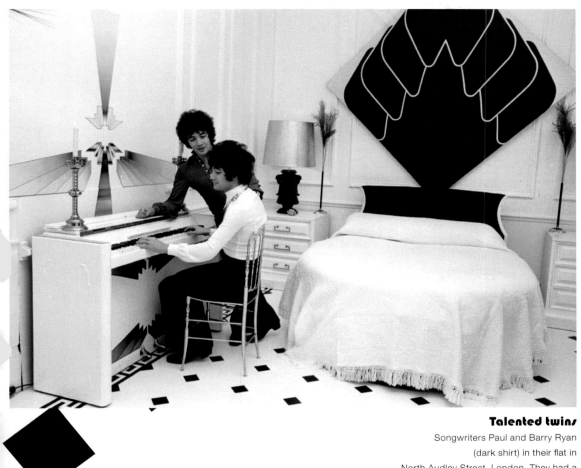

Talented twins

Songwriters Paul and Barry Ryan
(dark shirt) in their flat in
North Audley Street, London. They had a
major hit with *Eloise* in 1968.

19th November, 1968

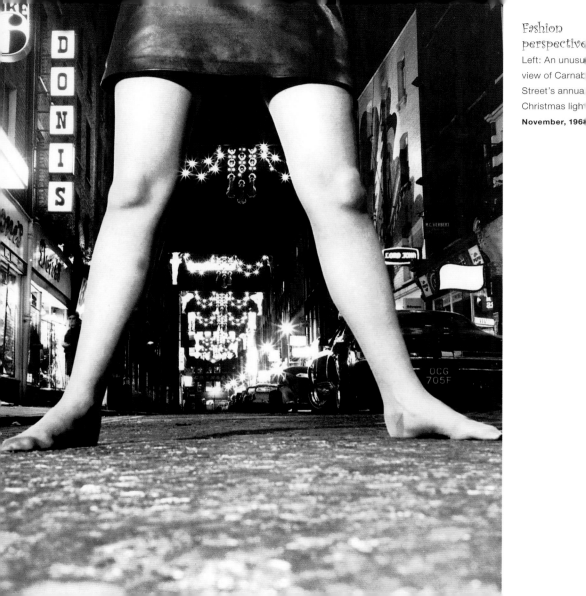

Fashion
perspective
Left: An unusu
view of Carnab
Street's annua
Christmas ligh
November, 196

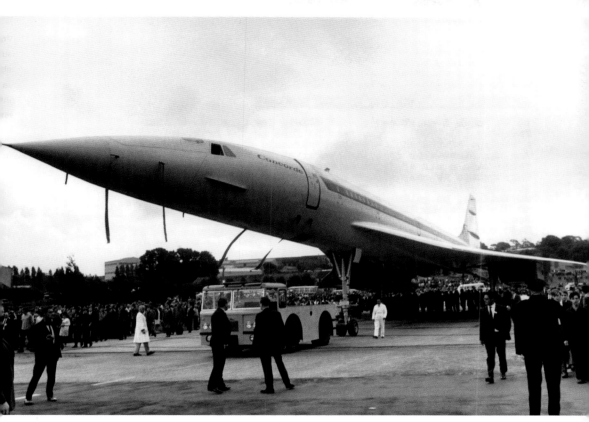

Iconic Concorde

Supersonic airliner Concorde 002, a joint Anglo-French engineering triumph, is wheeled out of its hangar at Filton in Bristol. Although only 20 were built, the aircraft would have a long and illustrious career, flying between London and New York in a record-breaking three hours. It was finally withdrawn from service in 2003, following the fatal crash of an Air France machine in 2000.

12th September, 1968

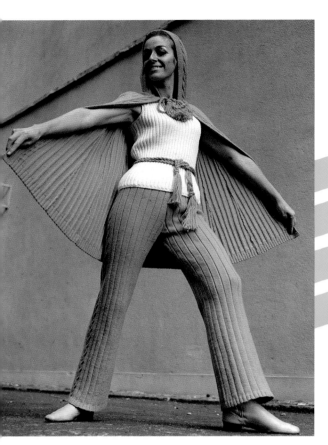

Left: A knitted cape
worn with matching
trousers and contrasting
sleeveless sweater.

1969

Circus performers

Right: Members of the *Monty Python* team during filming for the first
series of the cult television series at Calf Rocks on Ilkley Moor in
Yorkshire. L–R: Eric Idle, John Cleese, Terry Jones and Michael Palin.

1969

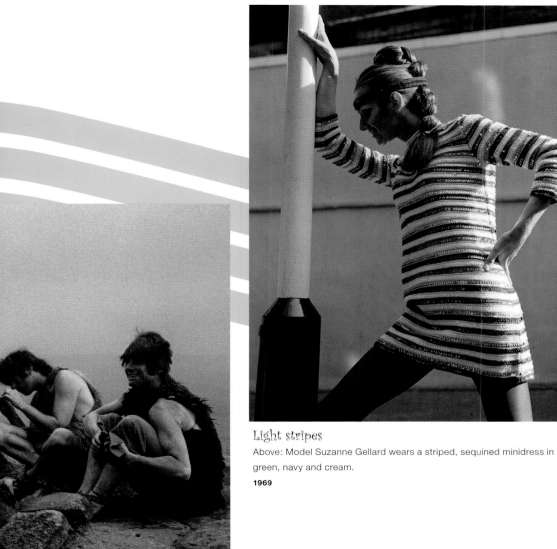

Light stripes

Above: Model Suzanne Gellard wears a striped, sequined minidress in green, navy and cream.

1969

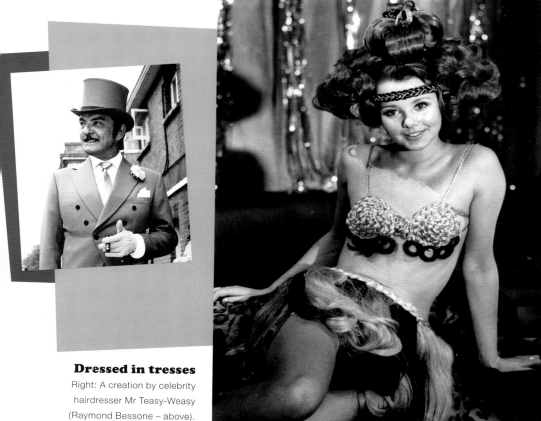

Dressed in tresses

Right: A creation by celebrity
hairdresser Mr Teasy-Weasy
(Raymond Bessone – above).
The entire outfit – bra, skirt
and headband – were made
from human hair.

14th January, 1969

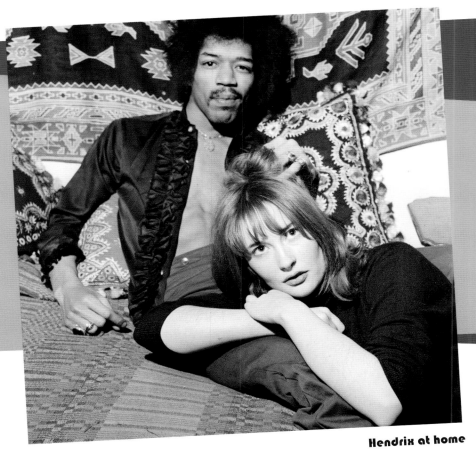

Hendrix at home

American singer and guitarist Jimi Hendrix with girlfriend Kathy
Etchingham in their Mayfair flat in London. On stage, Hendrix would
play his guitar with his teeth and behind his head; he would finish by
smashing it and setting fire to it. A victim of the drink-and-drug excesses
of the rock 'n' roll lifestyle, he died in September, 1970, aged just 27.

7th January, 1969

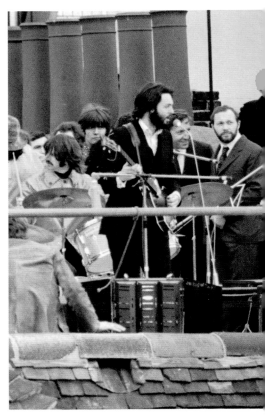

The 'look'

Alexandra Bastedo, the 25-year-old actress who starred in television's espionage/science-fiction series *The Champions*, had the Sixties 'look'. Today, she runs an animal sanctuary in West Sussex.

3rd January, 1969

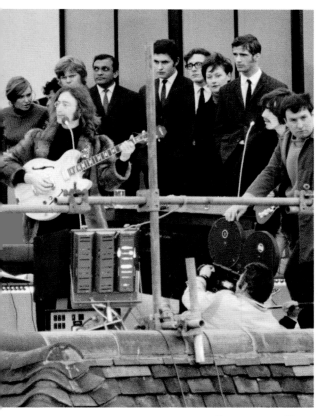

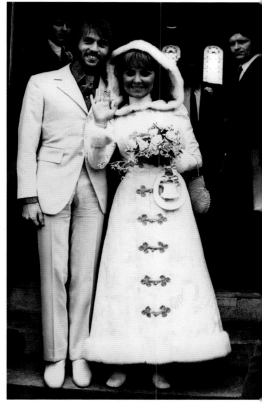

One more time

The Beatles give their last ever performance together before breaking up in 1970, on the roof of the Apple building in London's Savile Row. It was made during the filming of a documentary of the band rehearsing and recording the album *Let It Be*. The 42-minute session drew crowds in the street below and on adjoining rooftops.

30th January, 1969

Young lovers

Lulu poses with her new husband, Maurice Gibb of the Bee Gees, on their wedding day in Gerrards Cross, Buckinghamshire. Gibb's older brother, Barry, was opposed to them marrying, believing them to be too young. Their marriage lasted four years, but they were driven apart by the demands of their careers and heavy drinking.

19th February, 1969

Best Mini

Manchester United football star George Best, reunited with his luxury Mini after a six-month driving ban imposed by a Manchester court for crashing into another car while drunk. In 1968, he had been voted Footballer of the Year by the Football Writers' Association.

28th January, 1969

Mini match

A pink and orange psychedelically patterned Mini, with owner Sandra Ford wearing a matching outfit.

23rd February, 1969

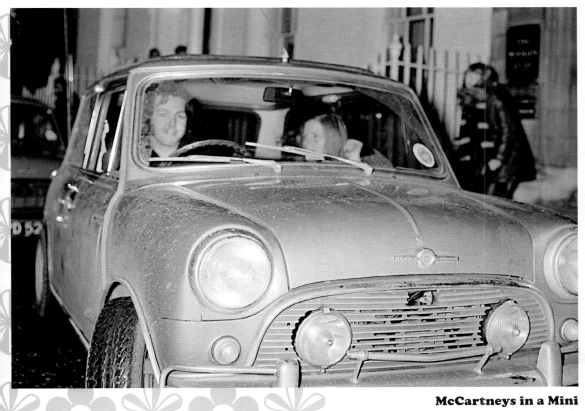

McCartneys in a Mini

Newly-married Paul and Linda McCartney leave the Apple building in Savile Row, London. The couple had met in 1967 at a Georgie Fame concert, where she had been working on a photographic assignment.

6th April, 1969

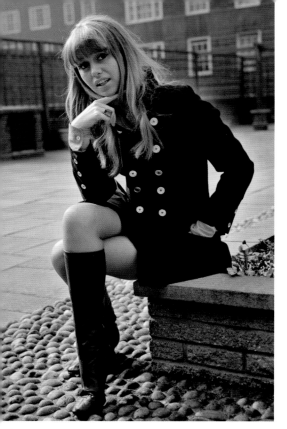

long run

Above: Susan George, aged 19, the young British actress and former child star who subsequently appeared in a number of films and television programmes in a long career that spanned over three decades.

7th March, 1969

Self-promotion

Below: Designer Mary Farrin modelling one of her own designs outside her boutique in South Molton Street, London.

9th March, 1969

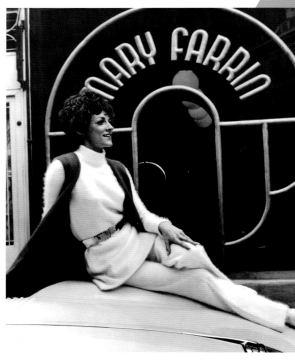

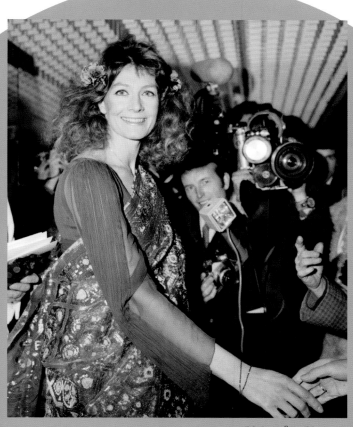

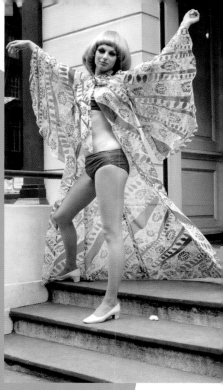

Chilled out

Above: After designers Janet Lyle and Michael Fish launched their summer fashions in March, the models braved a flurry of snowflakes to show off new bikini styles and wraparound cotton coats for the photographers, drawing a curious crowd of shoppers in Clifford Street, London.

24th March, 1969

Vying for Vanessa

Photographers clamour for the attention of actress Vanessa Redgrave as she arrives at the Odeon, St Martin's Lane, London, for the premiere of *Isadora*, in which she starred, giving an acclaimed performance. In the Sixties, she was known for her political activism.

4th March, 1969

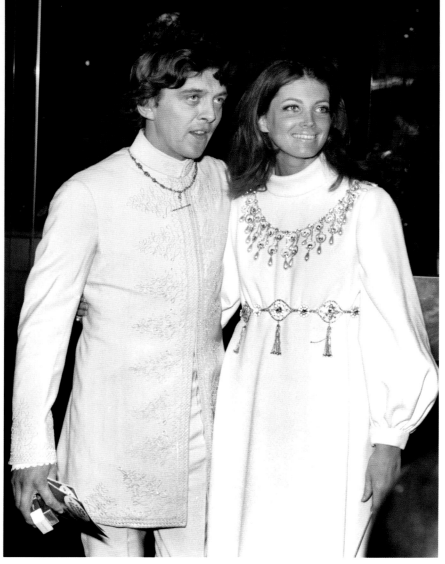

Double act

Left: Husband-and-wife actors David Hemmings and Gayle Hunnicutt attend the premiere of the film *Oh! What a Lovely War*. The couple had married in 1968. By the late Sixties, Indian-style clothing had become very fashionable, largely influenced by pop stars who had embraced Eastern mysticism.

10th April, 1969

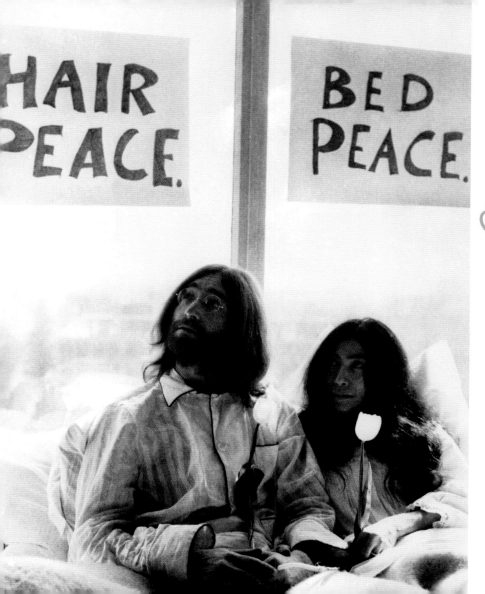

Lie-abeds

After marrying in Gibraltar on 20th March, 1969, John Lennon and Yoko Ono spent a week-long honeymoon at the Hilton Hotel in Amsterdam, campaigning for peace in Vietnam by staying in bed.

25th March, 1969

255

In the department

Left: Actor Peter Wyngarde, who played suave crime-busting novelist Jason King in the popular Sixties TV series, *Department S*. Although Wyngarde's TV roles portrayed him as a womaniser, in fact he was gay and popularly known in acting circles as Petunia Winegum. His kipper ties, wide-lapelled suits, mutton-chop sideburns and droopy moustache epitomised the look many men aspired to in the late Sixties.

6th June, 1969

Going solo

Right: Singer/songwriter Robin Gibb of the Bee Gees in contemplative mood after quitting the band to pursue a solo career. He had felt that his work was being overlooked in favour of that of his older brother, Barry.

29th April, 1969

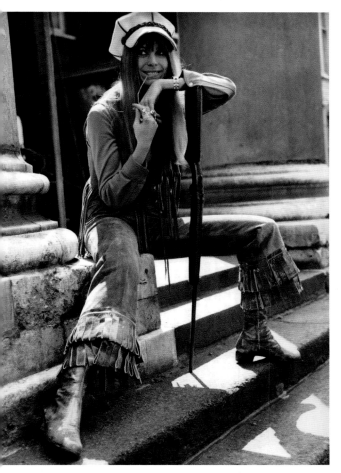

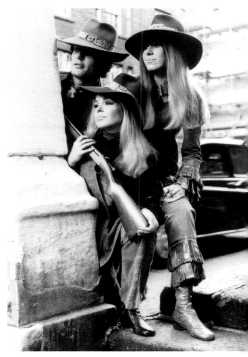

Riders of the range

Below: Western-inspired outfits for 'cowboys and gals' of felt stetson hats, with rattlesnake bands, and jackets and trousers trimmed with leather tassels.

May, 1969

Sharpshooter

Above: A Western-inspired outfit of suede tassled jeans, worn with a matching waistcoat, blouse and leather boots. The white, gaberdine cap is more reminiscent of an old-time American locomotive driver's.

28th May, 1969

Chain reaction

Some fashions were designed to be eye-catching rather than practical. Witness this origami hat worn with a trouser suit that has two-piece legs connected by chains.

1st June, 1969

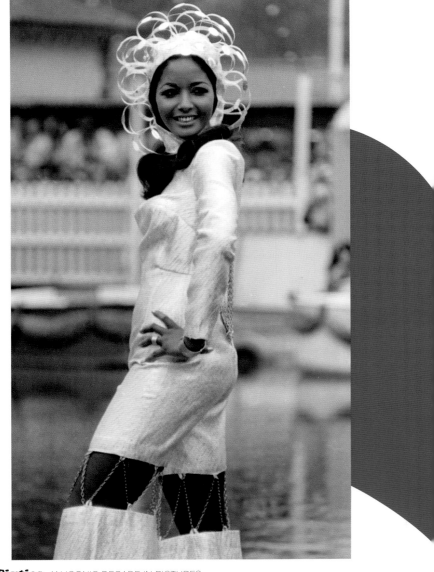

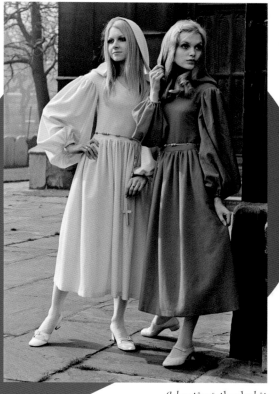

Fashion model and actress Madeline Smith (R)
wears a cowled-neck 'monk' dress.

7th March, 1969

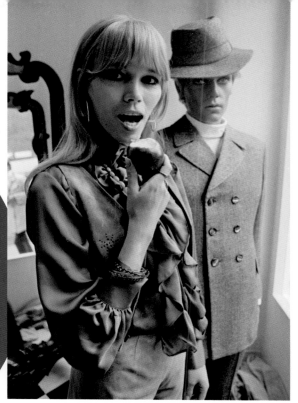

Who's your friend?

Above: A fashionably attired woman in
a Carnaby Street boutique, complete with friend.

1st June, 1969

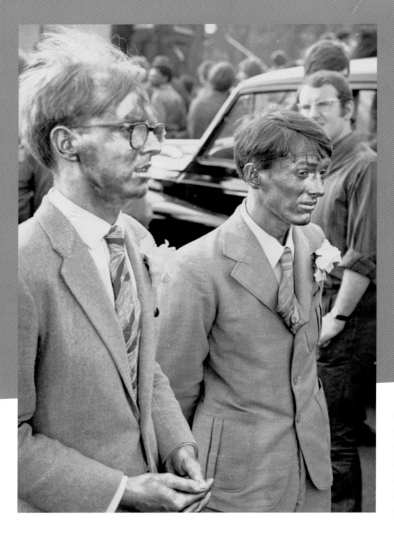

Odd couple

Modern artists Gilbert and George (real names Gilbert Proesch and George Passmore) blend into the crowd during the Rolling Stones free concert in London's Hyde Park.

5th July, 1969

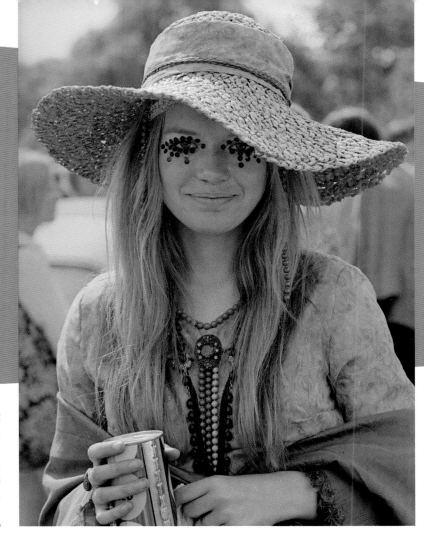

Hippy hat

A hippy girl with large floppy hat and elaborate, sequined eye make-up, at the free Rolling Stones concert in Hyde Park, London.

5th July, 1969

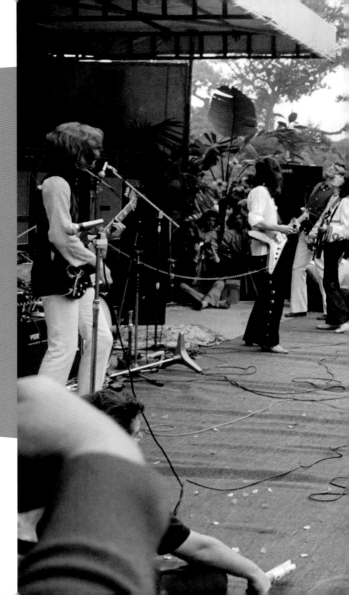

Remembering Brian

The Rolling Stones on stage during their free
concert, dedicated to Brian Jones, in Hyde Park.

5th July, 1969

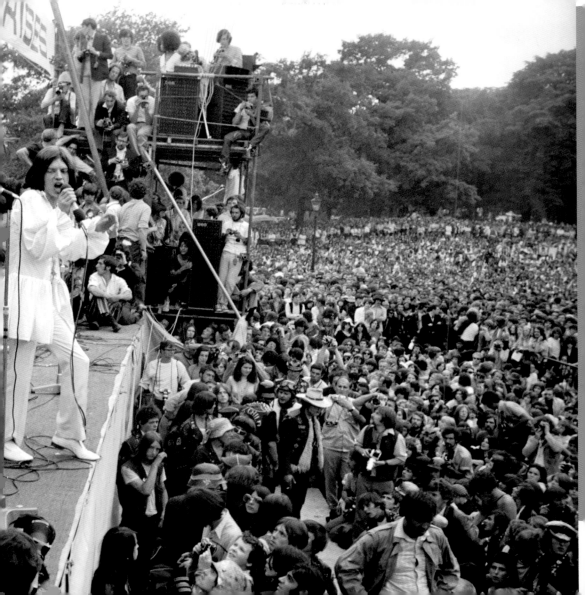

As tears go by

The huge crowd of mourners at Rolling Stone Brian Jones'
funeral in Cheltenham included his sister, Barbara (L), and
girlfriend, model Suki Potier (second L). Jones had drowned
in the swimming pool of his home in East Sussex.

10th July, 1969

Sharp-dressed man

Barry Gibb of the Bee Gees, who had been
voted Best Dressed Personality of the Year
by a radio station, greets crowds who had
gathered to see him in Carnaby Street.

July, 1969

The Swinging Sixties AN ICONIC DECADE IN PICTURES

Right: A multi-coloured, knitted wool, Russian-style peasant coat, worn with a headscarf, designed by Carosa: a look more at home on the Russian Steppes than in the Home Counties.

1st August, 1969

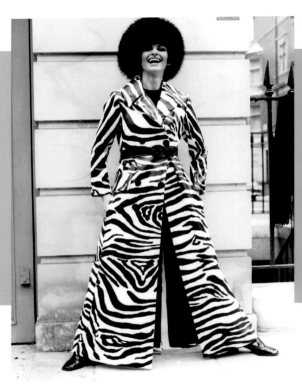

Worth it

Part of the new fashion collection from the House of Worth: a long coat in chunky-knit fabric, giving a fish-scale texture, edged with mahogany suede and worn over matching suede trousers.

25th July, 1969

Zebra stripes

Above: A zebra-print plastic maxi coat, worn with a black fur hat, by designer Michael of Carlos Place, London.

24th July, 1969

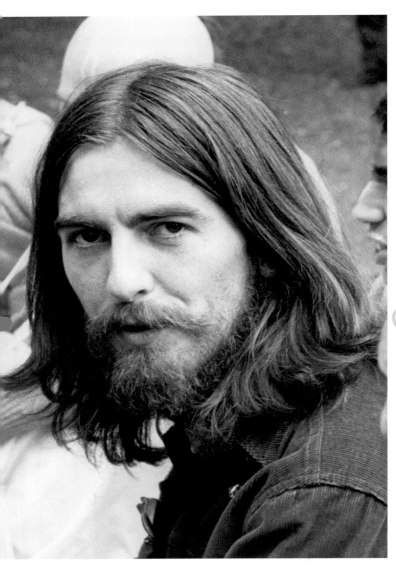

Hippy circus

Right: Hippies gather in Piccadilly Circus in central London, probably from a nearby squat at 144 Piccadilly.

15th August, 1969

My sweet Lord

Left: George Harrison of The Beatles, pictured at a Krishna Temple meeting in London. The Beatles' lead guitarist had embraced Indian culture and Hinduism in the mid-Sixties, and helped to raise awareness of sitar music and the Hare Krishna movement in the West.

28th August, 1969

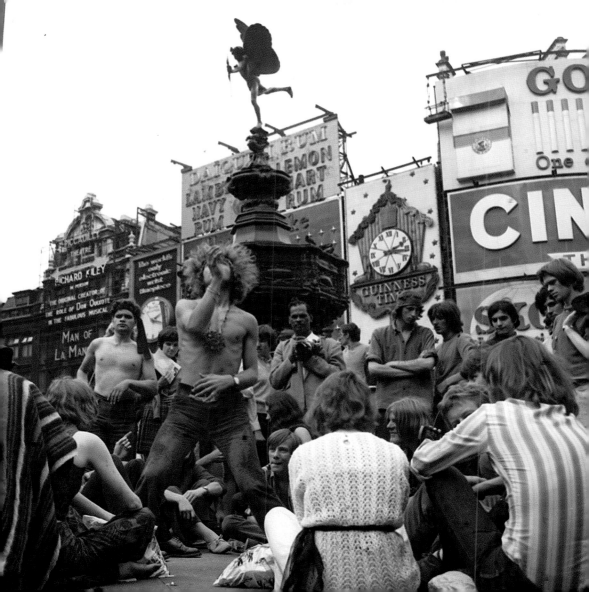

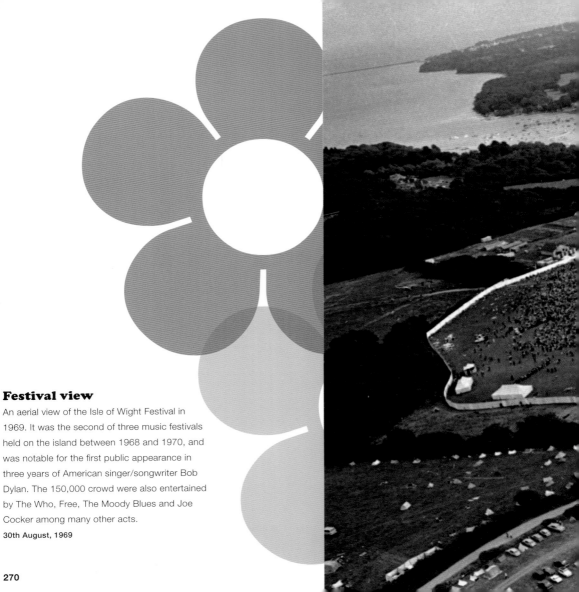

Festival view

An aerial view of the Isle of Wight Festival in 1969. It was the second of three music festivals held on the island between 1968 and 1970, and was notable for the first public appearance in three years of American singer/songwriter Bob Dylan. The 150,000 crowd were also entertained by The Who, Free, The Moody Blues and Joe Cocker among many other acts.

30th August, 1969

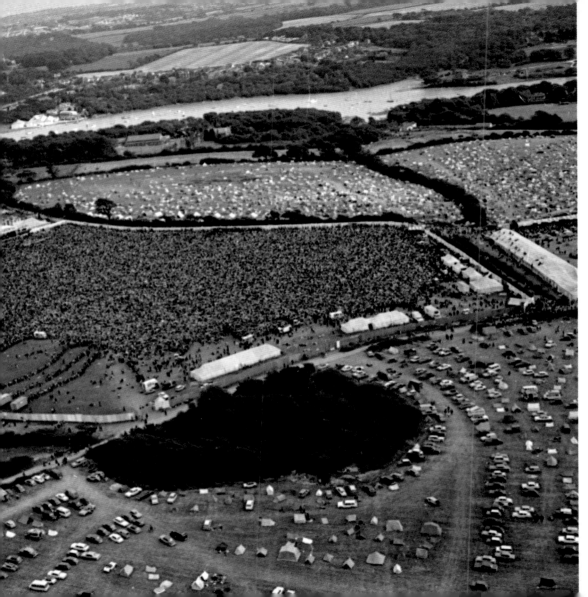

Love in the afternoon

A young couple make
their own entertainment
at the Isle of Wight Festival.

30th August, 1969

Bubbling with enthusiasm

Music fans chill out at the Isle of Wight Festival with a little bubble blowing.

Their accommodation seems to consist largely of old car parts and a tarpaulin.

30th August, 1969

The Swinging Sixties AN ICONIC DECADE IN PICTURES

273

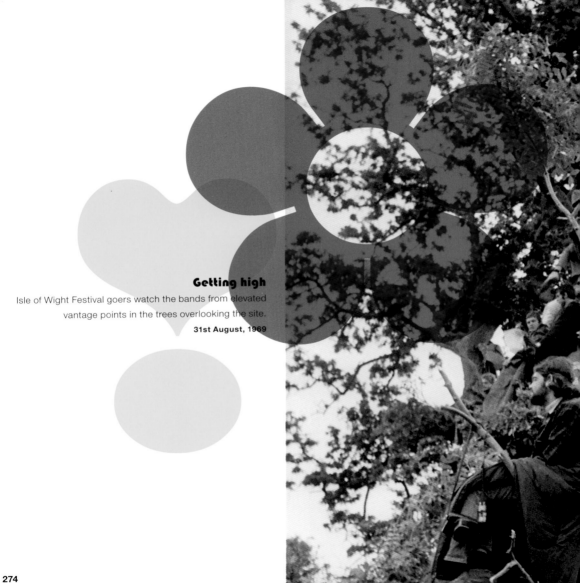

Getting high

Isle of Wight Festival goers watch the bands from elevated
vantage points in the trees overlooking the site.

31st August, 1969

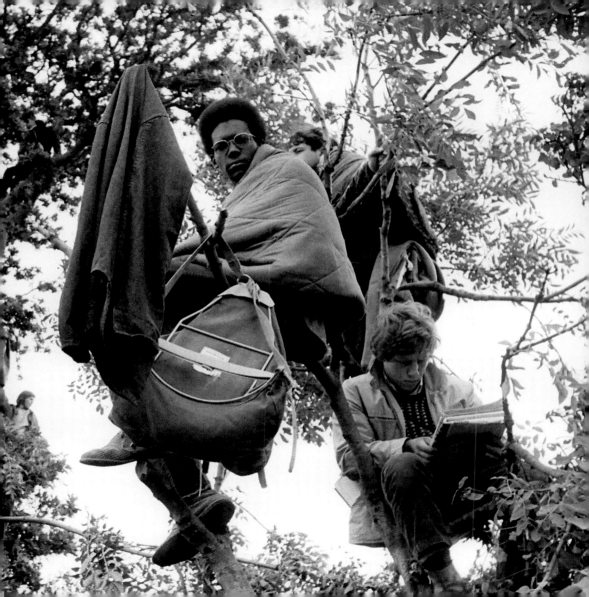

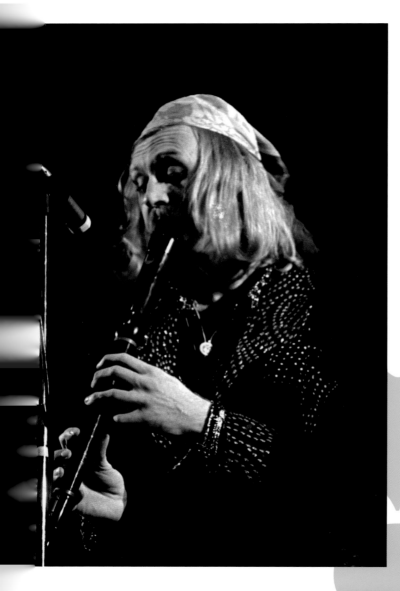

Flower power

Right: Hippies taking a trip at a music festival: a sea of vibrant prints, beads, sandals, headbands and flowers.
c.1969

Eccentric act

Left: Vivian Stanshall of The Bonzo Dog Doo-Dah Band performing at the Isle of Wight festival. The band's comical performances combined elements of music hall, trad jazz, psychedelic rock and avant garde art.
30th August, 1969

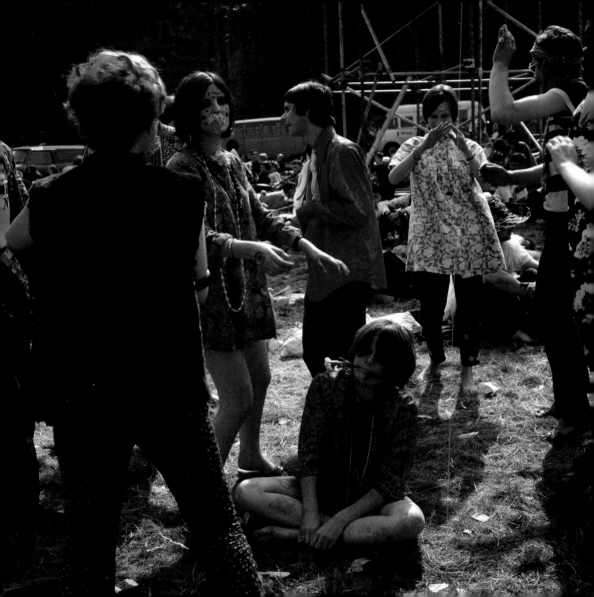

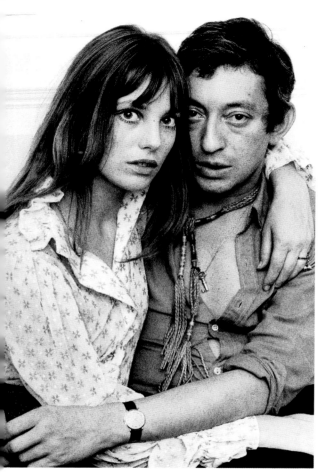

Controversial duo

Above: French actor Serge Gainsbourg with his actress wife, Jane Birkin. In 1969, the couple released the sexually-explicit song *Je t'aime... moi non plus*, which was banned by the BBC.

29th September, 1969

Autumn sleeves

Below: The London branch of Christian Dior shows its autumn collection: (L) long brown velour sports coat; (R) brown velour jacket and miniskirt, worn with a satin blouse, fabric waistcoat and two-tone, calf-length boots.

September, 1969

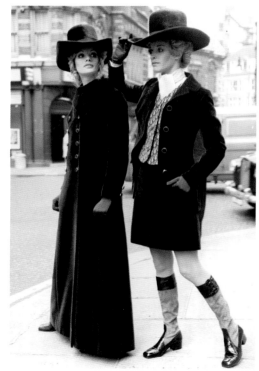

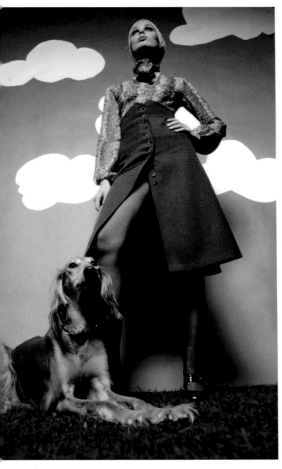

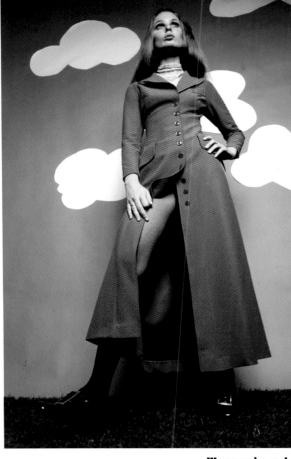

Falling standards

The end of the Sixties saw hemlines start to move downwards as the maxi styles that would dominate the early part of the Seventies began to appear.

1st October, 1969

Woman in red

A red button-through, maxi dress with generous thigh-revealing split.

1st October, 1969

Century 21

Actresses in 'futuristic' outfits on the Moonbase set of *UFO*, a sci-fi TV series made by Gerry and Sylvia Anderson's Century 21 Productions company. The couple had previously made several successful puppet series, including *Thunderbirds* and *Captain Scarlet*.

30th October, 1969

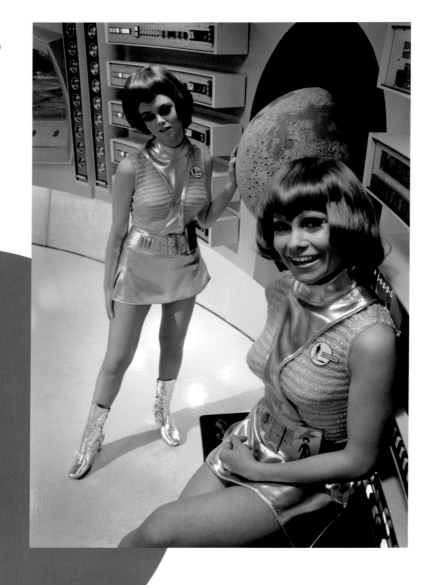

Black holes

Black tights: fashion items that had
holes in them before you'd even
put them on.

1st October, 1969

The Swinging Sixties AN ICONIC DECADE IN PICTURES 281

Panda eyes

Right: Renowned Sixties
model Penelope Tree
demonstrates make-up artist
Paul Richards' latest look:
multi-coloured panda eyes.

1st November, 1969

Horror heroine

Model turned actress Madeline Smith in an empire-line minidress and thigh boots, a distinctive Sixties look. In 1969, she made her first appearance in a Hammer horror film, *Taste the Blood of Dracula*, and went on to become a regular heroine of the genre, as well as making frequent appearances in television comedy shows.

3rd November, 1969

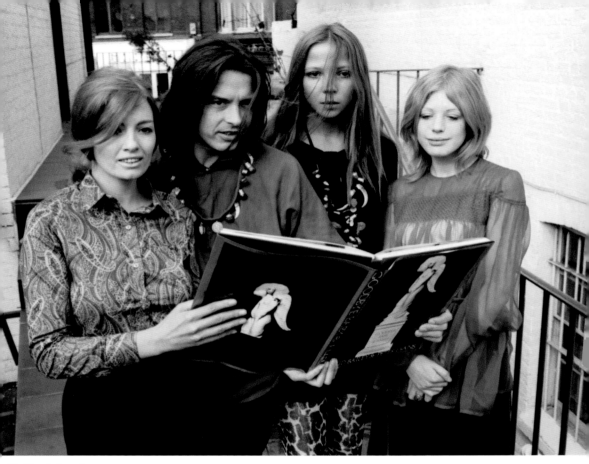

Bailey's book

Celebrity fashion photographer David Bailey shows off his new book, *Goodbye Baby & Amen*, to (L–R) models Christine Keeler and Penelope Tree (his girlfriend), and singer Marianne Faithfull, who seems to be the only one actually interested in it.

9th November, 1969

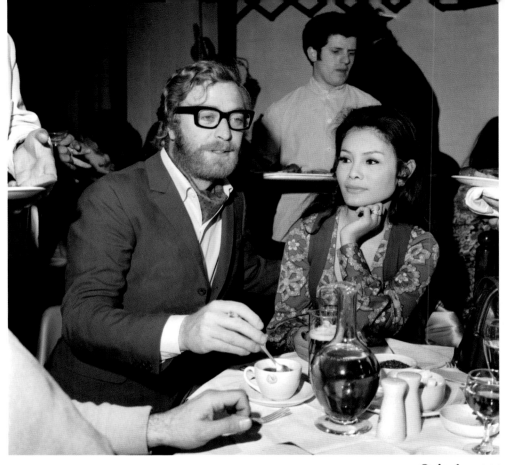

Caine's sugar

Legendary British actor Michael Caine with girlfriend Minda Feliciano,
seen at the launch party for photographer David Bailey's new book.

9th November, 1969

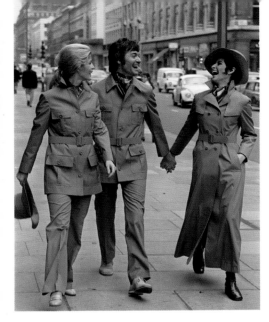

City safari

Left: Safari suits and raincoats, on display in the King's Road, London, rather than on the plains of Africa.

24th October, 1969

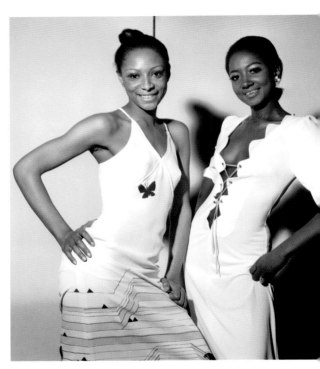

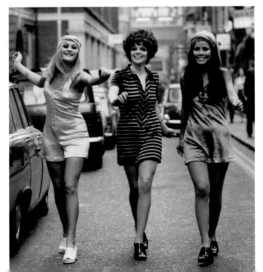

Take three girls

Left: Spring and summer chenille fashions from the Pour Elle collection, on show in London: (L–R) cream velvet playsuit, black and white striped minidress, velvet aubergine minidress.

3rd November, 1969

Pale and interesting

Left: Dresses by Mary Quant: (L) white crepe sleeveless dress with striped skirt and butterfly motif; (R) white dress with scalloped lace-up bodice and matching sleeves.

12th November, 1969

Space-age Christmas

Carnaby Street entered into the excitement generated by the NASA moon landings in 1969 by putting up space-themed Christmas decorations.

11th November, 1969

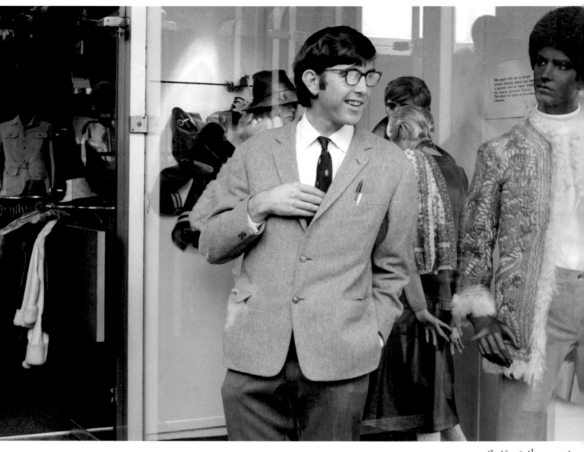

Above and right: Actor John Alderton, filming on location in the King's Road, Chelsea, for the television sitcom *Please Sir*, in which he played harassed teacher Bernard Hedges. He is seen before and after his transformation to trendy man about town, outside men's fashion boutique Skin.

13th November, 1969

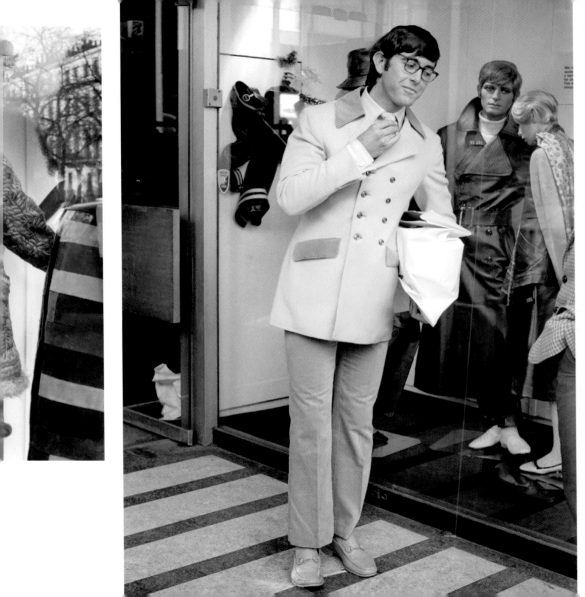

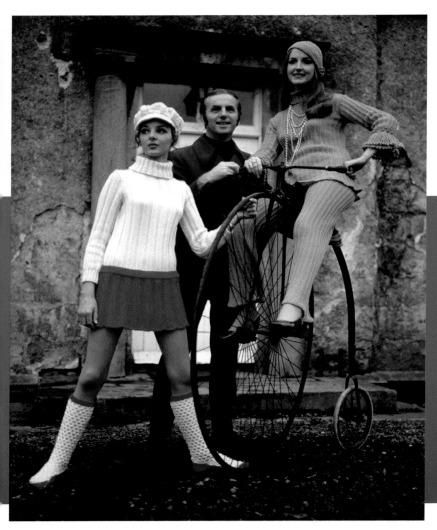

Designer knits

Left: Irish designer Cyril Cullen with models wearing his creation (L) red knitted miniskirt and white polo-neck jumper, worn with matching woollen hat and red an white long socks; (R) blue knitted trouser suit, the perfect outfit for riding a penny-farthing.

24th November, 1969

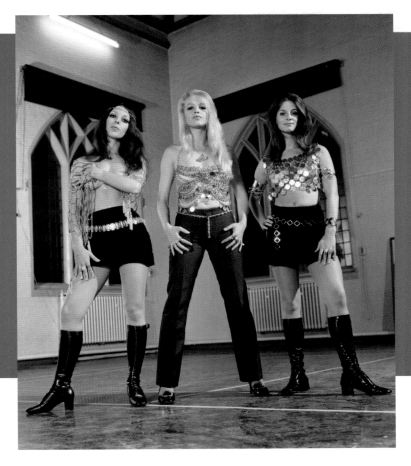

Pan's trio

Three members of Pan's People, the dance troupe who became a permanent fixture on *Top of the Pops*, as well as appearing on other television shows, such as *The Price of Fame*, in the late Sixties. L–R: Louise Clark, Babs Lord, Dee Dee Wilde.

1st December, 1969

The Swinging Sixties AN ICONIC DECADE IN PICTURES 291

Seeing red

Above: A red velvet waistcoat worn with matching trousers, a
short-sleeved, white satin blouse and a knitted white hat.

15th November, 1969

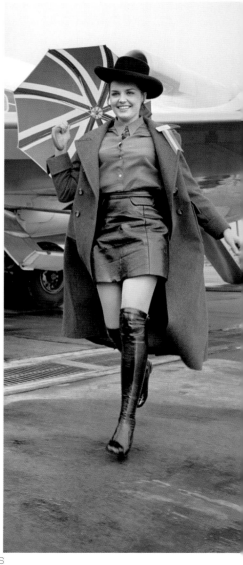

Flag waver

Left: Suzanne Angly, Miss France, arrives at Heathrow Airport for the Miss World pageant at the Royal Albert Hall in London. Her leather miniskirt and over-the-knee leather boots caused quite a stir in the arrivals hall.

19th November, 1969

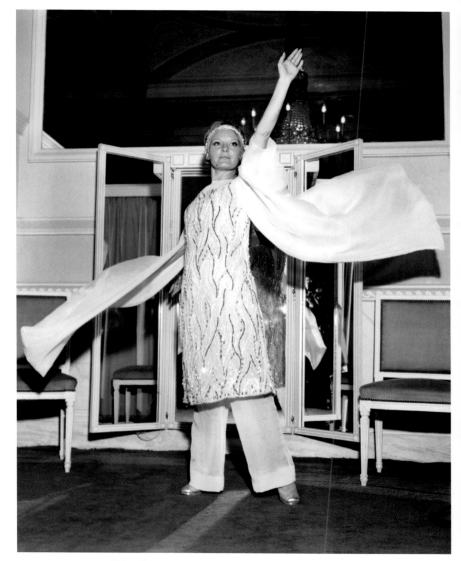

Petula's premiere

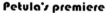

Right: British singer and actress Petula Clark, star of the film *Goodbye, Mr. Chips*, performs a twirl at the Christian Dior salon in the outfit they had designed for her to wear to the premiere of the film.

24th November, 1969

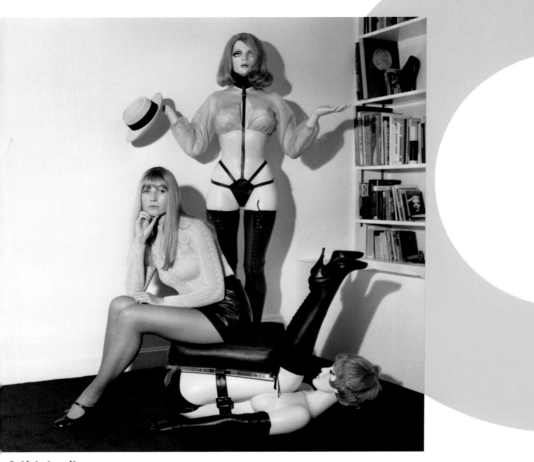

fetish furniture

A novel chair and hat stand, designed by the artist Allen Jones
and made from fibreglass and leather: talking points at any dinner party.

12th December, 1969

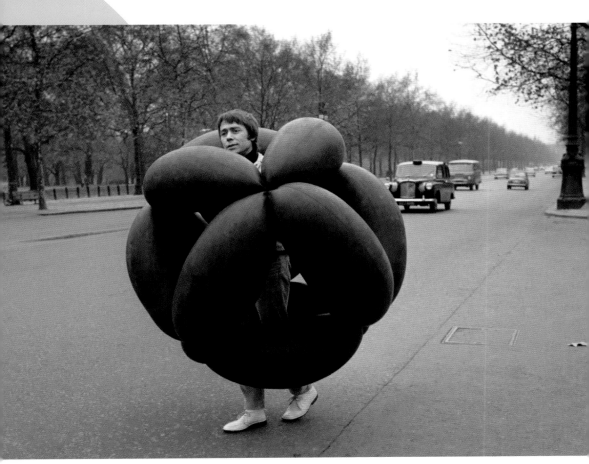

In the ball

An exhibition held at the Institute of Contemporary Arts (ICA) in The Mall, in London, challenged artists involved in the visual arts to design games and toys. Sculptor Garth Evans is pictured arriving with his Body Ball design.

27th November, 1969

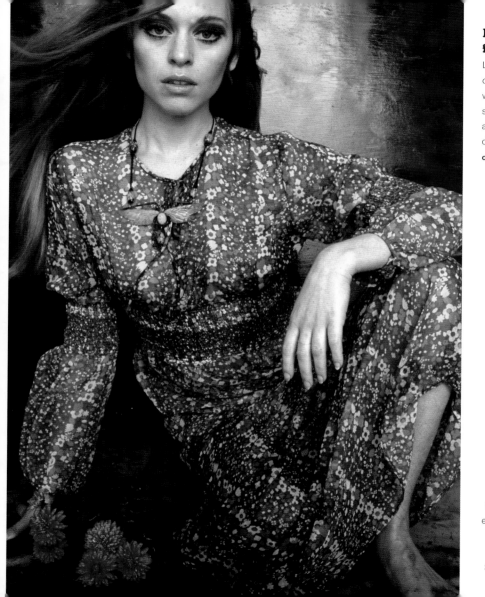

Floaty and floral

Left: A floaty chiffon dress in a floral print, with ruched waist and sleeves, worn with a striking, beaded dragonfly necklace.

c.1969

Romany romance

A hand-crocheted skirt and fringed shawl, worn with a cropped top, matching scarf, and chunky pendant and earrings; the Romany caravan completes the romantic theme.

22nd December, 1969

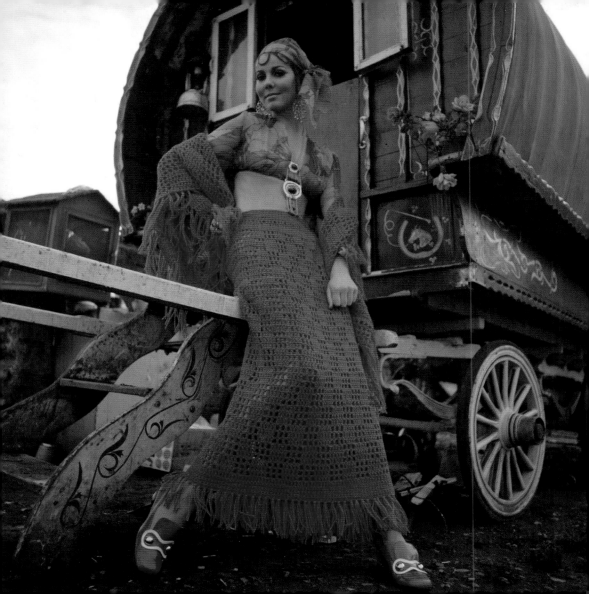

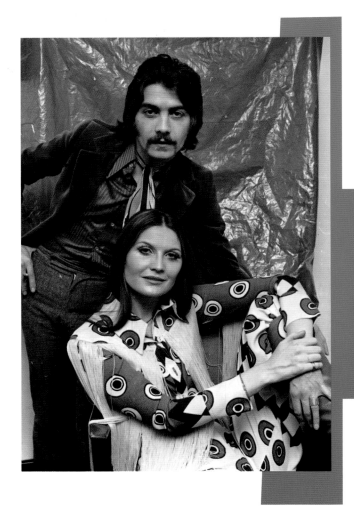

Right: Singer/songwriter, impresario and record producer Jonathan King poses for a *Daily Mirror* fashion shoot wearing an exotic Chinese kaftan. King had found fame after writing and singing *Everyone's Gone to the Moon* in 1965. In 1967, he gave rock band Genesis their big break.

1969

Golden couple

Left: Fashion designer Jeff Banks with his wife, singer Sandie Shaw, who formed a glamorous partnership in the late Sixties.

c.1969

The publishers gratefully acknowledge Mirrorpix, from whose extensive archives the photographs in this book have been selected.

AMMONITE
PRESS